ENGLISH ILLUSTRATION:
THE NINETIES

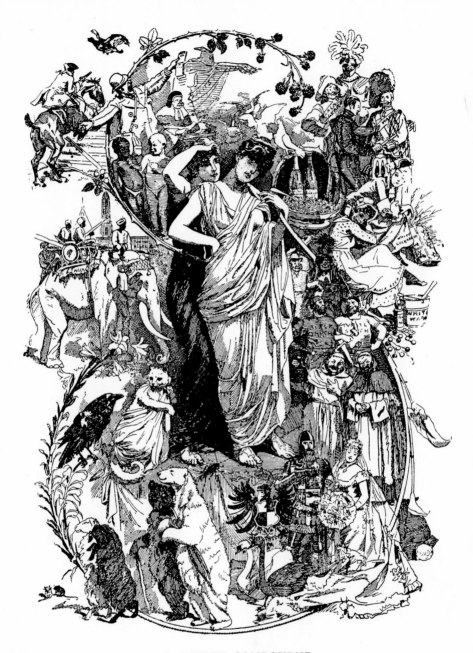

1. LINLEY SAMBOURNE
Black and White
from *Black and White*

JAMES THORPE

ENGLISH ILLUSTRATION: THE NINETIES

HACKER ART BOOKS, INC.
NEW YORK 1975

First published by Faber and Faber Ltd., London, 1935.

Reissued 1975 by
Hacker Art Books, Inc.
New York

Library of Congress Catalogue Card Number 72-95117
ISBN 0-87817-128-2

Printed in the United States of America.

To
FRANK REYNOLDS

PREFACE

Forty odd years ago four boys, whose sixth-form dignity entitled them to the liberty of the library, used to meet before morning school to test one another's discernment in spotting the work of the artists in *The Daily Graphic*, then in its fourth year. The signatures were covered, and although certain distinctive styles were obvious enough, others were more difficult to attribute. In those blessed days when motor-cars were not, our enthusiasm was at least as justifiable and instructive as the modern boy's passion for the hot, oily, smelly interior of an internal-combustion engine. This early love of black-and-white drawings, fostered and encouraged by experience, has remained with me since, and a wish to impart some of its fascination to others first prompted the production of this book. Gleeson White's charming record, *English Illustration: the Sixties* (Constable, 1897), which gave me an insight into the glories of that golden period, seemed to call for some sort of register of the later decade, which was almost equally fruitful in its production. The present volume is an attempt to supply this sequel.

Holbrook Jackson in his excellent 'review of art and ideas'— *The Eighteen Nineties* (Grant Richards, 1913)—has given an intelligent general account of those glorious days even without mentioning W. G. Grace, K. S. Ranjitsinhji, Lohmann, Richardson or Lockwood. It was a period of great production, not only in illustration, but in books, in the theatre, in painting, sport, industry, science and music: a period of definite departure from traditions, and of bold experiment. For, despite the superiority of the bright young things of to-day, they were the greatest and happiest years of England's history, when her supreme dignity and power were unchallenged, and selfishness, greed and hesitancy had not yet begun to weaken our prestige; when we set the example to the other countries of the world, and were not influenced by the imitative absorption of shallow,

meretricious qualities from America or by the stark ugliness of Bolshevism; when the main roads of England were still beautiful and interesting; when we had time to live decently and intelligently, without the modern senseless feverish haste in finding means to live. And now my young friends may continue their uncontrolled laughter!

To compile a complete iconography of the illustrators of the nineties would be the work of a lifetime, and would require a great number of extensive volumes. What has been essayed here is to give a general review of the period, an introduction to a vast and pleasant subject, and a record of much that has already been undeservedly forgotten, so that anyone interested may be put on the trail, which can be explored along its course and through its many ramifications. In sheer bulk the output of work was tremendous, and lengthy and interesting monographs could be written on the work of very many of the individual artists. The vast number of illustrations considered has been divided mentally into four qualities, the poor, the competent, the accomplished and the distinguished. To a sympathetic critic this classification has been difficult, but good intentions have had perforce to be overlooked and the merit judged by the results produced. About the first class I have been discreetly silent, the second I have, as far as possible, mentioned, the third I have acknowledged with occasional comments, and of the fourth I have enthused unashamedly and perhaps sometimes with exaggeration, supporting my personal admiration in many instances with examples. Omissions and errors of judgment there must be, but I hope these will be attributed more to the excitement of the enthusiast than to any critical malice.

For much appreciated assistance I am grateful to the courteous officials of the British Museum at Bloomsbury and Colindale, the Victoria and Albert Museum, the National Portrait Gallery and the Chelsea Public Library, and to the publishers and owners of copyrights who have kindly given permission to reproduce illustrations. To my friend, R. S. McMinn, my best thanks are offered for his very capable and drastic revision of the manuscript.

CONTENTS

CONTENTS

CONTENTS

ILLUSTRATIONS

To make a representative selection from the hundreds of thousands of drawings published between the years 1890 and 1900 is a difficult and bewildering task, especially if one is sympathetic. In some cases many would have to be printed to show the full range of one artist's powers and methods. It is obviously impossible, in a book of this size, to present even one example of each of those artists mentioned in the text, and many are perforce unrepresented. So far as is possible, those have been selected whose work shows originality of treatment and is therefore more likely to be of interest. The examples have been taken generally from work done within the prescribed period, although there are a few exceptions. This limitation must sometimes prevent the presentation of the artists' best work which was done later, but it is hoped that these early drawings may be of interest by comparison. Owing to the restrictions of reproduction and the difficulty of obtaining original drawings the choice of half-tone illustrations has had to be very much modified. Earnest efforts have been made to trace the owners of copyrights, to whom acknowledgment is gratefully made. Where this has been found impossible, it is hoped that the omission will be generously pardoned.

ILLUSTRATIONS

xiv

ILLUSTRATIONS

xv

ILLUSTRATIONS

ILLUSTRATIONS

xvii

ILLUSTRATIONS

ILLUSTRATIONS

ILLUSTRATIONS

THE ART OF THE ILLUSTRATOR

From the earliest dawn of intelligence mankind has been interested in drawing. The oft-quoted incised design of the cave-man not only pleased the artist but perhaps afforded enjoyment to his immediate neighbours. When later he added some crude colour the appeal was intensified, for people have always preferred their art coloured rather than plain. The child loves the gaudy plates of the toy-book far more than the subtle charm of the black-and-white illustrations. The old tag, 'penny plain, twopence coloured', does not exaggerate the difference in relative value. To most people art means neither more nor less than a coloured painting in a frame, preferably gilt. To suggest that the illustration which is so lightly turned and forgotten may contain greater artistic merit would only invite an indulgent smile. Thus the modern editor seeks to gain a reputation for generosity and to hide the poverty of his illustrated pages by a reckless and indiscriminate distribution of very primary tints. For the glamour of colour is often successful in distracting the untutored eye from glaring faults in drawing, perspective or composition, qualities which demand for their appreciation a certain amount of knowledge and discrimination.

When our early ancestor further developed his drawings to represent hieroglyphics—or word-pictures—and letters, he very much reduced the scope of his appeal. The reading of letters required more intelligence than was necessary to understand the meaning of a drawing. So even in these days of alleged enlightenment, many people who are too tired to read gather much of their information about current affairs from reproductions of photographs. The cinema palace is far more popular than the public library, and demands much less intellectual effort. Even

the most sedate newspaper is compelled to print at least a page of illustrations to retain the support of its readers, who, in most cases, totally ignore the wisdom of its leading articles. A cartoon, particularly if it is humorous, carries far more conviction than many columns of well-reasoned argument.

Although some readers of newspapers and magazines devote more attention to the illustrations than to the letterpress, they are quite indifferent and remarkably ignorant about the means by which these illustrations are produced. Very few people can (or even wish to) differentiate between the work of the various draughtsmen in the comparatively few publications in which their work is now employed. The merit of the drawing is judged solely by the appeal of the explanatory lines beneath it. In many cases the artist's signature is illegible, or is carefully suppressed by the editor, whereas the writer's name is plainly printed in clear type at the head or foot of his article so that, although he may not be read, he is better known, and has thus more chance of acquiring notoriety. Even this advantage does not altogether dispel the hatred with which the author generally regards the illustrator of his work, who, he complains, does not present his conception of the scene or character. Yet, however clearly this is described in the text, no one else—not even the much abused artist—can visualise exactly what was in the mind of the writer. The illustrator can only offer his own interpretation, and hope that by so doing he may add slightly to the readers' interest.

Nor is this lack of interest and understanding of the illustrator's craft confined to the general public. There was recently issued a selection from the writings of one of our best loved classic authors, with a generous addition of many charming drawings by a very delightful artist. One reviewer wrote a column of quite superfluous and belated laudation of the writer, and made no mention whatever of the illustrations which were the sole reason for the publication. This is by no means an exceptional example, although the oracle does generally mention in the last two lines that 'Mr. —— contributes some illustrations'. The catalogues sent out so freely by the second-hand

booksellers often casually describe a book as 'illustrated'. This may mean that it contains a large number of reproductions of drawings by an accomplished artist, or that there are a few conventional tailpieces or decorations supplied by the printer. We are not told, because the illustrations are regarded by the booksellers, as they are by so many of his customers, as a mere accident and not as a possibly important attraction of the book. This ignorance is regrettable in so far as it restricts the full enjoyment of a form of art no less satisfying than paintings, and much more easily accessible. Although there is still an ignorant and foolish contempt for drawings published in newspapers, magazines or books, good illustrations supply a very interesting and inexpensive field for study and enjoyment. For little more than the price of a dozen etchings or one painting, a very satisfactory collection can be made of the best examples, which will supply a far wider and more representative display of art. Its development and appreciation will provide a very delightful interest for a lifetime, and can be indulged with far less demand on space and money than the acquisition of more pretentious forms of artistic production. In 1901 the Board of Education, acting with the authorities at South Kensington, held a very interesting and comprehensive exhibition of black-and-white drawings for illustrations. In the English section alone there were 1300 items, but other countries were less adequately represented. Nowadays such excellently missionary work is left mainly to the directors of *Punch*, who have already launched three separate collections on extensive tours.

Despite the pronouncements of modern critics, all art is illustration. The original meaning of the word by derivation is 'to light up' or 'illuminate'; from which it comes to mean 'to explain, elucidate, interpret or decorate'. The artist conceives an idea, either from his inner consciousness or from outside suggestion, and explains or elucidates it—if he is skilful he also illuminates it—so that it appeals to others. The degree of his success in accomplishing this decides his importance as an artist. If he fails to make his idea intelligible to others, however

brilliant it may be in its conception, he fails as an artist. The painter, the sculptor, the musician, the writer, or any other artist is an interpreter, and he can only be judged and appreciated not by the visions of his fancy but by the results of his exposition of them. In its later and narrower meaning 'illustration' has now come to signify the decoration and interpretation of printed matter in books and papers. But there is no reason why this meaning should be restricted to drawings which appear between columns or pages of letterpress. The engravings and etchings of Botticelli, Dürer, Holbein, Rembrandt, Hogarth, Rowlandson and Gillray were none the less illustrations, even if they were issued separately or in portfolios.

The earliest illustrations in England were in the old monastic manuscripts where the scribe decorated his page with ornamental initial letters and borders. In many of these illuminations colour and gilt were used. When William Caxton set up his press at Westminster in 1476, he substituted for these decorations woodcut designs which could be printed simultaneously with the type and thus produced the first illustrated books in this country. As used by Caxton and his successors these designs were generally the work of the printers and were often very crude in workmanship. Sometimes finer blocks were obtained from the Continent and used indiscriminately without close regard to their appropriateness. But under the influence of the early printers the cutting and engraving of wood-blocks gradually improved in this country. Sometimes a single printed sheet would be issued describing an important event, real or fictitious, and decorated with a crude illustration. This might be produced from the printer's stock of wood-blocks, or a design might be specially commissioned. Many of these 'broadsides' were produced during the civil war in Charles the First's reign and were the origin of our illustrated papers. Later they were used with caricatures for political propaganda and as lampoons against public characters. John Day (1522-1584), who was an engraver as well as a printer and designer of type, was one of the first to encourage the production of specially invented illustrations. In

some cases, where the importance of a book justified the outlay, etchings and engravings were made on copper plates, and gradually the wood-engravers devoted their skill and attention to imitating these as closely as possible. Thus the woodcut lost much of the characteristic quality of its rugged charm, and became an incomplete substitute for the copperplate.

For a long time the designer was at the mercy of the engraver, who was often more interested in displaying his own skill than in translating truthfully the artist's drawing. Thomas Bewick (1753-1828) was the first man who successfully combined both professions and engraved his own designs, most of which were inspired by his wide knowledge of rural life and natural history. He was a hard worker and a conscientious craftsman, and first demonstrated the full possibilities of the wood-block as a medium for reproducing drawings. In his early days Bewick designed bill-heads and trade-cards for commercial purposes, but most of his best work appeared in books—his *British Birds* and *British Quadrupeds* are classics—and he may be justly considered as the earliest great English book-illustrator. His brilliant and successful example prompted many capable artists to make drawings especially for reproduction by wood-engraving, and also inspired a far higher standard of work by the engravers. The newspapers, too, began to see the attractive possibilities of this progressive revival, and *The Observer* (founded in 1791), *Bell's Life in London* (1820) and even *The Times* (1785) published occasional engravings. The origin of the modern *Times* picture-page was a crude woodcut of Nelson's funeral car, which appeared on 10 January 1806. Sometimes two or three papers would combine to share the expense and use of a block. *The Gentleman's Magazine*, founded in 1731, to which Dr. Johnson was a contributor, also decorated some of its pages with woodcuts. The illustrated newspaper was thus vividly foreshadowed, and on 14 May 1842, Herbert Ingram produced the first number of *The Illustrated London News*, which aimed at giving the news of the week with reproductions of drawings made specially for the purpose. *Punch* had, however, already appeared in the

previous July with similar intentions from a humorous stand-
point.

The great difficulty with which these pioneers had to contend
was the length of time required to make the engraving, which
would take even a skilled craftsman several days. The problem
was gradually solved to some extent by dividing the drawing
and the block to be worked upon into a number of rectangular
parts. On each section of the wood the supervising engraver of
the paper indicated at the edges the general direction the lines
were to follow. Each craftsman completed his portion, keeping
as far as possible to a more or less uniform style, and the pieces
were then clamped firmly together. The whole block was then
worked on in the office, and any inconsistencies and faults in
joining were corrected before it was ready for the printer. This
obviously required very carefully organized economy of time
and punctual team-work. About 1851 or 1852 experiments
were made in photographing the drawing on to the block, and
this not only saved time but also gave the artist more freedom.
He could now work on any kind of wood or paper that he
preferred and was not handicapped by the restriction of having
to draw on the wood. This method, however, did not come into
general use until about twenty years later. W. L. Thomas, the
editor of *The Graphic*, was the first to make any considerable
use of this improvement, which had the advantage of leaving
the original drawing intact as a guide for the engraver. For news-
paper printing an electrotype was made from the wood-block
and backed with metal so that it could be set and printed simul-
taneously with the type. This mass production naturally did
away to some extent with the individual engraver and led to the
development of commercial firms, employing a number of
skilled craftsmen and training their own apprentices. Of these
the two best known were J. Swain and Dalziel Brothers. The
specialists, like William Linton and W. H. Hooper, devoted
their attention to work for which, not being directly connected
with the news, more time could be allowed.

William Harvey, a pupil of Bewick and an eminent designer,

relates an experience which throws much light on the methods of this period. 'When Whittingham, the well-known printer, wanted a new cut for his Chiswick Press he would write to Harvey and John Thompson, the engraver, appointing a meeting at Chiswick, when printer, designer and engraver talked over the matter with as much deliberation as if they were about to produce a costly national monument. After they had settled all points over a snug supper, the result of their labours was the production months afterwards of a small woodcut measuring perhaps two inches by three.' A delightful commentary on the feverishness of modern methods; and the Chiswick Press still continues to flourish!

About 1860 an American artist, Mr. Clinton Hitchcock, discovered by accident a method of reproduction which was cheaper and quicker than wood-engraving. A very finely ground and sifted chalk powder was spread thickly on a metal plate and subjected to great pressure. This consolidated the chalk into a hard cake with a very smooth surface, and a wash of size was passed over it to prevent the ink spreading. The drawing was made with a fine, soft brush. Then with a stiffer brush the uncovered chalk was gradually removed, leaving the lines of the drawing in relief. The plate was hardened by immersion in a chemical solution, and from this a mould and then a stereotype plate were made. The whole process occupied only four or five hours, and the cost was about one-twentieth that of a woodblock. The resulting print had much of the quality of a wood-engraving with a certain lack of softness. For some reason—probably the difficulty in drawing on the chalk block—the process, which was known as Graphotype, never became popular.

The success of *The Illustrated London News*, which was sufficient to enable it to send out the first war-correspondent—S. Read—to the Crimea, led to the usual rush of imitators, few of whom survived. But in 1869 *The Graphic* was started and, pursuing a sound, artistic policy of its own, achieved great success by conferring prestige on the artist rather than on the engraver, and survived until 1932.

7

On 2 July 1859, Messrs Bradbury & Evans issued the first number of *Once a Week*, and a set of the first thirteen volumes contains a very complete collection of what was best in illustration of that period. All the greatest draughtsmen are well represented, often by their finest work, and as *Once a Week* was the earliest of our illustrated magazines, it was by virtue of the quality of its contents indisputably the best. Those who are interested in the subject of these early illustrated papers may be referred to *The Pictorial Press* (Hurst & Blackett, 1885), by Mason Jackson, from which much of this information is derived. It contains also many interesting reproductions of the earliest woodcuts.

While these great developments were taking place in the newspaper world, the publishers were issuing a profusion of illustrated books of all kinds. Many of them contained some of the finest illustrations that have ever been produced in this country, rendered with the highest skill of the wood-engraver. It is remarkable that these have not already attracted the attention of the collector, for they can still be easily acquired at a very modest outlay, can be conveniently stored on a few feet of shelves, and form an interesting record of a great artistic period. One of the most advanced of these publishers was Charles Knight (1791-1873), who as early as 1832 had published *The Penny Magazine*, which survived until 1845. In connection with the Society for the Diffusion of Useful Knowledge, Knight issued a number of excellent books in cheap parts, *The Penny Cyclopædia*, *The Pictorial History of England*, *The Pictorial Shakespeare*, *Half-Hours with the Best Authors* and *The Land We Live In*. The firm of Dalziel Brothers, with its staff of artists and engravers, compiled many illustrated anthologies and collections of poetry, which, although they bore the imprint of publishers, are still known as 'Dalziel books'. Most of these are treasured by those who appreciate the charm of fine drawing and good engraving.

This season of rich harvest marks one of the two great periods of English illustration which has formed so important a feature

in the history of English art during the past hundred years. It is generally referred to as 'The Sixties', and a very capable and learned record of its chief creators—artists, engravers and publishers—was compiled by Mr. Gleeson White in *English Illustration: The Sixties* (Constable, 1897). Two great masters, Menzel in Germany and Meissonier in France, had already set a high standard of book-illustration, and this undoubtedly influenced their English followers. In this country much of the work was produced by artists who were painters, or afterwards became painters, and employed this method of acquiring experience and financial assistance to enable them to devote their energy and time entirely to painting pictures. Many of these men did some of their best work in making drawings for the engravers, and although some maintained their connection with this branch of art to the end of their working career, others who deserted it became more famous later as painters. Among the greatest artists who contributed to the rich vintage of the sixties were Fred Barnard, the best and most human of the illustrators of Dickens; Arthur Boyd Houghton whose fine imaginative work is surprisingly little known; Birket Foster, who made hundreds of exquisite drawings full of the quiet charm of the English countryside; Sir John Gilbert, a giant in method and achievement, who contributed tremendously to the early success of *The Illustrated London News*; Charles Green who rendered so lovingly the manners and customs of the eighteenth century; Charles Keene, one of the greatest of all English draughtsmen, whose masterly excellence has never been fully appreciated; and J. E. (afterwards Sir John) Millais, whose drawings for *The Parables of Our Lord* are masterpieces of illustration sufficient in themselves to secure his fame. Other great men whose work is admirably appreciated and displayed in Mr. Gleeson White's book were Ford Madox Brown, E. Dalziel, George du Maurier, J. W. North, G. J. Pinwell, D. G. Rossetti, Frederick Sandys, William Small, John (later Sir John) Tenniel, Frederick Walker, J. D. Watson and many others. The drawings of these men were all reproduced by the wood-engraver, and although in many cases

a certain charm was added, in others the original design lost much of its personal quality. Many artists complained of this misinterpretation, and in the case of Charles Keene's drawings, for example, a comparison with the original and its subtle variations of line and ink tints, or even with a 'process' reproduction, is sufficient to show clearly that the artist's grievance was often a real one. Another more real drawback—especially for posterity—was that the original drawing was destroyed by the engraver, and there was thus no evidence to support their contention.

Between the years 1880 and 1890 experiments were made in mechanical reproduction which were eventually sufficiently successful to supplant the method of wood-engraving and to create a revolution in the printing of drawings. Economy in time and cost, and far greater accuracy were the most valuable virtues of the new process. Newspapers could print an illustration within a few hours of its delivery, whereas before they would have had to wait several days. The construction of a line block may be explained briefly as a development of the process of etching. The pen-and-ink drawing is photographed in reverse on to a zinc plate covered with a sensitized gelatine film. The lines are protected against the action of the acid, which is used to eat away the white or unprotected parts of the design, and are thus left raised in relief to receive the ink, in the same way as metal type. The zinc plate is then backed with wood to strengthen it and raise it to the required height so that it can be set with the type for printing. In an etching, on the other hand, the lines are cut and sunk below the surface, and after the ink has been rolled into them the white surfaces are wiped clean. Half-tone blocks, which are used to reproduce photographs and tone drawings, are generally made of copper. The illustration is photographed through a glass screen with fine lines of varying mesh drawn across in both directions. These break up the design into a collection of dots of varying degrees of size and closeness, thus producing a close approximation to the gradations of tone in the original. The degree of the mesh varies according to the required fineness of the block and the quality of the paper on

which it is to be printed. The chief of these early firms of block makers were J. Swain, Carl Hentschel and Meisenbach. The first line block (a map) was printed in 1876, and the first half-tone (by Meisenbach) in 1884. About 1888 both processes began definitely to supplant the wood-engraving. *Punch* held out until the issue of 3 December 1892, and the cartoon continued to be printed from the wood-block until the end of 1900.

This revolution in reproduction led to an enormous increase in the number of illustrated papers and books and a great revival and advance in black-and-white drawing. The artist could now rely on having his design reproduced very nearly in facsimile. So long as he did not ask too much, the new method, as it developed and improved could print anything he drew, and this gave him greater freedom in his work. The demand for drawings increased, prices improved, and an increasing number of artists devoted their time and talents entirely to black-and-white illustration. Some of this was poor and transitory, but much of the better work was of a quality to compare favourably with that of the best produced during the sixties and, with the elimination of the engraver, had the additional merit of the direct personality of the artist. This second great period of English illustration, which is often referred to as 'The Nineties', has never yet been fully recorded, and this book is an attempt to supply in some measure a history and appreciation of its accomplishment.

For the information of the uninitiated, and to explain the meanings of professional terms used in later pages, a brief description of the method of producing a black-and-white drawing may be of some service. The artist first makes a rough pencil-sketch of his subject, with explanatory notes to be submitted for the editor's consideration. Generally this has to be made very easily intelligible, as few people—even editors— can understand the possibilities of a rough sketch. When it is sent in with others, it frequently happens that the least likely suggestion is accepted. If the idea is approved, the artist is directed—often with profuse warnings and instructions—to complete the drawing. He then

11

proceeds to arrange the design or composition so as to explain the subject most clearly and effectively. Suitable models are engaged and studies are made from them in the poses required: but many artists prefer to work without these aids and to rely on their memory and invention. A suitable background and accessories for the setting have to be found and sketches made of these. The artist is then ready with all his references to begin the drawing, and this may be made with one or more of many mediums: pen-and-ink, pencil, lithographic or ordinary chalk, Conté crayon, charcoal, lamp-black or ivory-black (in oil or water-colours), Chinese white or process white. In fact, almost any substance that will make a black mark may be used. As a rule the drawing is made on a smooth, white board, although papers of varying texture are sometimes preferred. Some very effective results have been made on a board covered with a thin grey clay surface, the whites of the design being obtained by removing this surface with a knife. Lamp-black and ivory-black are used in the same way as water-colours, either as thin, transparent washes or, mixed with white, as 'body colour' of varying degrees of opaqueness. Chinese white or process white is used to supply the strong lights and also to correct or cover errors in drawing. Discrimination in the use of white is one of the tests of the capable craftsman. Most artists make their design rather larger than it will appear when reproduced, as the reduction often improves its effect, but this depends largely on the style of work and the discretion and knowledge of the artist. The completed drawing is then scribbled on, with instructions by the editor, in indelible pencil of various colours, thumbmarked by the block-maker, often torn, and generally lost. Very rarely is it returned in presentable condition to the artist whose property it remains.

Gradually the development of the half-tone block facilitated the reproduction of photographs, and as the initial cost of these was far less, they began to take the place of drawings. Thus the new process, which had at first brought so much encouragement to the artist, presently threatened to extinguish him. To-

day the pictorial record of news is almost entirely in the hands of photographers, who are generally attached to the staffs of the newspapers.

Thus the old 'news drawing', which, by virtue of the conditions under which it was produced, often reflected much of the personality of the artist, is a thing of the past and is replaced by the impersonal and mechanical accuracy of the photograph. The almost complete indifference of the public to the charms of good drawing and the irresistible claims of speed and cheapness are the two great factors in a change which, from the point of view of intelligent craftsmanship, is to be regretted. It must be admitted that the camera, used with discretion, is often a much more suitable instrument for such work, and definite progress is being made in its employment. The use of drawings is now restricted to the illustration and decoration of those books, advertisements, humorous ideas and cartoons which fortunately are still beyond the powers of the all-conquering camera.

Whether the more leisurely and less hurried methods will in time produce finer black-and-white work remains to be seen. At present there are few signs of such improvement. Our popular magazines, which should employ and encourage good drawing, were never at so low an artistic ebb. This is largely a result of the proprietors' characteristic policy of 'giving the public what it wants' instead of what it ought to have. The photograph is everywhere, and too often the same picture which we have already seen in the daily journal, and later in the weekly paper, reappears yet again in the monthly magazine. Of editorial originality or intelligence in the contents there is little evidence; only a pathetic endeavour to be 'smart' at all costs, and to imitate one another and the more obvious and worst features of American production. Many of the illustrations show only a vigorous striving after eccentricity or a determination to be different at all costs; but there is no merit in originality unless it is supported by some more positive virtue. In a recently published book of drawings the artist felt compelled to issue some words of explanation. 'The power to imitate by hand-skill and cunning

disposition of forms and colours is no longer the dominating objective of the artist. Representation begins to have a far wider significance in art.' (What exactly does this mean?) 'Presentation of a purposive selection from the more significant shapes, instead of unselective imitation, is the avowed aim of our day.' But surely this does not excuse bad drawing and neglect of any arrangement or design! Deliberate puerile naïveté and sensational and freakish styles of drawing are generally a cloak for incompetence or a hopeful intention of a short cut to notoriety. The cult of ugliness, which is so prevalent in all forms of art, appears to be encouraged, perhaps on the same principle of 'giving the public what it wants.' With one honourable exception (and even here I have heard a distinguished literary contributor declare the post unnecessary) the art editor has ceased to exist, possibly because there is so little art to edit. Such work as he used to do in the way of selection, discrimination and arrangement is now left to the editor, who in many cases has qualified for his position by long and faithful service in the counting-house of the proprietors. At one time magazines were treasured for the excellence of their literary and artistic contents; now they are rarely favoured with more than a cursory glance, which is perhaps quite as much as their lack of merit and futile inanity deserve. There is probably, even in these days of useless hurry and superficial interests, a public for magazines, provided that these are produced with intelligence, and that their contents differ from those of the daily newspaper, with which it is hopeless and unnecessary to compete. Perhaps some day another enthusiast will arise who will select an editor with knowledge and sympathy, and give him a free hand to engage accomplished writers and artists who shall be allowed and encouraged to work in their own way to the best of their ability. Together they will produce a magazine, genuine and sincere, intent rather on its own excellence than on imitating the flashy mannerisms of others, and content to be an individual production with character of its own rather than a unit in the bewildering mass of uniform and unwanted publications that cover the bookstalls.

Perhaps, though, it is too late. To those who are interested in good magazines, and even to the modern editor, I would recommend a brief study of some of the illustrated volumes of *Once a Week*, *Good Words*, *The Cornhill Magazine*, *The Pall Mall Magazine*, *The English Illustrated Magazine*, *The Idler* (especially in its later issues), and *The Butterfly* in England, or *Harper's Magazine*, *Scribner's Magazine* and *The Century Magazine* in America.

England has a proud reputation in illustration, and it is much to be regretted that this is being neglected and allowed to decline. True it is—'and pity 'tis 'tis true'—that black-and-white art has never been appreciated at its full worth. The excellent work of such men as Arthur Boyd Houghton, George J. Pinwell, Randolph Caldecott, Charles Keene, Frederick Sandys, William Small, Phil May, Hugh Thomson, William Hatherell, Frank Craig and many others was never fully recognised during their lifetime, and has since been to a very great extent forgotten. Only one official body has ever acknowledged its claims in any way, when in 1896 the Royal Institute of Painters in Water Colours elected Phil May and Hugh Thomson to membership on the strength of their black-and-white drawings. Rumour has it that Lord Leighton, then President of the Royal Academy, contemplated proposing Phil May, whose work he much admired, for election as an associate. Unfortunately Leighton's death prevented this, but that august body has consistently ignored until recently those lowly but talented workers in the field of English Art which it is their mission to foster and encourage.

CHAPTER II

SOME ILLUSTRATED
WEEKLY PAPERS AND
TWO DAILIES

In considering the vast volume of black-and-white work of
this period, it is obviously necessary, for the purpose of this
book, to fix some definite limits of time, and only that pro-
duced between the years 1890 and 1900 has been examined. So
far as is possible, most of the illustrated newspapers and maga-
zines and many of the books published between those years have
been placed under review, although it is more than likely that
some have been overlooked. For such inevitable omissions the
reader's kind indulgence is claimed, in view of the enormous
field of operations.

The year 1890 marks fairly definitely the beginning of a new
epoch in black-and-white art, as a result of the change in the
methods of reproduction. A growing wave of popularity and
achievement lifted and propelled it on its way and brought it
during the next twenty years to the highest point of its accom-
plishment. People still had leisure and discrimination to enjoy
Art in all its many forms, and those which appeared in print re-
ceived intelligent appreciation and criticism. The feverish haste
and unsettled conditions of modern life, the thraldom and de-
vastation of the motor-car and the decay of intellectual interests
in the sordid rush for wealth had not yet begun to exercise their
baneful influence on English manners. Largely as a result of the
example and teaching of William Morris there was a wide sym-
pathy for the domestic arts and crafts which exercised a strong
influence on our mode of living. Education had not yet de-
scended to the low level of incomplete mass production, which
unfortunately has failed to teach its victims how very little they
know. Publishers and editors had sufficient intelligence, know-

16

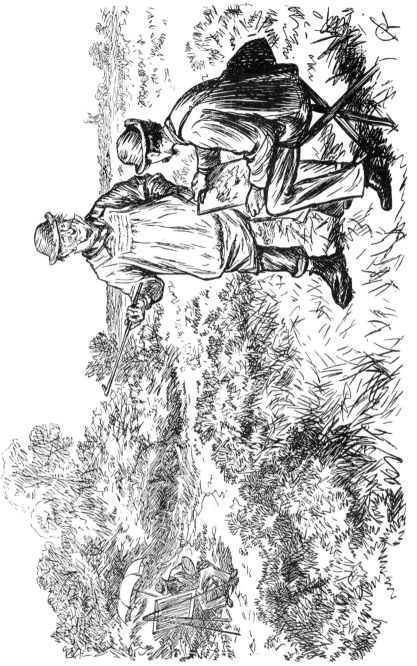

2. CHARLES KEENE

Punch drawing: 'The more haste, the less speed'

By courtesy of the Proprietors

3. CHARLES KEENE
Pen-and-ink study, probably done at the Langham Sketching Club
From the author's collection

ledge and enterprise to cater for an appreciative public, and in the flood of books, papers and magazines that followed the new facilities, much that was good appeared and flourished. Randolph Caldecott had died all too early in 1886, but many of the old artists who had drawn for the wood-engravers were still working, notably Charles Keene, Fred Barnard, William Small, John Tenniel, George du Maurier, Charles Green and Robert Barnes. These men, adapting their methods with varying success to the new conditions, were more than sufficient to carry on the old traditions into the new period.

PUNCH

Punch merits first claim on our attention both by virtue of its seniority—it was founded in 1841—and because it has always diligently fostered the art of black-and-white drawing. Nor has it ever, so far as I know, published a photograph, not even of a film star, and in this respect it is probably unique. Charles Keene, in the full glory of his long matured power, was still the most distinguished contributor. Early in 1890 he was compelled by ill-health to cease working and nothing of his appeared between 3 May and 16 August, the date of his last contribution. To the end of his career he maintained unimpaired his supreme excellence. Many of the drawings published in 1890 show all the fine appreciation of character, masterly manipulation of the pen, and charm and appropriateness of backgrounds which were characteristic of his method. Keene died on 4 January 1891, in his sixty-eighth year, and in the issue for 17 January Punch paid him a graceful poetic tribute, referring to 'that dexterous sleight which gave our land the unchallenged consummation of graphic mastery in black-and-white'. Keene's character and work have been ably appreciated by G. S. Layard (*The Life and Letters of Charles Samuel Keene*, 1892) and by Joseph Pennell (*The Work of Charles Keene*, 1897), both delightful volumes. 'Peaceful he lived and peacefully departed.'

Linley Sambourne was, after Keene, the greatest of the *Punch* artists. Deriving much of his technique from Dürer and Rethel, he developed a bold style of his own and cultivated accuracy and invention, qualities which made him the greatest cartoonist *Punch* has ever had. His work, like Keene's, had great influence on many of the younger black-and-white artists, and Phil May, among others, acknowledged his indebtedness to the master. The junior cartoon which he contributed every week was always conscientiously produced and full of knowledge and interest, and the portraiture was excellent. The headings and tailpieces to the volume were also his, and there are some delightful drawings of holiday reminiscences. He succeeded Sir John Tenniel as principal cartoonist in 1900 and continued until his death in 1910. Tenniel's cartoons were successful because of their direct simplicity, but they were by this time weak in drawing with an unpleasant angularity and lacked the strength and invention of Sambourne's work. The famous 'Dropping the Pilot'—a double-page design—appeared on 29 March 1890. George du Maurier was another of the old hands, but his work, like Tenniel's, had become very mannered and lacking in variety. Both had done their best work in the earlier period, some of Du Maurier's designs having been very fine and full of a promise which he never quite fulfilled. Du Maurier, however, shared with Harry Furniss a very large measure of popularity among the readers of *Punch*. Furniss's work was marked by an exuberant and irresponsible ingenuity, and this, with a boisterous sense of humour, compensated to some extent for its lack of design and hurried drawing. E. T. Reed, a recent recruit, was rapidly improving and establishing his position, and when, in March 1894, Furniss quarrelled with *Punch* and retired, Reed ably succeeded him as parliamentary caricaturist. His work, although at first rather laboured, was always amusing, his portraiture good, and some of his studies in the Law Courts excellent. In the Almanack for 1894 E. T. Reed introduced his 'Prehistoric Peeps', which created a tremendous sensation and brought him great popularity, although one at least of his many

4. LINLEY SAMBOURNE

'The Mahogany Tree', from *Punch*, 18 July 1891

By courtesy of the Proprietors

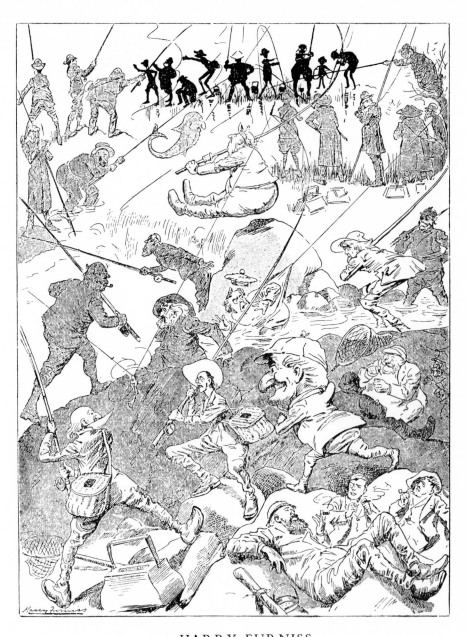

5. HARRY FURNISS

'Mr. Punch's Fishing Party', from *Punch*, 24 September 1892

By courtesy of the Proprietors

imitators has derived from them even greater fame. The draw-
ings of hunting subjects, which have always been a feature of
Punch's pages, were generally the work of G. H. Jalland, and
smaller illustrations on a variety of topics were contributed
regularly by E. J. Wheeler and J. Priestman Atkinson.

Punch at this time was decidedly a close corporation, but
gradually new contributors were introduced. Of these J. Ber-
nard Partridge, who made a first appearance in February 1891,
was the greatest acquisition. Most of *Punch's* artists had served
their apprenticeship in his pages, but Partridge already had a
considerable reputation as an accomplished and delightful
draughtsman. He was elected to the staff the next year, began
to do the second cartoon in 1899, and since the death of Linley
Sambourne in 1910 has been chief cartoonist. His drawings are
always correct, sparkling and graceful, and full of charm. Be-
ginning with small illustrations to articles, he established his
position with the drawings for 'Mr. Punch's Pocket Ibsen',
'Voces Populi' and, later, 'The Man from Blankley's'. Everard
Hopkins and Arthur Hopkins, both academically correct if not
particularly humorous draughtsmen, and W. T. Maud, who
later became war-correspondent for *The Graphic*, made their
first appearance in the same year. On 18 July 1891, *Punch*
celebrated his jubilee with an excellent number wherein
Sambourne's double-page drawing of 'The Mahogany Tree'
appeared. Portraiture, design and execution are equally accom-
plished in one of the finest pen-drawings that has ever been
published in this or any other paper. The original hangs in the
room in which the weekly staff meetings are still held—for
lunch now instead of dinner. At the end of the year Reginald
Cleaver made his first appearance, an artist who had much to do
with the great success of *The Daily Graphic*. Early in 1892 W. J.
Hodgson, another hunting man whose work resembled Jal-
land's, added another name to Mr. Punch's list of sporting
artists, and the next year came two great humorous draughts-
men in J. A. Shepherd and J. F. Sullivan. Shepherd's drawings
of animals are the best and funniest that have ever been made,

and it is strange and regrettable that they were not more often and more widely used and appreciated. Sullivan's comments on the humours of the British workman were delightfully observed and faithfully recorded. A. C. Corbould—a nephew of Keene—also returned to the fold after an absence since 1890, with more hunting subjects. On 14 October, Phil May, the greatest name since Keene, made a modest first appearance, soon established his position as an observant humorist and a masterly draughtsman, and was elected to the table in February 1895. Of May's work I have already written ecstatically and at length in *Phil May: 1864-1903* (1932), so that further superlatives are unnecessary. May was a genius, and although he had learned from others, his methods were entirely his own. Evolved from a structure of sound and careful preparation, his drawings had all the freshness and spontaneity of a quick sketch. He possessed also a fine masculine sense of real humour, and, with Charles Keene, compelled *Punch* reluctantly to admit that an appreciation of this quality was not the monopoly of the higher classes. He also did much to simplify the verbal 'legends' beneath the drawings, and to remove the unnecessary explanatory brackets which were then so popular. His best work for the paper was done in the larger spaces of the Almanacks and special numbers. May did much by the vigour and eloquence of his line to influence pen-drawing. No artist's work was ever more imitated; none was more difficult to imitate with success.

In 1894 Fred Pegram appeared with a very elaborately and tightly finished drawing, but his later contributions showed greater freedom and charm. A. S. Boyd and Frank Lockwood also contributed. The Beardsley boom was delightfully satirised by E. T. Reed and Bernard Partridge in drawings which were quite as accomplished as those that inspired them. W. F. Thomas, who so ably carried on W. G. Baxter's records of the doings of Ally Sloper, and G. L. Stampa were two of the newcomers in 1895. The latter, whose work has much improved since then, is still a regular contributor. The Almanack for 1896, perhaps the best ever produced, contained May's 'Labours of 'Arry'—

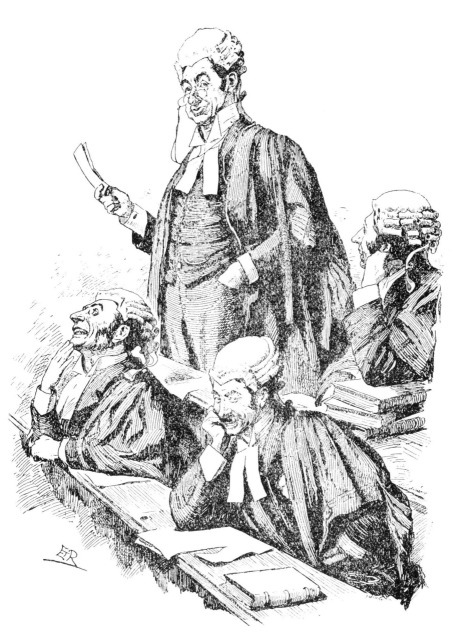

6. E. T. REED

'Legal Expressions', from *The Sketch*, 28 June 1893

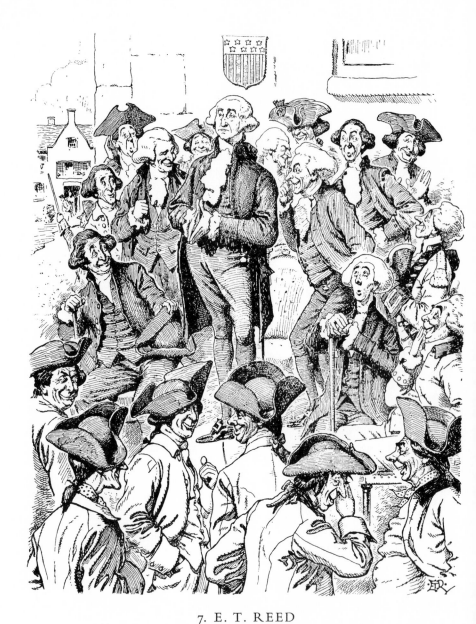

7. E. T. REED

'Unrecorded History, No. VII. George Washington trying to tell a lie', from *Punch's Almanack*, 1896

By courtesy of the Proprietors

a delightful series of twelve full-page drawings. In January 1896 appeared L. Raven-Hill's first contribution, which began a brilliant connection with the paper that has culminated in his present position as second cartoonist. Raven-Hill, like Bernard Partridge and Phil May, had already made a reputation both as draughtsman and humorist before he added to the glories of *Punch*. Later he gave us many delightful rural subjects with pleasant glimpses of Wiltshire backgrounds. Other recruits during this year were Charles Harrison, A. Chasemore, Jack B. Yeats, Sydney Harvey, J. H. Roberts, R. J. Richardson, G. Denholm Armour, Gordon Browne and W. Alison Phillips. With the arrival of Richardson and Armour, *Punch's* staff of 'hunters' now numbered five, so that this department was certainly well equipped. In 1897 appeared F. H. Townsend, who later became *Punch's* first art editor, G. J. Jacomb-Hood, Tom Wilkinson, with a style too closely resembling May's, Charles Pears, Lewis Baumer and G. R. Halkett, who understudied E. T. Reed and was perhaps better known as the cartoonist of *The Pall Mall Gazette* and editor of *The Pall Mall Magazine*. In the Jubilee number which appeared on 19 June, May had an excellent double-page 'Dream of Victorian Derby Days' containing dozens of portraits, and in the Almanack for 1898, a series of eight splendid drawings, 'From Petticoat Lane to the Lane of the Park'.

Punch was by this time certainly widening his net, and in the next few years included James Greig, W. Rainey, Max Cowper, Will Owen, Tom Browne, A. Wallis Mills, Starr Wood, Ralph Cleaver (with some of the technique but less of the skill of his brother) and Malcolm Patterson. In 1900 a new feature was added in the form of some extra pages containing a short story with illustrations. The South African War provided an introduction for some drawings by Charles L. Pott on military subjects, and David Wilson and W. J. Urquhart were other new contributors.

Looking back over the ten years, one may justly claim that they formed one of *Punch's* most brilliant periods. With three

such great Masters as Keene, Sambourne and May, and competent artists like Partridge, Raven-Hill, J. A. Shepherd and E. T. Reed, the artistic standard was certainly very high. It is difficult to judge fairly the relative merit of the humour, much of which must conform to contemporary standards and conventions, and to-day may appear old-fashioned, but certainly most of the artists were also great humorists. The policy of admitting and inviting the work of outside contributors added to the strength and variety of its contents and provided a reserve of talent from which vacancies on the staff could be filled. No illustrated paper in England has done more than *Punch* to maintain the high level of black-and-white drawing.

THE ILLUSTRATED LONDON NEWS

The *Illustrated London News* followed *Punch* less than a year later, in May 1842. Its programme was even more ambitious, for its contents had to be more generally topical, and we have already seen the difficulties with which it had to contend at first as a result of the slow methods of reproduction. Even in 1890 most of the illustrations were still printed from woodblocks, although there were a few half-tones by Meisenbach, rather muddy in appearance and apparently touched up by the engraver to relieve the uniform greyness. The news drawings were contributed mostly by A. Forestier, W. H. Overend, R. Caton Woodville, Walter Wilson and W. B. Wollen, all very capable artists, whose work, produced at very high pressure, maintained a consistent level of excellence. These men did the work which is now done almost instantaneously by the camera. They made their drawings either from sketches and notes taken on the spot by themselves, or sometimes from material, often very fragmentary, supplied by other people. These illustrations, generally of full-page or sometimes double-page size, had to be made so rapidly that there was no time for reference to models

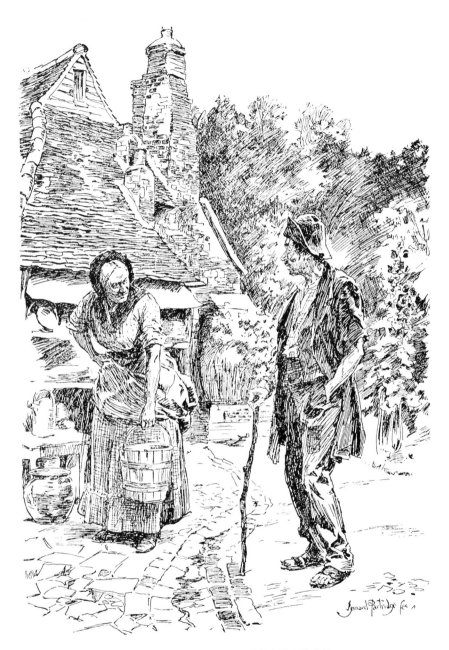

8. J. BERNARD PARTRIDGE

Drawing from *Punch*, 31 August 1895

By courtesy of the Proprietors

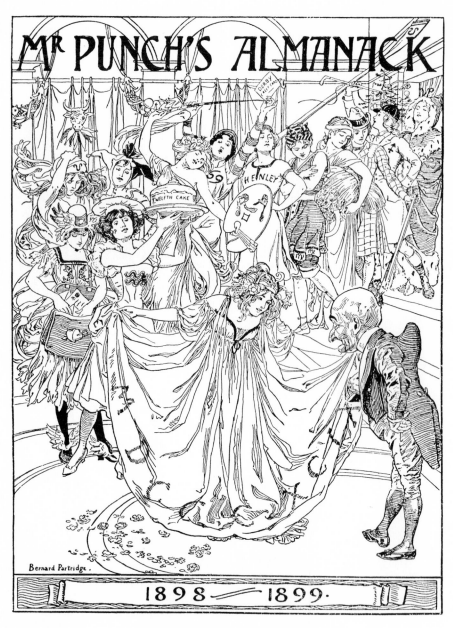

9. J. BERNARD PARTRIDGE

An example of his decorative manner

By courtesy of the Proprietors

or authorities. Thus a wide and ready knowledge of form, portraiture and details of every kind was necessary to ensure accuracy. The strain of regular weekly production must have been very great, and the results, judged in the light of these facts, were remarkable triumphs. W. Douglas Almond also contributed smaller news drawings, generally in chalk or pencil, which were very sound in workmanship. H. C. Seppings Wright—'Our artist in America'—sent line-drawings which introduced quite a modern note among the wood-engravings. Melton Prior was another roving artist who contributed sketches from various parts of the world. Some of these were printed as they were received, others were worked up more elaborately by artists on the staff. Herbert Railton's pen-drawings of architectural and topographical subjects were in the modern spirit and their decorative qualities made them very popular with editors and readers. In addition to the news illustrations the editor wisely introduced subjects of more general interest. These were not necessarily of a topical character and could be produced in more leisurely fashion by the artists and engravers: large portraits of distinguished people, famous paintings, sentimental themes—'The Happy Days of Spring' or 'Waiting for Papa'—and discreetly humorous episodes were thus presented. Fred Barnard illustrated the serial story—always a popular feature in those days—but the wood-engraving has apparently taken sad liberties with his drawings, particularly in the faces. On the other hand the fine bold work, sure and capable, of G. Montbard, illustrating a series of English Homes which ran through several volumes, is particularly well rendered. Louis Wain's over-humanised and sentimental cats and dogs appeared from time to time, although it is extremely difficult to account for their enormous popularity.

Walter Wilson was one of the most prolific of the news illustrators, with great facility which amounted almost to a recipe. A strange peculiarity of his work is the marked facial resemblance of all his figures. In a large drawing of 'The Smoking-room of the Carlton Club', there are about a hundred portraits

of members, all of whom might be very closely related. This was largely due to a peculiar method of drawing eyes, which may have been the result of constantly repeated presentation of members of the Royal Family. Many capable draughtsmen share this inability to present variety of character, a failing which often separates them from the great illustrators. The summer number afforded Forestier the opportunity to show how much better work he could do as an illustrator of stories, apart from the rush of news drawings. H. M. Paget, too, made some capable illustrations for the serial in the second half of the year. R. Caton Woodville was another of the giants of those days with tremendous energy and ability and a thorough knowledge of detail—particularly of military accessories. It was no unusual achievement for him to produce for *The Illustrated London News* several page drawings, a double-page, and two or three story illustrations in one week, in which he also found time for work on a large oil-painting of a crowded battle scene. Fred Pegram appeared in strong contrast with some carefully worked pen-and-ink drawings of theatrical subjects, and some translations of photographs into line. These artists produced most of the work printed during the ten years under consideration and right well did they maintain the reputation of the paper.

In 1891 Overend did the illustrations—rather weak in characterisation—for a Clark Russell story, Gordon Browne contributed a drawing from behind the scenes at a pantomime, and Pegram some drawings from Monte Carlo, very modern in treatment and reminiscent of the work of F. H. Townsend. Julius M. Price, one of the paper's war-correspondents, sent rough sketches from Siberia, some of which were carefully re-drawn by Pegram. Forestier illustrated very pleasantly Mark Twain's *The Tramp Abroad Again* and Hall Caine's *The Scape-goat*, but these were not his best work. Gordon Browne made drawings for Mrs. Lynn Linton's *The Tents of Kedar*, but these suffered from a lack of variety in facial expression. Caton Woodville was in his element with some melodramatic and dashing illustrations for Henry Herman's *Eagle Joe*. Bernard Partridge

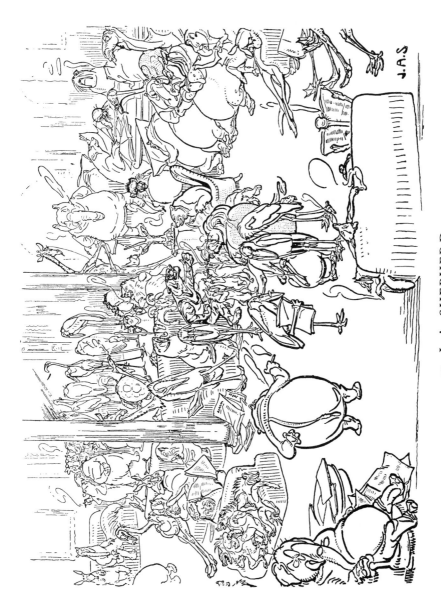

10. J. A. SHEPHERD

'The Smoking-room at the United Birds' and Beasts' Club', from *Punch's Almanack*, 1894

By courtesy of the Proprietors

THE SLIDING-SCALE.

(A TALE OF DEALERS' PRICES.)

1. "Eh?" said the Curio-Dealer. "'Take half-a-crown for that plate?' Couldn't do it; must turn a penny over it. Half-a-crown's exactly what I gave for it myself. Now, if you like to say three-and-six——" But the Wayfarer wouldn't say three-and-six, so the Dealer kept that plate.

2. And another Wayfarer came along and wanted that plate. "What? Sell it for five pounds?" said the Dealer. "No; couldn't do it. Five pound's just what it cost me; say seven-ten, now——" But the second Wayfarer failed to say seven-ten, and passed out of our story.

3. Then there came an American Millionaire. "Ah, that's the finest plate in Europe!" said the Dealer. "I can't sell that under a lot of money. Eh? A thousand pounds? Couldn't do it, Sir! Why, I paid just that for it myself. Now, if you had said fifteen hundred——" And that Millionaire did say fifteen hundred, and secured the prize.

4. Well, somehow that plate subsequently fell into the possession of Jones. And when poor Jones came down in the world he thought he'd try to sell that plate. "Eh, what?" said the Dealer. "Give you eighteen-pence for that old plate? Pooh. Why I had it here once, and I sold it for a shilling then. If you like to make it ninepence——"

II. J. F. SULLIVAN

From *Punch's Almanack*, 1894

By courtesy of the Proprietors

made a delightful page of small sketches of 'Tragedy and Comedy,' and Fred Barnard showed how much more successful he was in line-drawings which escaped the distortion of the wood-engraver. Joseph Pennell's presentation of 'The Jew at Home' proved that he was wise to devote his able attention to architectural subjects.

In 1892 Phil May made an early appearance with some characteristic studies of the Drury Lane pantomime. Lucien Davis had some well-drawn but slightly metallic double-pages of perfect English people, all closely related and all very beautiful, engaged in correct English social amusements. Most of the illustrations were still produced by woodcut although the half-tones were definitely improving. The latter method was used successfully for supplements of several pages of reproductions of Royal Academy and New Gallery pictures. The movements of the members of the Royal Family were closely followed and conscientiously recorded by 'our special correspondents'. Caton Woodville did some fine drawings for Rider Haggard's *Nada the Lily*, but was less successful with the rustics in Robert Buchanan's story. W. H. C. Groome contributed some very Victorian full-pages, oozing with sickly sentiment. Mr. and Mrs. Joseph Pennell made an interesting record of a bicycle journey from Berlin to Buda Pesth, but the illustrations were too much reduced. For the Jubilee Number of 14 May Linley Sambourne made a fine cover design which was spoilt by the addition of the conventional *Illustrated London News* heading. A facsimile of the first number was presented, and a proud record of contributors —writers and artists—during the fifty years. The former contained a surprising drawing of a cricket match at Lords, with the ring of spectators in highly dangerous proximity to the players.

Everard Hopkins had a good double-page, well studied and drawn, of the Queen's Drawing-room, a very popular subject which he duplicated many times. Holland Tringham and G. Montbard continued their excellent drawings of English scenes, and G. J. Jacomb-Hood illustrated a story rather in the manner of the painter. Great excitement was caused in the latter half of

the year by a general election, which in those days was taken far more seriously than now. All the staff were busily employed, and Walter Russell (now Keeper of the Royal Academy) and Phil May were also pressed into the service. Cecil Aldin made an early appearance with an immature drawing of costers' donkeys, and Maurice Greiffenhagen did three illustrations, not yet in his finest manner, for a George Moore story. Jack B. Yeats had a spirited pen-and-ink page of the cattle market at Islington, and Dudley Hardy some theatrical drawings and some light-hearted illustrations to *A Ladder of Swords* by Gilbert Parker. W. B. Wollen contributed three pages of drawings of the Oakley Hunt and thereafter became the paper's accredited hunting representative. There was an interesting and unexpected page subject by S. H. Sime, fine in character and drawing, rendered by wood-engraving; but this method dealt very unfairly with some half-tone illustrations by Fred Pegram, whose line work was much more successfully reproduced by process. Wal Paget made some pleasant drawings with some of the quality of water-colour for Thomas Hardy's *The Pursuit of the Well-beloved*. William Simpson, one of the earliest contributors, continued to act as special correspondent, and Fred Barnard made a welcome reappearance in the Christmas Number with two good pages. Altogether a memorable year!

The year 1893 was marked by a more generous use of half-tone process blocks. Phil May contributed his usual page of pantomime sketches, and another of the Mansion House fancy-dress ball for children, both very sure. Adolph Birkenruth's illustrations in wash for Besant's *The Rebel Queen* were rather ethereal and lacking in character, especially when compared with Forestier's strong work for Gilbert Parker's story. In February there was an interesting interview with Sambourne with special reference to the cover design for *The Sketch*, the new project of *The Illustrated London News*. Walter Wilson continued his amazing output of drawings of Parliament, drawing-rooms and clubland. An interior of the library of the Athenæum shows thousands of books, each one carefully drawn. Caton

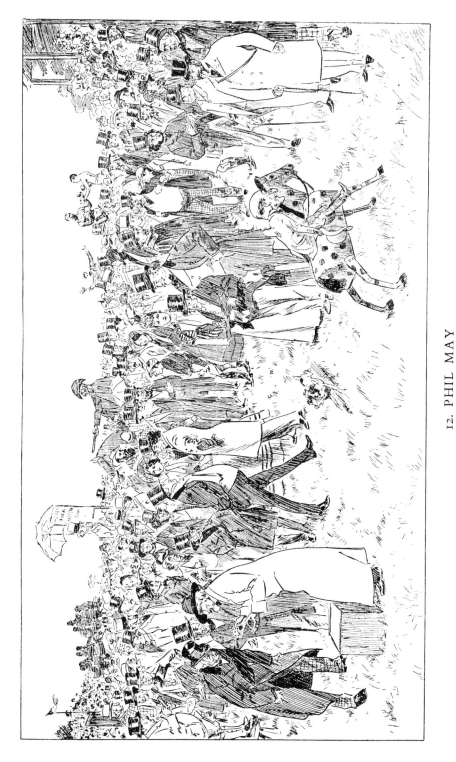

12. PHIL MAY

'A Diamond Jubilee Dream of Victorian Derby Days', from *Punch*, 19 June 1897

By courtesy of the Proprietors

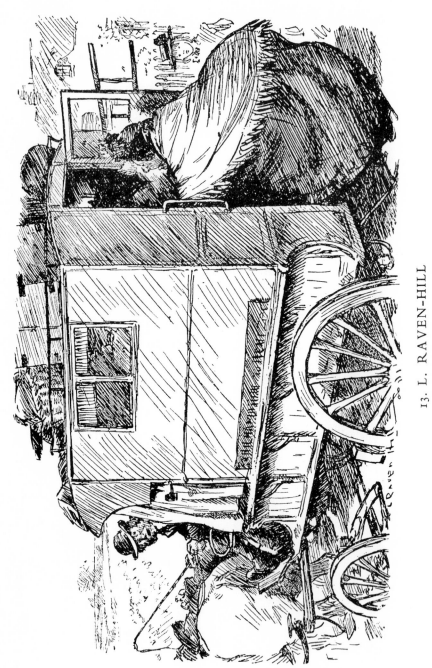

13. L. RAVEN-HILL
'Try Zideways', from *Punch*, 17 October 1900
By courtesy of the Proprietors

Woodville started a series of spirited double-page drawings of 'Battles of the Army'. In July came the royal wedding of our present King and Queen and Forestier and Wilson were again at the top of their form. F. de Haenen contributed a page drawing, George C. Haité one of Volendam, and Cecil Aldin began to find his true line among cattle and dog shows. In 1894, for the first time, the story-illustrators' names were printed. Beside such regular hands as Forestier, Caton Woodville and Jacomb-Hood, Miss Chris Hammond appeared in the summer number. On 4 August Walter Russell had a fine drawing of Ramsgate Sands, full of well observed character, and Aldin was represented by two pages in the Christmas number.

Early in 1895 appeared Charles J. de Lacy, an expert in shipping, a subject which was also ably illustrated by H. C. Seppings Wright and C. W. Wyllie, and later by Fred T. Jane. Photographs were beginning to creep in and to be reproduced directly, without translation by the artist. Walter Wilson had now dropped out of the ranks, and the parliamentary drawings were made by S. Begg, so tightly finished as to be almost indistinguishable from photographs. In July Gunning King struck an exactly opposite and fresh note with some admirably free drawings of election humours. In 1896 the war-correspondents, Melton Prior and Seppings Wright, were busy in Ashanti, South Africa (Jameson's raid) and Dongola. Fred Pegram reappeared with some much freer theatrical sketches, and in the summer number Cecil Aldin developed his 'Olde Worlde' manner, with seven pages printed in red-and-black. Wal Paget illustrated Henry James, and Forestier made some very good drawings for Frankfort Moore's *The Jessamy Bride*. An interview with Phil May by Julius M. Price contained nine unpublished drawings. Aldin had four more red-and-black drawings in the issue dated 26 December, and Robert Sauber four pretty pages in colour. Greiffenhagen's illustrations to a Grant Allen story marked a distinct advance in the carefully disposed contrast of tones so suggestive of colour. In spite of this infusion of new blood among the contributors the paper was tending to become

more a newspaper—a record of events—and rather less artistic in character. Walter Wilson had gone, Caton Woodville and Forestier (except for stray illustrations) appeared less regularly. In 1897 Ralph Cleaver contributed some line drawings superficially clever but lacking his brother's fine draughtsmanship; Archibald Thorburn's birds, correct and finished to the last feather, filled pages; and Robert Sauber illustrated stories and theatrical performances. But these were not the giants of old! Then came the Diamond Jubilee and all hands were summoned to cope with it. Double-pages galore appeared of every phase of the celebrations; a special number was issued, and there was little thought or opportunity for anything else. In 1898 Walter Wilson reappeared with more clubland drawings and Montbard continued his series of English Houses. The wood-block had by now disappeared, except very rarely for the reproduction of pictures and as a reminder to the moderns of the old methods. The photograph was beginning to oust even the news drawing. F. H. Townsend emphasised the possibilities of the new process with some vigorous story illustrations in line, far removed from the imitations of photographs, of which Arthur H. Buckland's drawings were more reminiscent. Hal Hurst contributed some double-pages which may be succinctly described as 'fluff', with plenty of dash and assurance but little of the sound construction and grasp of character, which are the real test of excellence. The greater part of 1899 and all of 1900 were devoted to the South African War and little else. Even a general election and the Boxer rising in China received only scant attention. Melton Prior, Seppings Wright and Caton Woodville were once more in their element, and Allen Stewart contrived in his drawings to convey much of the sharp contrasts of the strong South African sunlight. Photographs were very freely used, and many of S. Begg's transcriptions of these were so close as to be almost unnecessary. But in the midst of it all Caton Woodville continued to contribute story illustrations.

Although nearly fifty years of experience had produced by 1890 a smoothly working system, the achievement of *The Illus-*

14. HERBERT RAILTON

From 'Coaching Days and Coaching Ways', *English Illustrated Magazine*
By courtesy of Macmillan & Co. Ltd.

15. HERBERT RAILTON

From 'Coaching Days and Coaching Ways', *English Illustrated Magazine*
By courtesy of Macmillan & Co. Ltd.

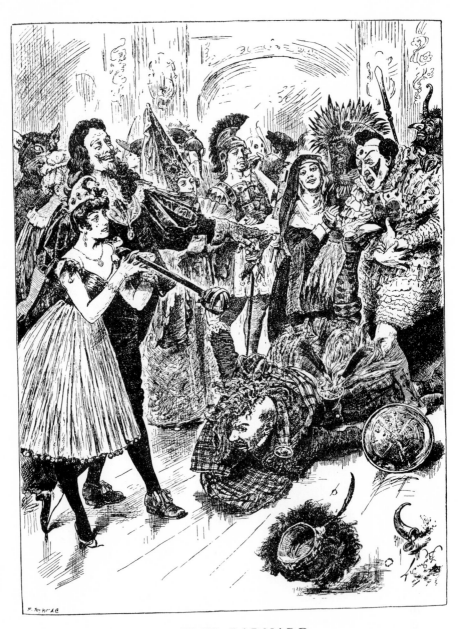

16. FRED BARNARD

From *The Illustrated London News*, Christmas Number, 1892

trated London News during the next ten years was very worthily impressive. The pictorial record of news, of which the paper was the pioneer, was made a well established fact and regular profession, from which succeeding imitators and rivals derived much knowledge, technical and artistic. The production of these news drawings under very difficult and hurried conditions was a very great triumph, and the number of artists capable of adapting their work with very satisfactory success to these restrictions was surprisingly large. Compared with the leisurely, comfortable and convenient way in which the painter of pictures worked, their accomplishment was worthy of far higher esteem than it has received. Such capable craftsmen as Barnard, Forestier, Wilson and Woodville were quite as worthy of consideration as many less accomplished artists whose work was exhibited and received more attention in public exhibitions. Nor were these drawings of topical subjects the only form of production encouraged by the proprietors, for many others were published solely on their merits, without consideration of the value of their subjects as news. On the technical side, too, considerable advance was made in the making of blocks both for line and half-tone process, and these ten years saw the passing of the wood-block as a regular method of reproduction.

THE GRAPHIC

The *Graphic* was founded in 1870 by W. L. Thomas, a pupil of W. J. Linton, the famous wood-engraver. From the outset it had a staff of capable artists, including, amongst others, Arthur Boyd Houghton, G. J. Pinwell, Charles Green and William Small, who were given every encouragement even at the expense of the hitherto all-powerful engraver. In 1890, when our interest begins, there were still three survivors of the early days, William Small, Charles Green and Robert Barnes, doing excellent work. All three were sound draughtsmen, with a long

experience of drawing for wood-engraving, which at the outset was the principal method of reproduction. By adopting the process of photographing the designs directly on to the woodblock Thomas preserved the artists' drawings. Many of these were exhibited in the Graphic gallery with the laudable object of arousing interest and advertising the paper. There were a few half-tone process blocks, but these were rather muddy in their tones and not yet satisfactory. Small was engaged mostly in story illustrations, which were allowed more time than the news drawings, and Barnes made occasional transcripts from life, full of good sound drawing, and character studies. Joseph Nash, R.I., was another survival of the woodcut period and a very regular contributor of news pages and double-pages. Sydney P. Hall, another old hand, who had acted as special correspondent in the Franco-Prussian war of 1870-71, was still drawing excellent portrait studies and other subjects. Charles Green was a fine draughtsman rather more modern in treatment than the others and often worked in line. He specialised in 'period' illustrations, principally of the Georgian and early Victorian eras. Frank Dadd and C. J. Staniland both served an apprenticeship on *The Illustrated London News* before transferring to *The Graphic*. Arthur and Everard Hopkins and H. M. Paget also worked for both papers. Arthur Hopkins's contributions were generally of society functions, often double-pages, carefully designed and drawn. Paget was an efficient illustrator, using black-and-white in the manner of the water-colour artist. John Charlton specialised in hunting subjects, well drawn and convincing, and Charles W. Wyllie in shipping and the sea. Lance Calkin did some fine portraits, many of which were reproduced by double-page wood-engravings. *The Graphic*, like *The Illustrated London News*, in addition to the news drawings printed special plates, some woodcuts, others in photogravure, and these were in many cases quite excellent.

Of the newer men the most important was William Hatherell, who worked mostly in wash, rather in the Small tradition, and to good drawing added a sound and interesting

method and great personal charm. Many of his drawings, although done in black-and-white, have all the tone values of a water-colour. He did a great deal of work for *The Graphic*, illustrating news, stories and general subjects, and influencing the style of many of his younger contemporaries. Another valuable recruit was Reginald Cleaver, the bright star of *The Daily Graphic*, who worked mostly in line with a marvellous method of realizing tone and light by means of shading in clear parallel lines. In his later work he seldom resorted to cross-hatching, and his method, which was very successful in translating photographs, lent itself admirably to reproduction. Percy Macquoid was another fairly regular contributor of carefully worked-out detailed drawings. W. Ralston did many humorous pen-and-ink pages, and A. C. Corbould sent subjects of a sporting character. One of the greatest and most regular artists on *The Graphic* was Paul Renouard, who worked mostly in pencil and black chalk and produced many masterly drawings, loosely handled, with plenty of interest. In 1890 Hugh Thomson contributed a page of four drawings full of action and character, and in the summer number illustrated with Herbert Railton a story by Outram Tristram. The three men had already collaborated very successfully in 'Coaching Days and Coaching Ways' in *The English Illustrated Magazine* (1888). Thomson was one of the greatest English illustrators, with a good method of drawing derived originally from Randolph Caldecott, great knowledge of period, costumes and setting, an Irishman's keen sense of humour and a great personal charm. It is this indefinable quality, allied to the presentation of character, which differentiates the great men from the capable craftsmen. There were at this time hundreds of draughtsmen all doing sound, honest work, whose very accuracy in many cases deprived it of strong appeal, but few of them possessed that charm which really comes from an infusion of the personality and enthusiastic enjoyment of the artist. Randolph Caldecott had it in great measure; Phil May had it; Charles Keene had it, and some others; but there were not many who could make us love them

for their work. Thomson's drawings are found mostly in books. He was the ideal illustrator for Jane Austen, for Mrs. Gaskell, for Maria Edgeworth, for Mary Russell Mitford and for Austin Dobson. In later periods and manners he was artistically not so happy.

Frank Dadd illustrated the serial by Baring Gould and also started a series of 'Types of the Army and Navy' drawn in colour. Harry (afterwards Sir Harry) Johnston sent sketches, also in colour, from Nyasaland, and C. Haldane Macfall, who was afterwards better known as a writer and art critic, a page of small drawings from Sierra Leone. H. W. Brewer was a regular contributor of architectural subjects, well drawn and conscientious in detail. In 1891 Thomson occasionally enlivened a page and was in specially good form in the Christmas number. W. L. Wyllie dealt capably with the Queen's visit to Portsmouth in March. Capt. R. S. S. Baden-Powell sent sketches from S. Africa, where he later became more famous at Mafeking. Albert E. Sterner, who, although an Englishman, worked in America, did a page of three drawings of 'Barbara Allen'. Frank Brangwyn had some fine drawings of ships and sailormen, and Lockhart Bogle some pencil portrait studies of City and Stock Exchange celebrities. Hubert Herkomer, and three of his Bushey students—D. A. Wehrschmidt, Borough Johnson, and J. Syddall—ably illustrated Thomas Hardy's *Tess of the d'Urbervilles*, the text of which had to be slightly modified for the tender susceptibilities of *Graphic* readers. Paul Renouard continued his fine chalk drawings, and another Frenchman, M. Bon Voisin, who signed his drawings 'Mars', contributed occasionally.

In 1892 Sydney P. Hall, Reginald Cleaver, Charles Green, Hugh Thomson, Paul Renouard, Herbert Railton, Phil May and William Small contributed representative work. Miss Mary L. Gow made eight delightful pen-drawings, full of colour suggestion, for the summer number. William Hatherell illustrated William Black's *Wolfenberg* delightfully. John R. Reid had a drawing of grouse, and G. Denholm Armour a page of

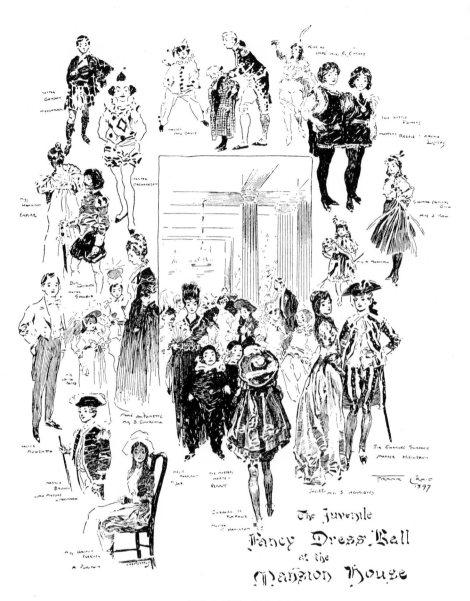

The Juvenile
Fancy Dress-Ball
at the
Mansion House

17. FRANK CRAIG

Page Drawing from *The Graphic*

18. REGINALD CLEAVER

'The Rt. Hon. A. W. Peel, the retiring Speaker'
From *The Daily Graphic*, April 1895
By courtesy of 'The Daily Sketch'

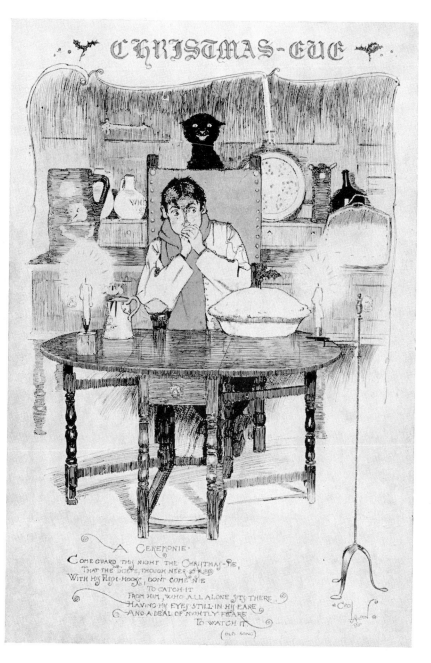

19. CECIL ALDIN
Pen-drawing with red tint
The Sketch, Christmas Number, 1895

20. G. DENHOLM ARMOUR

'An old English breed—long-horn bull'. Drawn in chalk and water-colour

Original $9\frac{1}{4}'' \times 12\frac{3}{4}''$

By courtesy of the Artist

hunting sketches in half-tone. In 1893 the proprietors had the excellent notion of sending Phil May accompanied by E. S. Grew, a member of the literary staff, on a tour round the world. The journey to America was by no means a success, and after a stay in New York, from which some excellent drawings were sent, they reached Chicago, where a World's Fair was in progress. Here May rebelled and, insisting that America did not agree with him, decided to return. The two travellers arrived back in London to find the streets gaily decorated and the initials G. and M., which might have stood for Grew and May, displayed every-where. It was, however, the sixth of July and the wedding-day of our present King and Queen! G. P. Jacomb-Hood and Seymour Lucas illustrated the two serials. Lance Calkin had a fine double-page on 1 April of the three-card trick in a railway carriage. A. S. Boyd made his appearance, and afterwards became closely con-nected with the paper as he was already with *The Daily Graphic*.

William Small illustrated William Black's *Highland Cousins* in 1894, but the drawings were hardly equal to his best work. W. L. Wyllie, following in May's track, sent sketches, some in colour, 'From the Old World to the New'. In September ap-peared John Gülich, a young artist whose work resembled in some ways that of Hatherell, with perhaps a little more drama-tic quality. Later the two men often collaborated on the same drawing. Brangwyn, May and Rainey made characteristic con-tributions during the year. Wood-engravings were still used and the artists' names were sometimes given below the drawings. In March 1895, A. S. Hartrick had two charming drawings of fishing subjects in his own individual style. C. E. Fripp sent war sketches from China, and Harry Johnston some more excellent drawings from British Central Africa and India, which proved him to be a capable artist as well as an able administrator. Claude Shepperson contributed two pencil-sketches in June, and Walter Russell a fine well-observed double-page of 'The London Hos-pital'. In the summer number Hatherell was seen at his best with ten or twelve excellent illustrations. Frank Dadd made some good drawings for Baring Gould's *The Broom Squire*. Frank Craig's

first appearance took place on 5 December with a pen-drawing, which gave little promise of his later general fulfilment. Cleaver and Thomson were prominent in the Christmas number.

In 1896 great attention was given to the coronation of the Russian Czar. Hatherell worked with Gülich and also with Small on double-page drawings. Gülich had a fine double-page drawing of 'The Boulogne Boat' (10 Oct.), and Edward de Martino, marine painter to Queen Victoria, also contributed. Hatherell and Gülich were now the two principal regular artists on the paper, with Frank Craig rapidly improving and developing a more personal style. In 1897 Gülich did some fine illustrations for a Bret Harte story, and R. W. Macbeth some interesting drawings of country subjects full of the feeling of out-of-doors. Later came the Diamond Jubilee which engaged the attention of the full staff of artists. Solomon J. Solomon illustrated Zangwill's story *The Turkish Messiah*. In 1898 Frank Richards did the illustrations for Crockett's serial *The Red Axe*, John da Costa contributed occasionally, and in March, Tom Browne appeared with a page of humorous drawings. Browne was a young self-taught artist from Nottingham, trained from the age of fourteen until he was twenty-one in a lithographic firm. He was a prolific and rapid worker and at one time was as a humorous draughtsman second only to Phil May. It is a strange and sad fact that six of the greatest of English draughtsmen died before reaching the age of forty; Tom Browne was one, and others were Randolph Caldecott, A. Boyd Houghton, George J. Pinwell, Frederick Walker and Phil May. And to this list must now be added the name of John Gülich, who died in December of that year at the early age of thirty-three. He had in eleven years' connection with *The Graphic* already established his position as one of the great illustrators, and his work both in black-and-white and in colour was full of promise. W. T. Maud was now acting as war-correspondent and sending sketches and finished drawings. Seymour Lucas's illustrations to the serial were printed in colour.

Gülich's vacant place on the staff, both as an individual artist

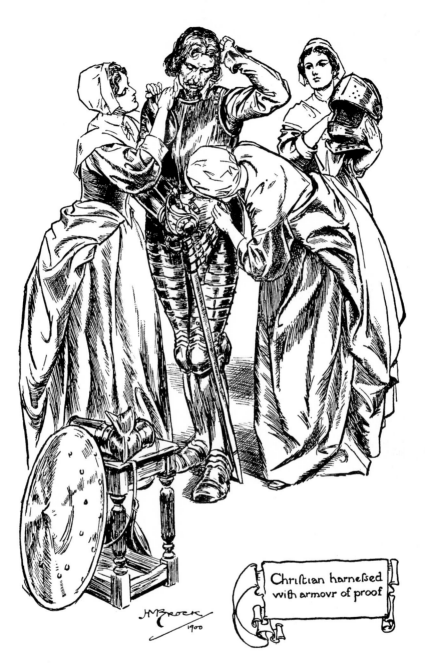

Christian harneſſed with armovr of proof

21. H. M. BROCK

From *The Pilgrim's Progress*

By courtesy of C. Arthur Pearson, Ltd.

22. R. W. MACBETH

Story Illustration from *The Graphic*, 3 March 1900

and collaborator with Hatherell, was taken by Frank Craig, whose work had very rapidly improved, and on 20 May 1899, we have an instance of four artists working on a double-page drawing, the two already mentioned being assisted by W. T. Maud and F. C. Dickinson—a newcomer. F. H. Townsend continued his excellent pen-drawings and Arthur Garratt sent interesting work. Ralph Peacock and Edgar Bundy illustrated stories, but, like Seymour Lucas, they were painters and cannot be considered as regular black-and-white men. Paul Renouard did some masterly drawings of the Dreyfus case in France. C. A. Shepperson appeared in the summer number, and John Hassall in the Christmas number, and other occasional contributors were Balliol Salmon, with very carefully finished pencil-drawings, Harold Speed and Byam Shaw.

In the South African war, which monopolised so much space and attention in 1900, *The Graphic* was represented by W. T. Maud and F. de Haenen. The brothers C. E. and H. M. Brock illustrated a story by Marriott Watson, and R. W. Macbeth one by Eden Phillpotts. The Brocks were both excellent pen-draughtsmen. C. E. is generally more highly esteemed, although H. M. surpasses him in strength, originality and vigour of line and drawing, and shows a greater sense of humour in his work. Both men have illustrated many books. Charles Dixon contributed capable drawings of shipping and the sea, and William Small was still working admirably.

The Graphic's record for the ten years was indeed a proud one. If it had no three recorders of news to equal the Forestier-Wilson-Woodville combination of *The Illustrated London News*, the artistic level of the drawings was generally higher and more interesting. William Small may justly be considered the artistic father of *The Graphic*, both by reason of the excellence of his own drawings and by the influence which these transmitted to the younger generation. With a long experience of drawing for the wood-engravers, his work was equally impressive and appropriate in the newer method of reproduction. For the basis of all good illustration is sound draughtsmanship, and this was

evident in all that Small produced. Perhaps because of its quiet excellence and absence of anything eccentric or sensational, his work has never received the full appreciation that it deserved; but he was undoubtedly a very great artist. Hatherell and Gülich, for example, both derived much of their charm and excellence from Small. Charles Green and Frank Dadd were also capable craftsmen, with a complete knowledge of the qualities necessary to a good illustration, and both set an example which was of value to their successors. To the work of Hugh Thomson and Phil May I have already referred in terms of enthusiastic appreciation, and they in themselves would have been sufficient to raise the record to distinction. One of the greatest and most original *Graphic* artists of the period was Paul Renouard, who, although born a Frenchman, did so much of his work in this country. His method was his own, strong, individual, self-reliant and conscientious, with a fine grasp of character and power of recording it. Under the able direction and encouragement of the Thomas family, *The Graphic* undoubtedly exerted a very great and beneficial influence on English black-and-white art. Many of the artists whose work appeared in its pages have testified to the personal kindness and sympathy of W. L. Thomas and his son and successor, Carmichael Thomas, and to the spirit of loyalty thereby engendered which had so much to do with *The Graphic's* success. Modern commercial methods and the absence of any intelligent appreciation by those in charge have contrived to dispel most of this spirit of comradeship which animated so many of the old papers and produced such favourable results. When Carmichael Thomas ceased to control its policy and destiny, it gradually declined and lost its personality, and after a spasmodic effort to imitate American methods expired in July 1932, deeply mourned by all true lovers of English illustrated journalism who could remember its proud record.

23. C. E. BROCK
Illustration from Galt's *Annals of the Parish*
By courtesy of Macmillan & Co. Ltd.

24. CHARLES GREEN

From *The Graphic*, 2 August 1890

THE DAILY GRAPHIC

Although *The Daily Graphic* obviously cannot claim to be included with the weekly papers, its connection with *The Graphic* was so close that it may best be considered here. The proprietors of the older paper were its proud parents, and many members of the staffs of the two papers often worked for both. The inception of *The Daily Graphic* as the first daily illustrated paper was in its way as bold a stroke as the birth of *The Illustrated London News* had been forty-eight years earlier. It is true that the methods of reproduction had been made much quicker, but the time available for making the drawing was proportionately reduced. The new paper proposed to do every day what the older did once a week. Much careful preliminary organisation must have preceded the production of the first number of sixteen pages on 4 January 1890. Many general articles with illustrations had been prepared which could be used at any time to fill a gap or to cover a delay. The issue contained thirty-nine small line-drawings, some still reproduced by wood-engraving, and some by the new process. G. K. Jones, W. Ralston, A. C. Corbould, A. S. Boyd, Mars, T. S. C. Crowther, H. Johnson, L. Raven-Hill, A. S. Hartrick, E. J. Sullivan, H. W. Brewer, Paul Renouard, Phil Ebbutt and Reginald Cleaver were some of the artists who assisted in the production. Of these the greatest factor in the success of the paper was Cleaver, an accurate draughtsman with great mastery of the pen, a clean, sure, open line, a great gift of portraiture and a sense of humour. These qualities helped to make him a very successful recorder of parliamentary proceedings. His early drawings were characterised by less certainty but greater freedom than his later work, from which he eliminated cross-hatching and produced his tones by almost mechanical shading with parallel lines. No artist has ever translated photographs into line with more success, and this quality of vivid actuality persisted throughout much of his original work. His drawings repro-

duced perfectly and must have rejoiced the hearts of the printer and the editor. A number of young artists worked in the office on portraits and any work that was wanted quickly, and thus gained very valuable experience and practice. E. J. Sullivan and A. S. Hartrick were two of the excellent graduates of this Daily Graphic School, and both retained and developed their own individuality. As an example of the success of the system of recording news pictorially it is interesting to note that when General Boulanger committed suicide on 30 September 1891, four fairly large illustrations of his career appeared in the paper next morning. At the end of each year a brief summary was published with a number of much reduced illustrations, beautifully and clearly printed.

As time went on, fresh additions were made to the staff and to the list of contributors: Oliver Paque (W. H. Pike) who invented an effective artistic shorthand by which, although portraiture was not attempted, a good general impression of the scene was suggested, D. Macpherson, a good draughtsman of landscape, buildings or figures, A. Kemp Tebby, Thomas Downey, Herbert Johnson, S. T. Dadd, G. Rossi Ashton (from Australia), Miss S. A. H. Robinson, Fred Whiting and Sydney Higham. Some of these were already accomplished illustrators, others only just out of the student stage and seeking experience. By 1893 many photographic portraits were being printed directly by half-tone without being translated into line-drawings, and the same method was used for reproducing drawings made on grey tinted erasing paper. Drawings were sent by foreign correspondents from various countries, and either printed as they were or redrawn by staff artists. Reginald Cleaver continued to make brilliant drawings of parliamentary scenes, public dinners, receptions and election meetings, many of them containing dozens of perfect portraits. Several artists worked for both papers and thus some of the records of the Phil May-E. S. Grew tour, 'Seeing the World', appeared in the daily as well as the weekly editions. War-correspondents too were shared, and thus W. T. Maud as a special correspondent and

25. H. W. BREWER

'A Suggestion for Improving Cheapside', from the *Daily Graphic*, 1896

By courtesy of 'The Daily Sketch'

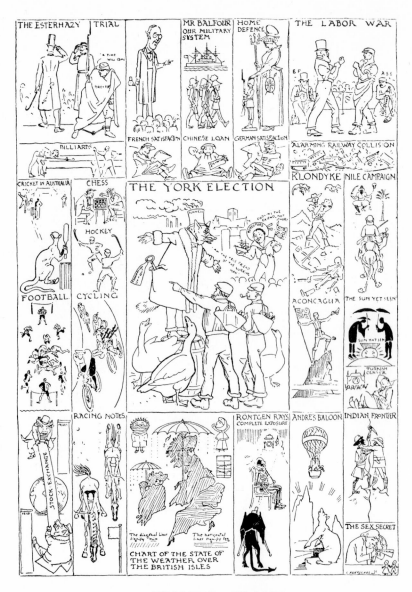

26. WALTER CRANE

'An Illustrated "Chronicle"', from *The Daily Chronicle*, 15 June 1898,
reduced from 9 by 13 inches

By courtesy of 'The News Chronicle'

Baden-Powell (Ashanti) sent sketches from various parts. Paul Renouard made some masterly pen-and-ink drawings in the law courts.

In 1895 Rossi Ashton, the Australian draughtsman, was in London and contributed fairly regularly, and Phil May became a temporary cartoonist with some fine bold designs dealing with the Venezuelan dispute with the United States. H. W. Brewer offered some elaborate, well drawn pen-and-ink suggestions for the improvement of London, and Oscar Eckhardt made some good East-end studies. By this time there was much greater freedom and confidence in the handling of the drawings, and many of the regular artists, notably R. B. M. Paxton and D. Macpherson, were doing quite notable work. Later came J. Duncan, Frank Gillett, who specialised in sporting subjects, and Hutton Mitchell. C. E. Fripp of *The Graphic* and Fred Whiting, now acting as special correspondent, sent sketches from China, and W. T. Maud and others from South Africa.

On 16 October 1900, William Luson Thomas died, having seen the triumphant success of the two excellent papers which he had founded. Of these perhaps *The Daily Graphic* exercised an even greater influence on pictorial journalism than did the weekly *Graphic*, which had been already anticipated by *The Illustrated London News*. Both papers trained and encouraged a large band of competent illustrators, and thus to some extent took the place of the Dalziels during the sixties. In looking back through these early years of the paper, one is impressed more by the general excellence of the production than by any single outstanding figure, with the exception of Reginald Cleaver. But very competent work was being done by many of the regular staff, notably A. S. Boyd, T. S. C. Crowther, H. W. Brewer, D. Macpherson, and R. B. M. Paxton; and E. J. Sullivan and A. S. Hartrick were two brilliant instances of artists who learned much of their methods and gained valuable experience in the excellent training of this school. Artists generally are difficult people to discipline, particularly if they regard work as distasteful, and it must have required great tact, diplomacy and en-

thusiasm to manage the Daily Graphic School so successfully. No daily paper has ever produced so regular a supply of consistently artistic drawing, and to have continued this for nearly thirty years is a very great achievement. As the scope and power of the camera increased, and competition made economy of production more necessary, photographs were used more generally and almost entirely replaced the drawings. Finally, *The Daily Graphic*, which maintained its individuality and dignity to the end, lost its public and was absorbed into the unintelligent narrow commercialism of to-day. In the development and encouragement of black-and-white art during the nineties, William Luson Thomas and his sons were responsible for a very great part of its success.

THE DAILY CHRONICLE

Apart from *The Daily Graphic* few London daily newspapers printed illustrations with any regularity. *The Pall Mall Gazette* and *Westminster Gazette* had political cartoons which appeared on most evenings, and some of the provincial papers also included a similar feature. In 1895, however, a forthcoming London County Council election suggested to the proprietor and editor of *The Daily Chronicle* the idea of supporting the Progressive cause by a series of articles on the work of the Council. These were to be illustrated by the best black-and-white artists of the day under the direction of Joseph Pennell, who was given a free hand. Pennell made a very judicious selection, and most of the work contributed was excellent and, after much tribulation, very well reproduced.

Whistler, Aubrey Beardsley, Sir Edward Burne-Jones and Walter Crane were pressed into the service, but most of the best work was done by those more accustomed to this particular form of art. Linley Sambourne contributed a cartoon, not however in his best vein, Alfred Parsons displayed his masterly pen-

technique in some excellent drawings of parks and commons, A. S. Hartrick was particularly prominent, and Pennell himself contributed some good examples of his penmanship. L. Raven-Hill, Maurice Greiffenhagen (not at his best), Walter Russell, Fred Pegram, E. J. Sullivan, F. H. Townsend, Herbert Railton, G. P. Jacomb-Hood, Percy Kemp and W. B. Wollen were all well represented. Alice B. Woodward, E. H. New and Edgar Wilson made some charming small decorations, T. Blake Wirgman some competent portraits, and Phil May's delightful drawing of the interior of a shop stood out by its simple, sound directness. From an artistic point of view the scheme was a great success and a triumph for Pennell and the printers. Politically it was a complete failure, for the Progressives, in whose cause it was evolved, were completely routed at the polls. The articles and drawings were afterwards collected and published as a book with the title *New London*. *The Daily Chronicle*, however, continued to reproduce many excellent drawings, particularly of architectural subjects by Hedley Fitton, and political cartoons by David Wilson and others.

THE SPORTING AND DRAMATIC NEWS

The *Sporting and Dramatic News* dates back as far as 1874, and the first volume of 1890 is numbered thirty-two. Its staff of artists was rather distinct from that of other papers and was concerned more with the literal recording of events than with any very artistic quality in the work. John Sturgess and W. Stanfield Sturgess drew horses in their own particular way, John's work being mostly connected with racing. The uniformity of action of the runners, always at full stretch with the bodies close to the ground, made them all very much alike, and one drawing of the Derby or the Grand National, with a modification of the jockeys' colours, would serve equally well for any year's race. John Jellicoe and S. T. Dadd could draw every kind

of subject: J. U. G. Temple, a regular contributor, dealt especially with fishing, J. Ayton Symington and G. E. Robertson with country subjects, Paul Hardy with historical and dramatic costume incidents, and Herbert Railton's decorative pen technique produced many interesting topographical drawings. H. B. Wilson, Stanley L. Wood and W. A. Donnelly were other contributors. But the greatest man of the staff was Alfred Bryan, who every week made six or seven caricature drawings illustrating the dramatic criticism of 'Our Captious Critic'. Bryan was a very facile and accomplished caricaturist with a great gift of portraiture. Besides producing an enormous quantity of his own work he also trained several capable pupils, of whom Horace Morehen (himself a contributor to *The Sporting and Dramatic*), Thomas Downey and J. A. Shepherd were well known. Most of the reproductions were still made from wood-engravings, with a few from half-tone and line blocks. R. H. Moore did many good line-drawings of dogs; A. Quinton supplemented the work of Railton in small sketches of 'English Homes of Sport'; Maude V. Clarke drew military subjects in half-tone; and E. Caldwell was another frequent contributor. The Christmas number—*Holly Leaves*—consisted mainly of wood-engraved pages by members of the staff and also by J. M. Price and Gordon Browne in subjects of sedate humour.

In 1891 Charles L. Pott, Arthur J. Wall, Cecil Aldin and Fanny Moody were newcomers, and Paul Hardy initiated a series of 'Old English Sports', very spirited drawings but lacking in presentation of character. The next year's volumes contained a poor double-page of Henley by George Lambert, some good pen-drawings by Lancelot Speed and Cecil Aldin, and some homely sentiment in wash by G. H. Edwards. To the Christmas number J. A. Shepherd contributed some early and very careful studies, and G. H. Jalland some hunting subjects. Many of the general illustrations were reproductions of photographs. In 1893 Paul Hardy continued his studies of the past with 'Trades of the Middle Ages" and Sydney Cowell contributed. Fred Barnard and S. H. Sime appeared in *Holly Leaves*, the latter with

27. MAX BEERBOHM

Caricature of Whistler and Sickert. 'Il est avec Whistler le peintre de la nuit'

Original $7\frac{3}{4}'' \times 12\frac{1}{4}''$

In the Print Room of the British Museum. By courtesy of Max Beerbohm

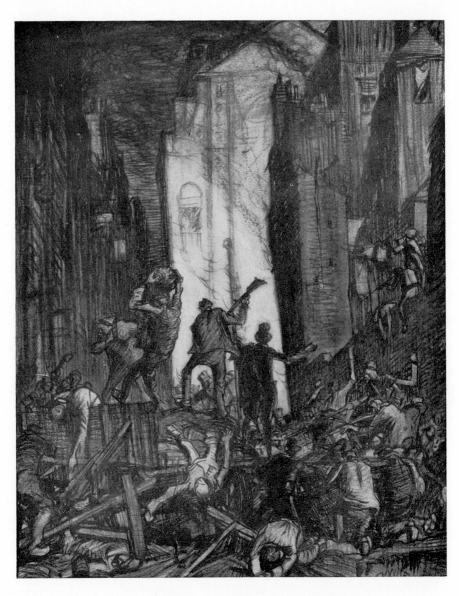

28. FRANK BRANGWYN, R.A.
Illustration for a book of poems by Verhaeren
Drawn in black and red chalk. Original $17\frac{1}{4}'' \times 14''$
By courtesy of the Artist

another wood-engraved study of an old clown, almost unrecognisable except for the signature. The next year Phil Ebbutt and Holland Tringham had drawings, John Beer some racing subjects, and Stanley Montefiore some studies of animals. Fred Barnard and Thomas Downey were in *Holly Leaves*. The 1895 volumes brought more photographs and some hunting drawings by G. D. Armour. R. Sauber, W. Ralston and Frank Chesworth were represented in the Christmas number. 1896 introduced a modern note. Edward Read, Gunning King, Stanley Berkeley, Ralph Cleaver, Seppings Wright and C. M. Padday (with drawings of football) contributed.

There was an infusion of *Illustrated London News* artists in 1897: Caton Woodville, Raymond Potter and S. Begg all had drawings, and Fred Thomas Smith some hunting subjects. Archibald Thorburn's meticulous studies of birds and rabbits were a feature of the next year, and Cecil Aldin (happily inspired by Caldecott) and Sauber appeared in the Christmas number. The latter's drawing of a girl skating, with three beaux in the background, is attached to this deliciously characteristic Victorian verse:

> 'Who is the lady ? That figure, such grace!
> They dare not in courtesy quicken their pace.
> Who are the trio? She wonders—Alack!
> Propriety dares her to take a peep back.'

In 1899 the illustrations consisted mostly of reproductions of photographs, many of which were of war scenes. Even theatrical plays were recorded by the same method. G. D. Armour and Fred T. Jane contributed drawings, and the Christmas number retained its usual character. Fred Pegram and Bernard Partridge did capable story illustrations, and most of the old favourites— A. Forestier, Gordon Brown, Louis Wain and S. E. Waller— were represented. The paper, in common with many others, suffered a severe loss by the death in May of Alfred Bryan who had contributed regularly. The theatrical drawings in 1900 were mostly the work of Balliol Salmon, but these were portrait

drawings of a scene in the play without any intention of caricature.

Although *The Sporting and Dramatic News* printed many drawings of artistic merit, particularly in the Christmas numbers, it cannot be compared in this respect with *The Graphic* and *The Illustrated London News*. It was more frankly a newspaper whose illustrations were intended to be realistic records of events rather than artistic impressions. When these events could be shewn in photographs, this method was preferred, and artists' work was limited to humorous or personal comments on sporting subjects. In Alfred Bryan it certainly possessed a very accomplished artist, whose gifts of humorous portraiture and prolific facility in drawing were of great value to the paper. He was certainly the outstanding feature of the volumes which we have been considering.

THE PALL MALL BUDGET

The *Pall Mall Budget* was already in its twenty-second year in 1890, having been founded so far back as 1868. As an offshoot of *The Pall Mall Gazette* it contained a weekly summary and reprint of some of the contents of the evening paper. Pictorially it consisted of F. C. Gould and others, for in addition to a selection of his daily parliamentary sketches he contributed one or more cartoons and occasionally illustrations to stories and news items. Gould always frankly admitted that he was no artist, but, if ability to express one's ideas and convey them clearly to others has any merit, he certainly has a definite claim to the title. Technically his drawing was deficient in the knowledge and dexterity of the good illustrator, but he had a gift of portraiture, an earnest enthusiasm for politics and a clearness of vision and statement that made his cartoons very persuasive in appeal. The late Lord Rosebery once truly described him as the greatest asset of the Liberal Party. His keen love of natural his-

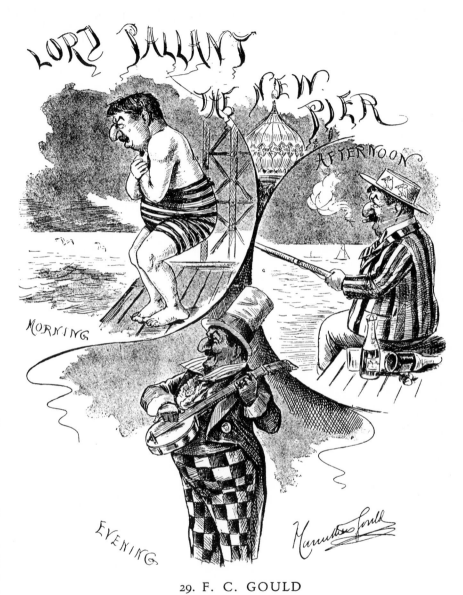

29. F. C. GOULD

Mr. Walter Pallant, part author of *The Circus Girl*, from *The Sketch*

30. E. J. SULLIVAN, R.W.S., R.E.

From *Sartor Resartus* by Thomas Carlyle

By permission of G. Bell and Sons, Ltd.

tory, of which he made full use in his work, often helped to lend interest to that section of his public that was not much concerned with politics. For many years he did the illustrations for the Christmas number of *Truth*, which dealt very successfully with the whims and follies of the year. Whatever were his merits as a draughtsman, he certainly was a very capable journalist and a delightful personality.

Many of the other drawings, most of which were in line, were distinctly poor and uninteresting, often merely unsigned transcripts of photographs, but such well-known illustrators as Charles Harrison, George Hutchinson, Harry Furniss, Louis Wain, who sometimes drew other animals than cats, and Warwick Goble contributed. Ronald Gray did some theatrical portraits, Henry Austin some topographical drawings in the Tringham-Railton manner, and Hugh Thomson an Arcadian political cartoon. In 1891 and 1892 there were some very early and not very promising drawings by Arthur Rackham, who later achieved much fame as an illustrator of books, some sketch-book notes by Frank Brangwyn, theatrical drawings by Charles M. Sheldon, and some crudely drawn humorous ideas by J. H. Roberts. Chris Hammond, George Thomson and Fred Pegram (who had joined the staff at the age of sixteen) did illustrations, and Herbert Railton and C. G. Harper drawings of houses and places.

In 1893 Gould left to join the staff of the newly formed *Westminster Gazette*, and his place as art editor and caricaturist was taken by G. R. Halkett, who, although not Gould's equal as a politician, was keenly interested in black-and-white art and soon made his influence felt in improving the quality of the illustrations. Halkett had previously succeeded Phil May on *The St. Stephen's Review* when he left in 1885 for his three years' contract with *The Sydney Bulletin*. He soon gathered a number of capable artists, who became regular contributors both to the *Budget* and also later to *The Pall Mall Magazine*, when he became its art director. In addition to his activities in these directions Halkett found time to collect and write about black-and-white

drawings and also to contribute to *Punch*. A. S. Hartrick, E. J. Sullivan and Balliol Salmon, all in the experimental stage, L. Raven-Hill, F. H. Townsend, G. D. Armour, A. Jule Goodman and St. Clair Simmons were among the men that Halkett introduced. Joseph Pennell did some fine strong pen-drawings of 'The Devils of Notre Dame', Val R. Prince carried on the well-known Railton tradition, and William Hatherell, Adolph Birkenruth and René Bull did illustrations. In 1894 Dudley Hardy in red-and-black, Maurice Greiffenhagen, F. H. Townsend, Phil May and Lewis Baumer were added, as well as Cecil Aldin, who illustrated several Kipling stories. Meanwhile Halkett himself was gaining in strength, and Alick Ritchie contributed a series of bird's-eye views. And then in the middle of this great accession of artistic strength the paper suddenly ceased, the only reason given being that Mr. W. W. Astor the proprietor had tired of it. A more personal reason was that the paper had been a hobby of his wife, who had taken much interest in its conduct, and that on her death he preferred to suppress it entirely rather than transfer it to less sympathetic ownership. It is a great pity that Halkett did not have longer in which to show that he could have made of a weekly paper as great an intellectual and artistic success as he did later of *The Pall Mall Magazine*. In the two years during which he had charge he had certainly raised it to the level of the best of its rivals, and its premature death was very widely and deeply regretted.

THE ST. JAMES'S BUDGET

Founded in 1880, *The St. James's Budget* did not print illustrations until 1893, the issue for April of that year being, with the exception of the Christmas numbers, the first to contain drawings. Even then many of these were ordinary line work such as appeared in the newspapers. Harry Furniss wrote and illustrated a weekly article called 'Paragraphs and Pictures' and there were

31. FRANK BRANGWYN, R.A.
Illustration for 'The last fight of the *Revenge*' (Gibbings)
Original 7" × 12¾"
By courtesy of Charles Emanuel

32. CYRUS CUNEO
Story illustration from *The Pall Mall Magazine*, Vol. xx., p. 502
By courtesy of The National Magazine Company

a few rather poor drawings by Robert Sauber. In later years Sydney Cowell and Ernest Prater did some very conscientious but stodgy illustrations; Charles Harrison (drawings at the theatres), Ralph Cleaver, J. Atkinson of *Punch*, and G. Montbard of *The Illustrated London News* also contributed. G. Rossi Ashton, A. C. Corbould, F. H. Townsend and O. Eckhardt were assisting in 1898, and in the Christmas number F. H. Newton Shepherd, a very charming artist, Paul Hardy, Lewis Baumer, R. Sauber, and F. H. Townsend appeared. On 13 October 1899 came the last illustrated number and the *St. James's Budget* reverted to the ordinary weekly summary of the *Gazette* which it had been before 1893. Its short career as an illustrated weekly was hardly long enough to develop any definite characteristics, and in an apparent lack of any enthusiasm or enterprise it hardly justified the experiment. Its disappearance, I should suppose, gave rise to little lamentation or even regret.

THE LADY'S PICTORIAL

Like *The St. James's Budget*, *The Lady's Pictorial* was born in 1880, and by 1890 it was a prosperous, well established and generously conducted weekly paper. There was a very liberal allowance of illustrations, well printed, and the volume of advertisements was a tribute to its popularity and large circulation. F. H. Townsend was the principal artistic contributor and did some fine free pen-illustrations to Sara Jeanette Duncan's *An American Girl in London*. Miss G. D. Hammond was working in wash, Walter Russell in line, and A. J. Finberg supplied pen-drawings of theatrical matters. Bernard Partridge and Maurice Greiffenhagen, both with excellent wash-drawings, Cyril R. Hallward, with humorous sketches, and A. Forestier also contributed. But perhaps to the feminine eye the two men who really mattered were Georges Pilotelle and 'Albert' who supplied the very numerous fashion drawings, the former with un-

believably majestic goddesses clad in wondrous raiment, of which the details of buttons, ribbons and embroideries were all conscientiously depicted, the latter with more realistic but no less impressive designs. It was the age of the small waist, and these drawings and the advertisements of corsets remind us forcibly that in those days 'il fallait souffrir pour être belle'. The magnificence of the whole production may be judged from the fact that an autumn number consisted of about 140 pages, half of which were devoted to advertisements, mostly of feminine wearing apparel and accessories. Of the remainder, at least one-half would consist of alluring fashion plates, which must have roused excitement and envy even in the generous bosoms of the placid Victorian mothers and daughters.

In 1893 Greiffenhagen was doing the story illustrations, some in wash, some in line, sometimes uneven but always virile, well designed and full of colour suggestion. Townsend illustrated theatrical plays, and Fred Pegram was beginning to make occasional appearances. These three men continued to work regularly and loyally throughout the period we have under consideration. Bernard Partridge contributed no less than twenty-four delightful illustrations to one article, and this fact shows the generous scale on which the paper was conducted. Cecil Aldin made sketches at dog shows, and R. H. Moore and Arthur Cooke also catered for this branch of feminine interest. Burke Downing drew architectural subjects, and James F. Sullivan contributed a humorous page. For the Christmas number, Townsend made thirty-one illustrations for a story by Miss Braddon. It is a pleasant reminder of the editorial courtesy of those gracious days to note that beneath most of the drawings appeared the line 'by Mr. ——'. The newspaper artist was then regarded at least as a colleague, sometimes even as a friend or associate, rather than as a factory hand or a potential pickpocket.

In 1895 Townsend illustrated the serial in a variety of mediums—pen, pencil and wash—with all the dash and freedom of a master. Pegram did the theatrical drawings. For the Christmas number Sauber designed a rather saccharine cover, and the

well-known trio, already mentioned, contributed of their best. The three men alternately illustrated serials, recorded the plays of the moment and supplied drawings of social interest. Other artists contributed from time to time—A. H. Collings, Leonard Linsdell, G. Oliver Onions (afterwards better known as a novelist), C. H. Taffs, A. M. Faulkner, R. Pannett, A. L. Becken, Clegg Wilkinson, Phil Ebbutt, J. Sanderson Wells—but although many of them had some of the tricks of handling their material, they lacked the soundness of drawing and the confidence that comes from experience. Henry S. Watson did some good and original pen-drawings of London, and J. Jellicoe contributed theatrical illustrations. E. J. Sullivan made some delightful story illustrations in 1898, and John Da Costa, C. H. Taffs, an accomplished illustrator, and Oscar Eckhardt, obviously influenced by Greiffenhagen's work, also appeared occasionally. Early in 1900 (18 March) Alfred Gibbons, the founder and proprietor, died, and with his death the high quality of the pictorial side of the paper began to deteriorate. Gibbons was an enthusiast and a keen admirer of good drawings. He treated his contributors generously, reproduced their work as well as was possible, and did not hesitate to congratulate them on anything that he considered above their usual standard. One of his most regular illustrators has described him as 'the perfect editor'. The natural result was that they loved the man and gave him of their best. The paper was produced harmoniously and with enthusiasm, and flourished tremendously. It is difficult to understand why this spirit of *camaraderie* and friendliness between editor and artist has so definitely disappeared. The artist is generally a person very sensitive to snubs and rebuffs, as also to appreciation, and a judicious measure of encouragement will always have the effect of sympathetic reciprocation in the production of the best work of which he is capable.

Apart from its financial value as an advertising medium, *The Lady's Pictorial* occupies a very high position in the record of black-and-white art of the nineties. Indeed it may be fairly said that for some years it was the best illustrated paper in England,

and many lovers of things artistic—even mere males—bought it (and especially its Christmas numbers) solely for the excellence of its drawings. For this three men were almost entirely responsible: F. H. Townsend, Maurice Greiffenhagen and Fred Pegram. Townsend and Greiffenhagen did many of their drawings in wash, using it transparently so that the pencil of the original design showed through, or in body colour of varying degrees of density. Both used white in the final stages, but whereas Townsend employed it mainly to emphasise the contrasts of lighting, Greiffenhagen used it rather as part of the colour pattern which always prompted his designs. Both men were equally effective in using the pen, but here again there was the same distinction in their intentions. Pegram's work was mostly in line, although he also did some charming drawings in grey tones of wash. His work was more delicate, more refined than that of the other two, and perhaps more scholarly. There was greater concentration on careful drawing, but he used black very sparingly, and there were fewer strong contrasts. All three were excellent and interesting draughtsmen, but Greiffenhagen, by reason of his sense of colour, was perhaps the greatest artist of the three.

THE GENTLEWOMAN

The first number of *The Gentlewoman* appeared on 12 July 1890, and although its most enthusiastic supporters would not claim for it any great artistic merit, it did print occasionally some interesting drawings. Dudley Hardy's illustrations, if they had not yet reached their full maturity, were characterised by a dashing spirit of experiment, and Fred Pegram's were more loosely handled—rather like his work in *Judy*—with a freer use of black than in most of his later productions. Holland Tringham also maintained his usual level of efficiency, and Everard Hopkins, working mostly in wash, contributed some interesting examples. Matt Stretch did some drawings that were more

33. FRANK DADD

Story illustration: wood-engraving from *The Graphic*, 29 September, 1890

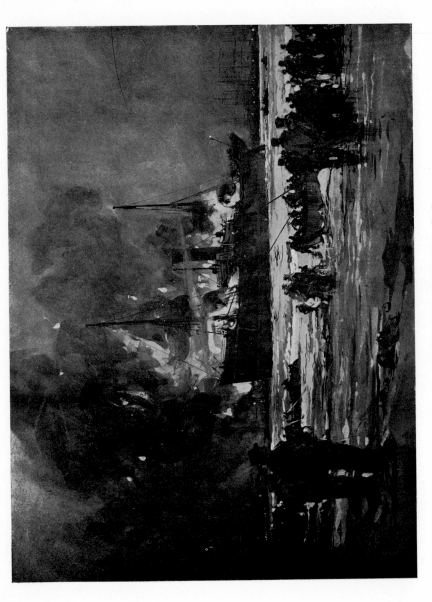

34. CHARLES DIXON, R.I.

'The S.S. *Mariposa* burning: Algoa Bay'

Wash-drawing, probably for *The Graphic.* Original 9″ × 12″

By courtesy of Frank L. Emanuel

interesting for their humorous intentions than for their artistic accomplishment, and M. B. Hewerdine made frequent and regular appearances but could not be considered a good draughtsman. In an unexciting Christmas number Walter Crane had four pen-drawings, and Hardy and Hopkins were represented, the former with some 'blobby' wash-drawings done in a spirit of 'hit or miss'. Later came some very promising illustrations in wash by A. W. Allen, whose name is not familiar elsewhere, some representative work by J. Barnard Davis, and by Paul Hardy and F. H. Townsend, both working in wash, which could not be considered as typical of their ability. Another Christmas number included a double-page drawing of kittens by Louis Wain and a presentation plate in colour, printed (in Germany) on silk. *The Gentlewoman* was that sort of paper!

Cecil Aldin appeared in the unusual role of an illustrator of serial stories, and although many of the drawings were uncertain, some were interesting because of their freshness of outlook and unconventional treatment. Ralph Cleaver and Hal Hurst were contemporary contributors, but in neither case was the work of much importance. Paul Hardy and Arthur Rackham also illustrated serial stories, the latter in a style apparently influenced by E. J. Sullivan. Sullivan himself had some extremely interesting drawings for a fantastic story by E. F. Benson in a prophetic Christmas number dated A.D. 2000. G. Vernon Stokes contributed at various times some very capable drawings of dogs and cats.

Although there is no evidence of any consistent artistic policy in the conduct of *The Gentlewoman*, there is always, in looking through its pages, the pleasant chance of finding some interesting work. It cannot be considered as a strong or even representative feature of the illustration of the period, and its reputation rests principally on its sternly Victorian record of fashions and society news, and on its dearly loved silk supplements at Christmas.

THE QUEEN

Although it was founded in 1861, when so much that was excellent in the way of illustration was being produced, *The Queen* consistently maintained in its pages a definite Victorian aloofness from any artistic enthusiasm. This sedate dignity is reflected in a brief notice of *Phil May's Annual* (December 1892), which announces dispassionately that 'the illustrations throughout are by *the editor*' (who at this time was Francis Gribble) 'and are *of an amusing description*'. This is a delightfully patronising commentary on May's boisterous humour, which should have produced in him an appropriate spirit of becoming humility.

Occasionally, however, and especially at Christmas, when it recklessly reproduced many book illustrations in connection with its reviews, *The Queen* printed some interesting work. Hal Ludlow produced some competent drawings for a serial story in 1892, and Enoch Ward, Lewis Baumer, Adolf Thiede and Phil Ebbutt were represented about the same time. Wal Paget's excellent illustrations to the serial in 1894 were apparently produced originally for the American *Lippincott's Magazine* and reprinted with the story. Sauber also did some good drawings rather under French influence for a serial by H. Seton Merriman. Cecil Aldin, C. A. Shepperson, Frank Richards and G. D. Hammond were other capable illustrators. F. H. Townsend made some good drawings at the theatres, and Arthur Wardle many conscientious studies of animals. But *The Queen* maintained no regular staff of artists, and their occasional employment appears rather in the nature of a reluctant concession to the popular fashion. One can almost visualise the attitude of both *The Queen* and *The Gentlewoman* to such 'persons' in the stately figure of a Victorian *grande dame* of majestic dignity, drawing in tightly her sweeping skirts of stiff silk, and looking down, with aristocratic and awe-inspiring mien, through her gold-rimmed lorgnette at the insignificant shabby figure with a portfolio

under his arm. Such people must be kept in their place! Both papers have by now become of historical value as reflections of certain aspects of the social life of the time.

MADAME

This was a later and much more modern form of the ladies' paper, which relied mainly for its illustrations on the work of the photographer. Its first appearance was made on 21 September 1895, and its principal claim to inclusion in this record of the period is supplied by the small initials and decorations designed by Edgar Wilson, Leslie Willson and Charles May, which certainly brightened its pages. These were in the first case artistic, in the second effective and in the last ingenious. In the earlier numbers of the paper Chris Hammond, G. Demain Hammond, Oscar Wilson, A. Jule Goodman and Reginald Savage, contributed pleasant drawings, some of which were reproduced in black-and-red. Very soon, however, the small number of drawings was reduced and their place taken by photographs.

BLACK AND WHITE

With a delicate grey cover and an excellent list of contributors *Black and White* first appeared on 6 February 1891. As usual, most of the reproductions were at first wood-engravings, but Linley Sambourne contributed a beautiful line medley, inspired by the paper's title. Harry Furniss described and illustrated the parliamentary doings of the week, and J. F. Sullivan also appeared as writer and artist. Some drawings of the opera 'Ivanhoe' by Reginald Savage and Charles Ricketts introduced two unusual contributors to illustrated journalism, as did also a fine design by G. F. Watts of 'The Recording Angel',

which was afterwards often used as a badge on many of the paper's publications. William Hatherell, W. H. Margetson, Holland Tringham, William Rainey with some good story illustrations in line, Paul Hardy, Frank Feller and J. Finnemore (military uniforms and fencing) were regular and more conventional contributors. George du Maurier illustrated a story, and Hugh Thomson did three fine jovial drawings to 'St. Valentine's Day', S. J. Solomon a pen-drawing of the persecution of Russian Jews, and Sir Frederic Leighton six illustrations. Edgar Wilson supplied some of his delightful pen-decorations, and Charles Ricketts a drawing, rather confused in design, which would have been better for simplifying. Borough Johnson had a good double-page of a Salvation Army subject, and F. H. Townsend a spirited pair of a fancy-dress dance and a street dance, both spoilt by engraving. H. C. Seppings Wright, Frank Calderon and W. S. Stacey were other competent contributors. Gordon Browne illustrated a short story, Everard Hopkins made one of very many drawings of a Royal drawing-room, and P. Tarrant some good half-tone illustrations. Theatrical drawings were supplied by F. H. Townsend, and a steeple-chase provided a subject for G. D. Giles. E. F. Skinner illustrated 'Ancient Tales and Legends', and Amy Sawyer 'The Lost Princess'. W. B. Wollen, H. B. Wilson, Enoch Ward, W. Rainey, Stanley Berkeley, A. C. Corbould and S. T. Dadd were other competent contributors. L. Raven-Hill had some interesting impressionist pen-drawings of London omnibuses, and Walter Crane a fine design in line. J. F. Sullivan illustrated his own poem, and Fred Villiers, the war-correspondent, recorded the funeral of Earl Granville. Reginald Savage contributed a drawing to the series of 'Ancient Tales and Legends', and E. F. Brewtnall, Mrs. Stanhope Forbes and Maurice Greiffenhagen did some excellent work. The disastrous effect that bad wood-engraving can produce is seen by comparing the two Phil May drawings of 'L'enfant prodigue'. Later he contributed some Newmarket notes which were much more successful, especially the second set. J. H. Bacon did some half-tone illustrations, and Amy Sawyer a

good wood-engraved subject drawing. G. P. Jacomb-Hood, William Parkinson, Charles Wilkinson (ships), Frank Calderon (horses), John Beer (the Derby) and Stanley L. Wood were later contributors. Charles Ricketts had an illustration to a Swinburne poem, Fred Barnard a double-page medley of Henry Irving in about forty characters, and C. H. Shannon a drawing of the building of the Tower Bridge. Dudley Hardy contributed some illustrations, and Walter Osborne, the Irish artist, some pleasant landscapes of the Curragh; William W. Collins did a wash drawing of Chelsea Hospital, Fred Hall some caricature portraits of Newlyn artists, and W. Hennessy some loose, colourful pen-drawings, rather in the manner of Fred Barnard. These all make up an impressive list of items in what was certainly a very distinguished first volume.

In 1892 we have Paul Hardy, Stewart Browne, Adolph Birkenruth and James Greig as new contributors, Bernard Partridge, with a wash-drawing, some more Newlyn caricatures by Fred Hall and topographical drawings by H. P. Burke Downing. S. Begg did many drawings of football, a very homely Wimbledon meeting, and theatrical plays, in a looser manner than some of his later more photographic work. Linley Sambourne showed Britannia welcoming the German Emperor, and Raven-Hill had a wood-engraved page, 'After the Theatre', and some good drawings for an article about cabs. Wal Paget and William Hatherell did some excellent illustrations, and Holland Tringham made some effective drawings on grey 'scratch paper'. René Bull, G. Greville Manton, F. G. Kitton, W. Rainey (some good types of election orators) and A. Jule Goodman were well represented. D. Y. Cameron had some drawings of Edinburgh, some in half-tone and some in line; G. D. Hammond, George Hutchinson and John Gülich story illustrations, and Cecil Aldin some hunting subjects and drawings of Smithfield.

In 1893 we notice the general tendency of these papers to neglect their early artistic sympathies in favour of a more prosaic record of events. Art was limited to very excellent engravings of paintings and illustrations to stories. Most of the draw-

79

ings were of news subjects, but Miss E. Œ. Somerville illustrated 'Beggars on Horseback'. There were some good Gülichs in the Christmas number and some impressions in colour by C. E. Fripp of life in Japan. In 1894 the war between China and Japan was pictorially reported by Ernest Prater and Fred Villiers, and Miss Somerville continued her illustrations of the riding tour. James F. Sullivan reappeared, and George Roller and Oscar Eckhardt contributed drawings. Begg was gradually approximating to the photograph. In 1896 we have Charles M. Sheldon representing the paper in the Sudan campaign and René Bull acting as war-correspondent in Constantinople, several of their sketches on the spot being reproduced in facsimile. J. Greig also sent drawings from Paris. Two artists working in the same medium—wash—show the two opposite extremes in method, Adolf Thiede with tight, carefully finished drawings, and W. Dewar with much looser and more interesting results. John Bacon, Walter Wilson of *The Illustrated London News* and Albert E. Sterner, a delightful draughtsman, also contributed. In the Christmas number D. A. Wehrschmidt (a pupil of Herkomer), Maurice Greiffenhagen and J. Watson Nicol did story illustrations, and J. A. Shepherd depicted Christmas at the Zoo. In 1897 René Bull was among the Afridis, and Charles M. Sheldon also sent war drawings from the Dargai heights. F. H. Townsend had some fine wash-drawings, particularly in the Christmas number, to which Albert E. Sterner, Fred Pegram, Maurice Greiffenhagen and A. S. Boyd also contributed.

W. Dewar had a fine double-page of Goodwood in 1899—broad, dashing impressionist treatment—and Raven-Hill another, 'From country field to Covent Garden'. C. M. Padday, A. S. Hartrick, Arthur Garratt (working in body-colour or oil) and Harold Copping all sent good contributions. 'Rip' did some cartoons and skits on affairs in South Africa, where the energetic René Bull was acting as special correspondent, and A. S. Forrest some country sketches. Nor was cricket neglected, for Ernest Prater had a drawing of the Test Match at the Oval, in which the two batsmen are running with only one pad each. Although

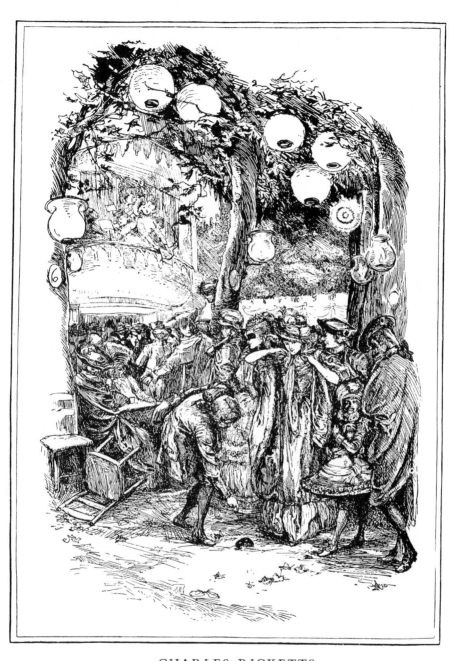

35. CHARLES RICKETTS

'Vauxhall 17—', from *Black and White*, 28 February 1891

36. HOLLAND TRINGHAM

'Balliol College', from *The English Illustrated Magazine*, November 1893

By courtesy of Edward Arnold and Co.

this was thirty-five years ago, I refuse to believe that either the English or Australian captain would have allowed his men to go in so incompletely equipped. To the Christmas number S. H. Sime supplied the title-page, and H. R. Millar, L. Raven-Hill, Cecil Aldin and Tom Browne contributed illustrations, the two last in colour. In the 1900 volume A. S. Hartrick, S. H. Vedder, L. Daviel (fine pen-work) and Arthur Garratt were well represented. Fred Pegram with some good line-drawings, E. J. Sullivan, not so successful in wash, and F. H. Townsend, equally efficient in both mediums, contributed to the Christmas number.

For some reason *Black and White* gradually declined in popularity and was afterwards absorbed into *The Sphere*. Throughout its career it maintained a high standard both on the literary and artistic sides, and having regard to its excellent contents, it is very difficult to account for its failure to survive. The list of contributors to the first volume is almost unprecedented in excellence. Perhaps it over-estimated the appreciation by the public of such good fare, or perhaps the early enthusiasm which prompted it evaporated, as it so often did in other similar instances. In any case *Black and White* will always occupy a very high position in the records of illustrated journalism of the period, and some of the early volumes are well worth keeping for this reason. It must also be counted as something of an achievement to have enlisted Ricketts, Shannon and Watts into illustrated journalism.

CHAPTER III

SOME OTHER ILLUSTRATED WEEKLY PAPERS

THE SKETCH

This vigorous offspring of *The Illustrated London News* first saw the light on 1 February 1893. Described as 'A Journal of Art and Actuality', it proposed to deal with the events of the day in a more lighthearted way than its dignified parent. It was well equipped with some excellent and attractive cover designs by Linley Sambourne and a large and varied list of contributors, assisted by some of the artists from the older paper. Melton Prior, Caton Woodville—masquerading in lighter vein as 'Villedebois'—Seppings Wright, J. Walter Wilson and Raymond Potter all helped at the start to set the youngster on its legs. Frank Lockwood also contributed sketches and there was an appreciation of Sydney P. Hall as a 'famous war-sketcher'. Dudley Hardy was one of the most regular illustrators, with a great variety of subjects, a leaning to the production of fascinating and frivolous girls and experimental methods largely influenced by the Frenchman Chéret. L. Raven-Hill, J. Bernard Partridge, and Phil May were other stalwarts who gave of their best, finding the size of the full page conducive to greater freedom and variety of treatment. John Proctor produced the 'Cartoon of the Week' in the traditional manner, and James Proctor contributed small sketches of sporting subjects. James F. Sullivan, Harry Furniss, Leslie Willson and Louis Wain were other contributors who were also already well known. Ernest Goodwin ('Gee'), one of the many followers of Phil May, illustrated the humours of football; Edgar Wilson contributed some of those charmingly decorative fantasies in line which were

84

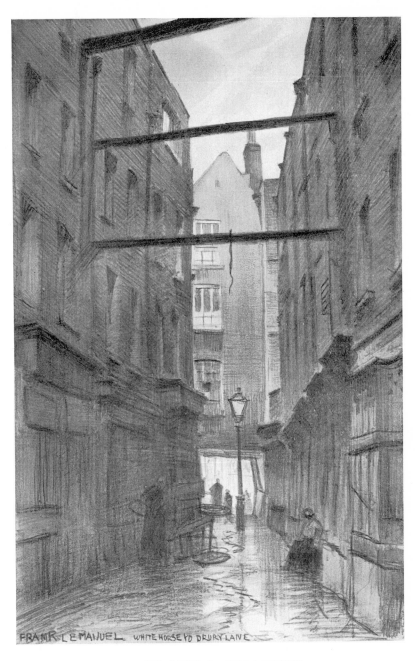

37. FRANK L. EMANUEL
Lead-pencil drawing. Original $9'' \times 5\frac{3}{4}''$
By courtesy of the Artist

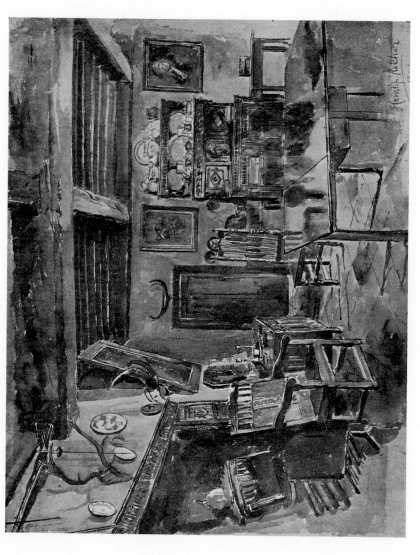

38. HANSLIP FLETCHER
'Kitchen, Ystumllyn'. Unpublished wash-drawing, 1896
Original $10\frac{1}{2}'' \times 13''$
By courtesy of the Artist

never fully appreciated; and C. A. Shepperson's drawings were full of that promise which was afterwards fulfilled and later earned him admission to associateship of the Royal Academy. A. J. Finberg, who became the well-known art critic and authority on Turner, had some slight pen-drawings, and Starr Wood, R.A.B. (Brownlie) and 'Crow' were others who contributed to the successful start of the new venture. Some of the drawings were certainly poor and 'cheeky', and full advantage was sometimes taken of the generous freedom allowed to artists, a freedom reminiscent of the policy of the earlier *Pick-Me-Up*. As an example of the joke of the period we may quote the unpardonable lines under an excellent drawing by Phil May, who was probably not responsible. 'Why do they call 'em Primmer Roses?' ''Cos they're growed by Primmer Ministers'. We have certainly advanced in this respect since then. The volume consisted of three-monthly issues, and as this began in February, the four volumes did not quite coincide with the year of the almanack.

In volume two, which began in May, E. T. Reed had some excellent studies of 'Legal Expressions'. Robert Sauber, Oliver Paque of *The Daily Graphic*, Cecil Aldin, Lance Thackeray and Frank Chesworth made first appearances, and there is a drawing by George Cruikshank. In the issue for 21 June is a mysterious page of sketches attributed, I think erroneously, to Phil May. They bear no evidence of his handiwork and must have been done by one of his many imitators, although his name is printed below them. Volume three contains work by F. H. Townsend, Sydney Adamson, Adolph Birkenruth, W. Douglas Almond, and Louis Gunnis, none of which calls for special mention, and in volume four are some portraits and theatrical sketches by R. Ponsonby Staples. Volume five has a first contribution from John Hassall, whose drawings were later to become a very regular feature. Fred Hall, robust and bucolic, and Jack B. Yeats were two other humorists who appeared fairly frequently. On 25 April Bernard Partridge produced an excellent portrait of Bernard Shaw. In volume six we find Herbert Railton and Hol-

land Tringham, whose topographical line-drawings bear so much resemblance to one another, and found their way into every paper and magazine of the period. Both men produced delightful vignettes of architectural or landscape subjects, which combined accurate representation with deft and decorative treatment. To some extent they took the place that Birket Foster held in the sixties, although neither had his variety and power of expression. John R. Reid, a capable draughtsman of landscape, James Greig and Caton Woodville (undisguised), with military studies, figure in volume seven. Three other interesting recruits were Frank Craig, Gilbert James, with decorative drawings of poetic subjects, and Thomas Downey, a pupil of Alfred Bryan of *The Sporting and Dramatic News*. In successive volumes we find work by Lewis Baumer, Gunning King, who later contributed some masterly studies of rural life and character, Frank Richards, Oscar Eckhardt, Hounsom Byles, Maurice Greiffenhagen (in chalk and wash), S. H. Sime, Harry B. Neilson (comic animals), Edward Read (diluted Dudley Hardy), Oscar Wilson and Leslie Willson, Charles Pears, working on tinted erasing paper, Malcolm Patterson (very conscientious pen-drawings), Hilda Cowham, who popularised children with thin, black legs, A. Campbell Cross, H. C. Sandy, fantastic in jokes and drawings, and Oates Whitelaw, with designs of variegated patterns. All these were additional to many of those whose names have been already mentioned, so that readers could not complain of lack of variety.

Gradually the photographs, as usual, began to crowd out the drawings, which were confined later to four pages, entitled 'The lighter side of nature,' and even these were sometimes reduced to one. Towards the end of the period David Wilson, who afterwards became cartoonist for *The Daily Chronicle*, Howard Somerville, now a distinguished painter, 'Rip' (Rowland Hill), who later did some excellent cricket portraits and illustrated *Truth* Christmas numbers, A. S. Forrest, who derived much from May and the Beggarstaffs, and Rossi Ashton, a contemporary of Phil May on *The Sydney Bulletin*, were represented.

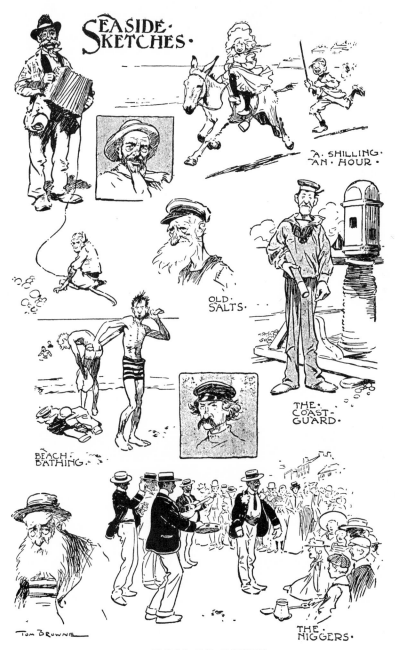

39. TOM BROWNE

'Seaside Sketches', from *The Sketch*

40. CHRIS HAMMOND

From *The Sphere*, 24 February 1900

If *The Sketch* did not produce any great additions to the sum of black-and-white art, it certainly afforded great scope for such brilliant exponents as Dudley Hardy, Phil May, Raven-Hill, S. H. Sime and Gunning King, and helped to develop the powers of many of the younger artists of whom later Tom Browne and John Hassall made perhaps the fullest use of their opportunities. It also introduced a more frivolous and joyous outlook on the affairs of the week and gave the British public full measure of one of its great joys—the theatrical portrait.

ST. PAUL'S

St. *Paul's* began in March 1894 as a monthly production with a slightly ecclesiastical flavour. Its principal artistic contributors were the two sisters, Chris and G. Demain Hammond. Both were water-colour artists and accomplished illustrators, with a deft manipulation of the pen, somewhat influenced by the work of Abbey. In addition to their work in newspapers and magazines, they illustrated many books. Chris was perhaps the more popular, but many of her figures—particularly the women —were spoilt by disproportionately small heads, and her sister was the more skilful draughtsman. In the field of black-and-white art they were at that time certainly the most distinguished members of their sex. L. Raven-Hill and Paul Hardy also appeared, but under the heartless treatment of the wood-engraver their work was almost unrecognisable. There were some very good reproductions of etchings by Edgar Wilson. The April number contained some sound drawings by H. P. Burke-Downing rather in the manner of Herbert Railton and Holland Tringham. In the May issue R.A.B. (Brownlie), R. Sauber and Oscar Eckhardt contributed, G. D. Hammond illustrated a serial story, and there was an appreciation of Phil May's work with a drawing of a monk, 'Choosing a Crucifix'. In June *St. Paul's* became a weekly paper with some intelligent art criticism,

articles on 'Leaders in black and white' and theatrical photographs. J. F. Sullivan, who in the earlier numbers had suffered badly from the wood-engraver, now appeared to greater advantage in half-tone, Edgar Wilson supplied some delightful little decorative headings, Dudley Hardy some thumbnails illustrating 'The world and its doings', and A. C. Corbould some drawings of the Military Tournament. Phil May illustrated the first article of a series, 'The Londoner's Sunday', with eight excellent drawings in Petticoat Lane, but unfortunately these were never continued. D. Macpherson, R. Sauber, Adolph Birkenruth and Reginald Savage—good in technique but weak in drawing—also contributed. The diverse character of the contents may be judged from the fact that notes on a stud sale and 'Chat of the churches' were printed on opposite pages. In July René Bull and Fred Hunt appeared, and there were some very 'cheeky' drawings by R.A.B. Much of this artist's work in line was distinctly weak, and it is difficult to account for his popularity among editors. Hal Hurst, Oscar Wilson, James Greig, Leslie Willson and G. Smetham-Jones, with some strong realistic pen-drawings, contributed to the August numbers.

Volume two began in September with a skittish design in black-and-red of 'Lady Kitty' on the cover. This character in various guises appeared as a regular feature for some time afterwards. Ernest Goodwin—a very diluted Phil May—'Luna', whose work closely resembled that of Hal Hurst, J. Jellicoe and Alick Ritchie contributed drawings. There were many reproductions of French artists—Forain, Gerbault, Steinlen and others —some coloured plates of flighty ladies by Dudley Hardy and an appreciation of Linley Sambourne with a typical drawing of Britannia. In 1895 A. Jule Goodman did some stage portraits in black-and-red. These were drawn with a sympathetic touch in chalk or pencil and were in many instances good. There were also contributions by B. E. Minns—loosely handled pen-drawings—C. H. Taffs, John Hassall and Starr Wood, and a portrait study of the Beggarstaffs—William Nicholson and James Pryde —by Phil May. L. Raven-Hill was discussed in an appreciative

article with reference to a forthcoming exhibition of his work. Some indifferent double-page war drawings were contributed by Frank Feller. In succeeding volumes C. A. Shepperson, Max Cowper and A. S. Forrest appeared, and Dudley Hardy made some more of his dashing drawings in black-and-red. Few illustrators of the time used the two colours with such restraint and success as Hardy, and although the drawing was sometimes weak, there was a sureness and abandon about the designs which made them far more attractive than those of more accurate draughtsmen. The same qualities were evident in the striking poster designs which he was producing about this time. By 1899 the paper had lost much of its original character. Reginald Pannett instead of Hardy was doing the Lady Kitty drawings on the cover, the South African war monopolised much of the public attention, and photographs, with reproductions of cartoons and drawings from other papers, took the place of original drawings.

Starting with distinct promise and a sympathetic policy towards matters connected with art, *St. Paul's* gradually declined in quality and individuality, and as a natural consequence quietly disappeared early in 1900.

THE NEW BUDGET

On the sudden, unexpected and much regretted demise of *The Pall Mall Budget* Harry Furniss, who had left *Punch* in the previous year, rushed in with hurried and insufficient preparation to take its place with *The New Budget*. The first number, which incorporated a previous unsuccessful Furniss venture called *Lika Joko*, appeared on 4 April 1895. Hugh Thomson's three drawings and heading for the 'Ballad on a wedding' were sufficient in themselves to justify the new publication. In addition there were contributions by F. H. Townsend, J. Bernard Partridge, A. C. Corbould, Lewis Baumer, Balliol Salmon, Gordon Browne and René Bull. The humorous drawings appeared to-

gether in a section called 'Folly as it flies'. Furniss himself contributed many hurried drawings with fancy signatures, such as 'A. S. Cribble', 'A. Newman', 'J. Owen', 'W. Kayess', 'Lika Joko', etc. Unfortunately one of these was done in very poor imitation of Phil May's work and was signed 'Phil Mace' in such a way as to deceive all but the initiated. May and *Punch* naturally protested, and Furniss was compelled to make an undignified apology. A photographic print of the interior of the House repeated each week, with a few parliamentary figures introduced by the artist, was another foolish attempt to take advantage of his readers, and there is little doubt that these irresponsible actions seriously prejudiced the future of the paper. Despite the excellent work contributed by those artists already mentioned and by E. J. Sullivan, A. S. Hartrick, G. D. Armour, W. F. Thomas, Adolph Birkenruth, Sydney Cowell, Jack B. Yeats, J. F. Sullivan, Frank Chesworth, Fred Pegram, C. H. Taffs and J. Hassall, *The New Budget* ceased publication on 30 October in the same year as its birth. In the seven months of its existence Furniss had certainly collected a very distinguished band of artistic collaborators, and there is little doubt that with more editorial restraint and discretion the paper might have filled successfully the distinct gap left by the passing of *The Pall Mall Budget*. Its brief career was undoubtedly distinguished, but it was all too breathless, and there was perhaps too much Furniss. Its predecessor, *Lika Joko*, whose existence seems to have completely eluded the vigilance of the British Museum authorities, was modelled more on the lines of *Punch*, but only lasted for six months. It contained some good work by Fred Barnard, G. Rossi Ashton, Jack B. Yeats, J. F. Sullivan, René Bull, W. F. Thomas, A. C. Corbould, J. Bernard Partridge and Gordon Browne.

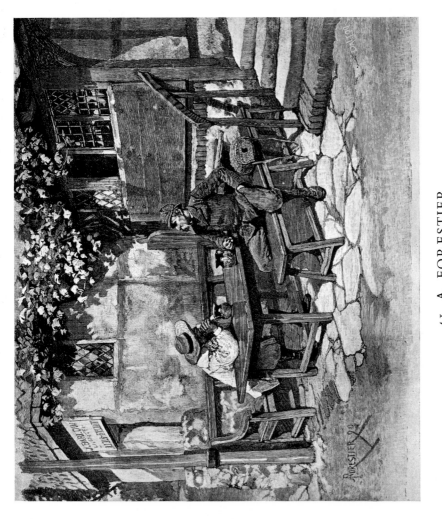

41. A. FORESTIER

Story illustration : wood-engraving from *The Illustrated London News*,
Christmas Number, 1890

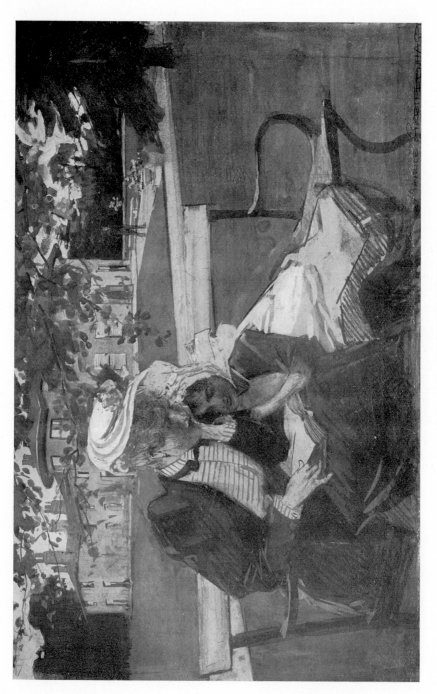

42. MAURICE GREIFFENHAGEN

Story illustration in wash, body-colour and chalk. Original 9″ × 14″

By courtesy of Charles Emanuel

THE UNICORN

Another short-lived effort, even more brilliant, was made by L. Raven-Hill with the publication on 11 September 1895 of *The Unicorn* at the low price of threepence. With a wonderful artistic staff which included all that was best in the *Butterfly*—Phil May, F. H. Townsend, Oscar Eckhardt, Max Beerbohm, Maurice Greiffenhagen, J. W. T. Manuel, Lewis Baumer, S. H. Sime, G. D. Armour and the worthy editor himself—it should have been assured of a certain measure of success. But, alas, only three numbers appeared, and *The Unicorn* passed into the limbo of good intentions.

FUN

Founded in 1860, *Fun* was taken over by the Dalziel brothers in 1870 and remained in their possession until 1893. Some of its early contributors were Arthur Boyd Houghton, Fred Barnard, Hubert Herkomer and George Pinwell. Thus it forms another link between the sixties and the nineties. In 1890, when our survey commences, the cartoonist was Gordon Thomson, a capable draughtsman with a pleasant style, rather like Fred Barnard's, an adequate power of portraiture without caricature and an effective method of presenting his ideas which, however, lacked force. J. F. Sullivan contributed a page of pictorial satire, T. Frederic Catchpole presented social subjects, and George Gatcombe illustrated the theatres and drew pretty girls. The two Irish brothers G. G. Fraser and F. A. Fraser (horses and hunting), Matt Stretch and J. H. Houghton completed the regular staff. F. A. Fraser was a survival from the earlier period of the sixties and a successful book illustrator. Other contributors were J. Leighton, J. Dimsdale, Fred Roe, Hal Hurst, A. T. Clarke, 'Kyd', A. J. Finberg and Percy Reynolds. In the Almanack were Fred Pegram, Hal Hurst and F. H. Townsend. In 1891 H. R.

Millar and G. C. Glover appeared, and Maurice Greiffenhagen contributed to the Almanack. 1892 brought Will True, who afterwards did poster designs, Phil Ebbutt of *The Daily Graphic*, Victor Venner, Starr Wood and Sydney Adamson. Most of the drawings were in line and very competent.

In 1893 Gordon Thomson went, and Wallis Mackay did the cartoon for some time. He was followed by an artist who signed his drawings with a jester's cap and bells and he, in turn, by another with the initials A.L.T. In the same year Max Cowper and J. H. Roberts, more humorous than artistic, contributed. In April 1894 John Proctor took over the drawing of the cartoon. Proctor was one of the best cartoonists of the time, with a fine bold method of using a pen and a good sense of design. In 1895 came Frank Gillett, another recruit from *The Daily Graphic*, Tom Wilkinson, like many of the other young contributors very much under the influence of Phil May, P. B. Hickling, 'Blot' and 'Quibus'; and in 1896 Malcolm Patterson, with some very sound and conscientious drawings. G. Welby Wilkinson, T. E. Donnison, whose Irish nationality was reflected in the faces of his characters, W. R. Spurrier, and Frank Watkins contributed in 1897, and in the next year H. L. Shindler, M. Clarkson, S. R. Blyth, Coleman Hicks and W. R. Cooper appeared. At the end of February 1898, J. Proctor ceased drawing the cartoons and his place was taken at various times by F. A. Fraser, J. Welby Wilkinson, William Duane and Matt Stretch, with varying but not powerful degrees of success. None of these possessed the qualities that make the good political cartoonist—a strong simple method of drawing, a plain and easily intelligible statement of the idea without distracting accessories, recognisable portraiture and, above all, a personal interest and enthusiasm in politics. It is this last quality which is so often lacking in the artist's mentality. Without it the cartoon lacks power of conviction; with it, as for example in the work of F. C. Gould, many faults in drawing and technique may be overlooked, provided the message is successfully conveyed. It is interesting to notice that on 24 January—thirty-five years ago!

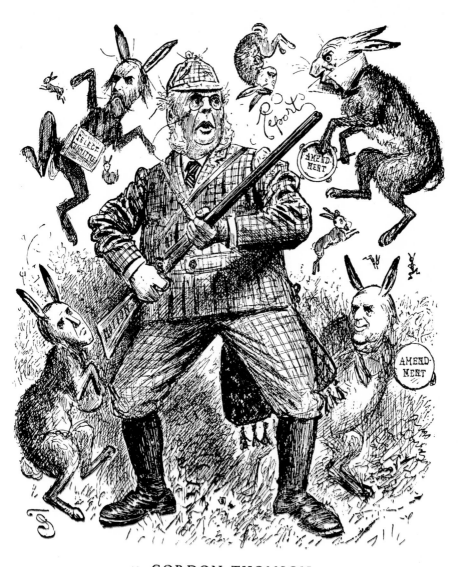

43. GORDON THOMSON

'March Hares': Cartoon from *Fun*, 5 March 1890

RETREAT?

44. JOHN PROCTOR

Cartoon from *Fun*, 24 August 1897

—appeared a cartoon on the subject of disarmament, and in this year of grace the world's statesmen are still grappling with the same problem. H. C. Sandy, A. T. Smith and W. D. Davis contributed during this year, and C. A. Mills and Berte Livett in 1900. In January 1901 *Fun* passed into the hands of George Newnes, and in July was transferred to Charles Shurey, the proprietor of *Sketchy Bits*.

With its early reputation and its competent performance in the first few years of the nineties, *Fun* should have had a larger success. There was much excellent work in its early volumes, but it probably lacked the central attraction of a good regular cartoonist. Gordon Thomson was adequate and John Proctor was excellent so long as they were working regularly, but there were long intervals when the substitutes were not good enough for the job. In those days more general interest was taken in politics, and a powerful weekly cartoon was a very great asset. Even in these commercial days, when parliamentary affairs have lost much of their appeal for newspaper readers, the good cartoonist is recognised by the most prosaic board of newspaper directors as a very valuable and attractive contributor. *Fun* failed probably from lack of this focus, and also because from the competent ranks of its contributors there never arose any outstanding personality.

JUDY

Judy was founded in 1867, another of the many attempts to attract some of the success of *Punch*. Five years later it was acquired by the firm of Dalziel Brothers and in 1888 came under the personal direction of Gilbert Dalziel. Gilbert Dalziel was another of those intelligent proprietors who treated his contributors as competent fellow-workers and friends and reaped the natural result of their loyal and wholehearted support. Among the regular artists in 1890 were A. Chasemore, Maurice Greiffenhagen (line-drawings), William Parkinson, Fred Bar-

nard, J. Bernard Partridge, Fred Pegram and Charles H. Marshall, who drew hunting subjects in which the horses were rendered more successfully than their riders. The double-page cartoon was drawn by Hal Ludlow—another example of the draughtsman who was not a cartoonist. His portraiture was good, but the treatment lacked the broad, simple virile method necessary for success and the result lacked conviction. Alfred Bryan illustrated the theatrical article, 'The Call Boy', and contributed political caricatures, all distinguished by his wonderful gift of presenting an immediately recognisable likeness to the original. Fred Barnard did some excellent character studies in masterly pen-work. Other contributors were Alfred Gray, T. Frederic Catchpole, W. F. Thomas, who worked more regularly for *Ally Sloper's Half Holiday*, H. R. Millar and J. B. Clark. In May William Parkinson became cartoonist, and although his portraiture was not very strong, his style, influenced apparently by that of Linley Sambourne, was certainly more suited to the purpose. This was undoubtedly a strong list of contributors, and for some years *Judy* contained some very excellent work, notably from Greiffenhagen, Partridge, Millar and Pegram, who about this time did some of his finest drawings.

Later came Shirley Hodson, Wallis Mackay and G. Smetham-Jones, who did some good illustrations to horsey subjects. F. H. Townsend's first contributions were very freely treated but were not as well drawn as his later work. In 1892, to celebrate the completion of the twenty-fifth year, a facsimile of the first number was presented and showed how far drawing and reproduction had advanced. In 1893 Leslie Willson, Ralph Cleaver and R.A.B. (Brownlie) were added to the list of contributors, and the next year A. S. Forrest and F. A. Fraser from *Fun*. In 1895 the make-up was changed, with clearer spacing and the use of a yellowish paper. Tom Wilkinson, Jack B. Yeats—brother of the famous Irish poet and an original humorist—'Yorick', Starr Wood, John Hassall and Fred Roe contributed during the year. Fred Barnard had a large cartoon in the Christmas number. By 1896 the quality of the drawings had very much depreciated and

45. MAURICE GREIFFENHAGEN

'A Sweeping Criticism', from *Judy*

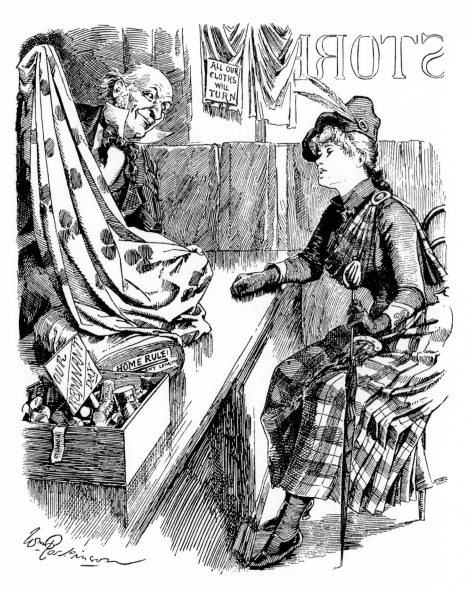

46. WILLIAM PARKINSON

Cartoon from *Judy*, 29 October 1890

many of them were decidedly poor. Greiffenhagen, Townsend and Pegram had gone, and a 'Weekly Blot Competition' was introduced! The glory had indeed departed. Fortunately, A. Bryan still remained, but R.A.B. (Brownlie) was attempting the rôle of cartoonist in succession to Starr Wood and indeed appeared to be the pervading influence of the paper. An inevitable suspicion has been confirmed by a contemporary contributor. R.A.B. *was* the art editor! G. Henry Evison and Charles Pears also appeared. In 1897 J. H. Houghton returned as cartoonist, but later R.A.B. and then William Parkinson followed him. Hutton Mitchell and Sydney Aldridge contributed drawings, but a comparison with the earlier volumes was pathetic and tragic.

In 1898 Bryan had gone and Thomas Downey had taken his place. 'Poy' and Scotson Clark in turn did the cartoon, but both were weak in drawing and were eventually succeeded by Downey. Louis Wain, Fred Sedgewycke, Popini (decorative drawings with a variety of textures), H. L. Shindler, Wallis Mills and Frank Gillett also contributed. In 1899 Harry Parkes and later C. Fleming Williams, the latter very much under the influence of Dana Gibson, did the cartoons, and Frank Reynolds made an appearance with some strong drawings. In 1900, under the editorship of De Marney, Reynolds contributed regularly with a success which carried him on by way of *The Sketch* to *Punch*, of which he became later a member of the staff and in 1921 art editor in succession to F. H. Townsend. H. R. Millar also returned to strengthen the artistic side, and F. Lynch contributed interesting portraits in half-tone. Berte Livett, Harry Hudson ('At the Play') and Frank Holland also assisted.

At this distance of time and without inside knowledge, it is difficult to account for the sad decline in the fortune of *Judy*. Between 1890 and 1894 it was an excellent production with a list of artists almost equal to those of *Punch*. Afterwards, when Dalziel sold it, it fell away badly, probably from lack of his directing influence, although in 1900 it shewed signs of regaining some of its former prestige. Perhaps it will be remembered for those ex-

cellent pen-drawings by Maurice Greiffenhagen in the earlier years, which included some of the finest work of that very capable artist.

MOONSHINE

Founded in 1879, *Moonshine* had by 1890 reached its twenty-first volume. The dominating influence was Alfred Bryan, who each week drew a double-page cartoon, a page drawing, 'Days with Celebrities', and two or three smaller illustrations. It should be remembered that in addition to this work he was regularly doing six or seven drawings for *The Sporting and Dramatic News*, several for *Judy* and occasional contributions to other papers. Three of Bryan's pupils, Horace Morehen, T. Downey and J. A. Shepherd, were also regular contributors, so that the paper had the appearance of a family affair. For the same reason there was little room remaining for other artists, and *Moonshine* in consequence, although interesting, suffered from a somewhat monotonous sameness. Shepherd was beginning those remarkable humorous drawings of animals which were followed later by the famous 'Zigzags at the Zoo' and acquiring a pre-eminent mastery of his own particular line of work. These early drawings, although excellent and full of well-observed character, did not yet show that freedom of line which characterised his more mature productions. Considering the perfect accomplishment of his draughtsmanship and his fine sense of design and humour, it is strange that Shepherd has never received the full acknowledgment of his position as one of the great masters of English black-and-white art. Certain it is that his work will always be recognised by the discerning as that of a very distinguished and original artist.

Among the few other contributors were Matt Stretch and Dower-Wilson in 1891 and J. Atkinson of *Punch* in 1892. In 1893 Louis Wain replaced Shepherd, and exemplified the difference between the one who produces by recipe and the other

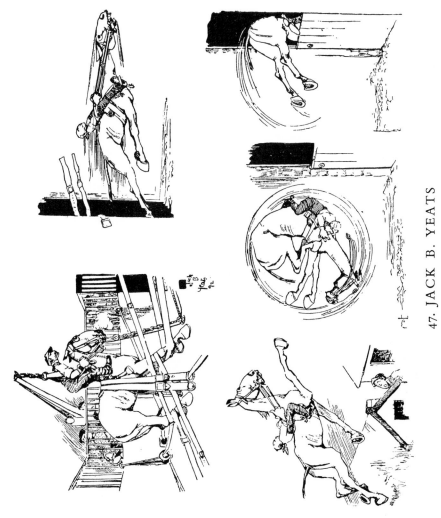

47. JACK B. YEATS
'The Demon Horse', from *Judy*, 1892

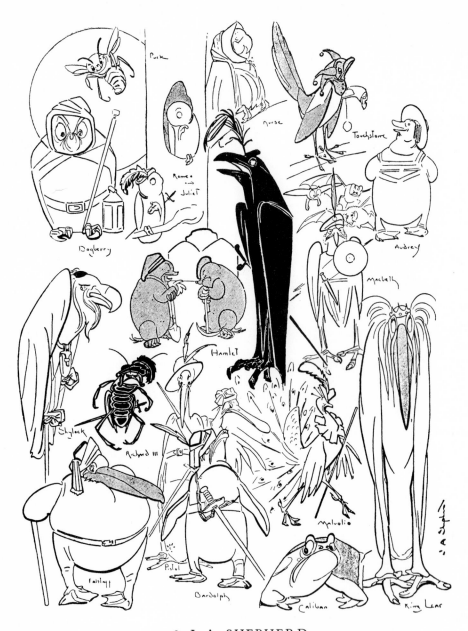

48. J. A. SHEPHERD

'A Midsummer Night's Dream', from *Punch's Almanack*, 1899

By courtesy of the Proprietors

who works by inspiration and close observation. In 1895 John Hassall did many drawings in bold line which introduced the newer and simpler methods derived from Phil May. In 1896 appeared T. E. Donnison with drawings of monkeys, and Hilda Cowham with fantastic impressions of children. In 1898 came G. L. Stampa, who since 1895 had made occasional appearances in *Punch*, and H. C. Sandy. In May of 1899 Alfred Bryan died at the early age of forty-seven, and his passing was a severe loss not only to *Moonshine*, of which he was the central figure, but also to many other papers to which he contributed. His place as cartoonist was adequately filled by John Proctor, and Horace Morehen supplied the theatre drawings with less success. The character of the paper was much changed, and in 1900 we have a distinctly modern production with contributions by John Hassall, A. S. Forrest, Tom Browne and Howard Somerville. Of the older men J. Atkinson still survived. If *Moonshine* had no very sensational career, it was always interesting and will be remembered if only for the work of Alfred Bryan and his more brilliant pupil J. A. Shepherd.

ALLY SLOPER'S HALF HOLIDAY

Founded in 1884 under the auspices of Dalziel brothers, this was an essentially Victorian production (even in its title) whose humour to-day would be almost unintelligible. Its inspiration was derived mainly from inebriation, which has ceased to rouse laughter, and chronic financial embarrassment, which in these days is hardly a subject for mirth. Its central figure was a marvellously inspired invention of that clever journalist, C. H. Ross, of *Judy*. Ally Sloper was a tall, gaunt figure with a head like a large egg, an enormous bulbous and rubicund nose, an expression of benign vacuity, a pot belly, very thin legs and large feet. He wore generally a distended top-hat of Micawberish design, a high collar and a stock, but the rest of his costume varied

according to his immediate occupation and circumstances. His family included a very plump wife, a son, Alexandry, who was a miniature edition of himself, a dazzlingly beautiful daughter Tootsie, and Evelina, a scraggy niece. His *entourage* included the McNab and Iky Mo, whose names perhaps suggest their characters, the Dook Snook, an impoverished and bibulous peer, the Honourable Billy, Lord Algy (in love with Tootsie) and several fascinating girl friends of Tootsie, of whom Lardie Longsox will serve as a type. Their adventures at seaside resorts during the summer, and their visits to theatres and other more unlikely places in the winter, supplied the theme for the front-page cartoon. This was at first the work of a very great caricaturist and draughtsman, W. G. Baxter, whose merit, owing perhaps to the ephemeral nature of his subjects and the setting in which his drawings appeared, has never been fully appreciated. In addition to his ability as a draughtsman he had an excellent sense of character and humour, and used his pen with well controlled freedom. Joseph Pennell with characteristic enthusiasm calls him 'the most genuine caricaturist who has ever lived in England', but this is a well-meant exaggeration. Ally Sloper was perhaps the most original funny character, but the credit for his invention must be given to C. H. Ross. Baxter adopted him and developed his possibilities with great skill, but he did not create him.

In 1890 W. F. Thomas had succeeded to the tradition of Baxter, who died young, and although at first he was sometimes uncertain, he soon developed a technique which was little inferior to that of his predecessor. Very wisely he did not attempt to alter or develop the tradition he had inherited; he was content to continue it and did so very ably. In addition to the principal cartoon he also illustrated a half-page of drawings for 'Our Weekly Whirligig', a *résumé* of events of the week. In these he had a free hand to display his own personality, and many of them were extremely good. Thomas also contributed occasionally to *Punch* and other papers. A. Chasemore was another regular and skilful contributor who drew 'Fashion Fancies'

49. ALFRED BRYAN
The Prince of Wales (afterwards King Edward VII), from *Moonshine*,
19 December 1891

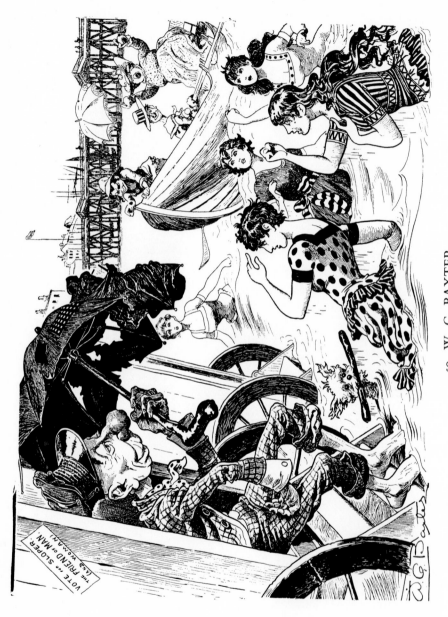

50. W. G. BAXTER.

Cartoon from *Ally Sloper's Half Holiday*

and illustrated imaginary interviews with distinguished people. He had a bold and simple style of humour and drawing and supplied theatrical costume designs, especially for Drury Lane. Hal Ludlow drew a weekly portrait of one of Tootsie's friends, and illustrations to the article about the theatres. All his characters, even the pantomime dame, were beautiful. George Gatcombe also supplied large numbers of drawings of fair ladies. The small portraits in the F.O.S. (Friend of Sloper) gallery were apparently the work of Alfred Bryan or of one of his pupils. William Parkinson was another regular and valuable contributor. Then there was the great army of the unsigned, some modest beginners who afterwards became famous, some unambitious workers who were content to draw a steady weekly income from this and many other similar papers. A pay-sheet of the time would probably reveal many surprises in the list of names of these unknowns.

A weekly feature, original in character and of mild Scottish humour, concerned the adventures of 'McNab o' that ilk'. This was the work of T. R. J. Brown, whose drawings I have not seen elsewhere. Maurice Greiffenhagen contributed charming little pen-drawings, but these were usually unsigned. The Christmas number was a distinct journalistic event, with twenty pages of boisterous humour, a double-page cartoon, which alone was worth the price of the whole, and an original song complete with words and music. And all for twopence! Starting with eight pages in 1890 the weekly number was increased in size to twelve pages by 1900, and the principal members of the staff continued to work regularly throughout that period.

That peculiar form of ignorant prejudice, then as now, very prevalent in this country, which refuses to see any artistic merit in a drawing that illustrates a frivolous or humorous subject, would quite fail to appreciate the excellence of *Ally Sloper's Half Holiday*. For its creative invention and original personality it deserves credit, especially in these days of helpless imitation and monotonous uniformity. It was essentially English and of its period, and this quality, although it entitles it to interest from

the point of view of history, is sufficient to account for its de-
cline and disappearance. Its humour, although perhaps occa-
sionally vulgar, was hearty and boisterous and in the English
tradition of Rowlandson. I know of one very small enthusiast,
at least, who looked forward excitedly each week for the appear-
ance of '*Sloper*'. But apart from all these qualities, and in spite of
the narrow prejudice mentioned, it contained much that was
artistic and excellent in drawing. It also served as a valuable
training ground for many young draughtsmen who afterwards
attained success in a wider sphere. Altogether *Ally Sloper's
Half Holiday* certainly justified its production, and added one
more item to the debt which English black-and-white art owes
to those discerning enthusiasts, the brothers Dalziel.

PICK-ME-UP

This lighthearted weekly paper made its first appearance on
6 October 1888, describing itself as 'A Literary and Artistic
Tonic for the Mind'. At first many of the drawings and much of
the humour were decidedly poor and old-fashioned, and it may
be said at once that L. Raven-Hill carried the paper to success.
As art editor he contributed a large number of the drawings and
used his knowledge judiciously in the selection of other artists.
Several of the best French draughtsmen sent work, including
Caran d'Ache, Gerbault, Guillaume and later Steinlen and
Willette. The editor in his drawings used various mediums—
pen and ink, wash or chalk—and was always interesting,
especially in the illustrations to Jingle's weekly theatrical criti-
cism. Edgar Wilson, whose decorations were later an important
feature, Bernard Partridge, Dudley Hardy, F. H. Townsend,
Albert Sterner, J. F. Sullivan and H. R. Millar were some of the
capable artists who helped in the early numbers. Phil May illus-
trated 'London Night by Night' and started the series of small
pen-portraits of celebrities which became famous under the title

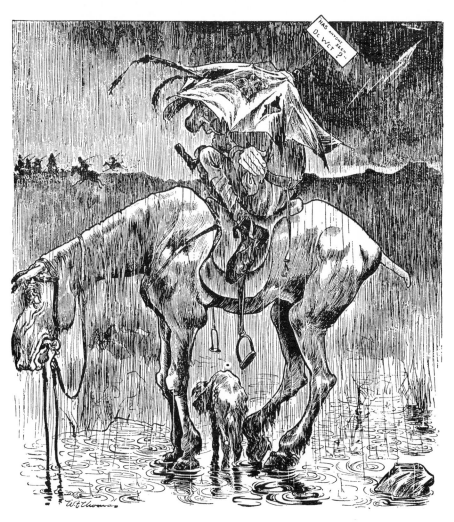

51. W. F. THOMAS

'Scenting De Wet', from *Ally Sloper's Half Holiday*

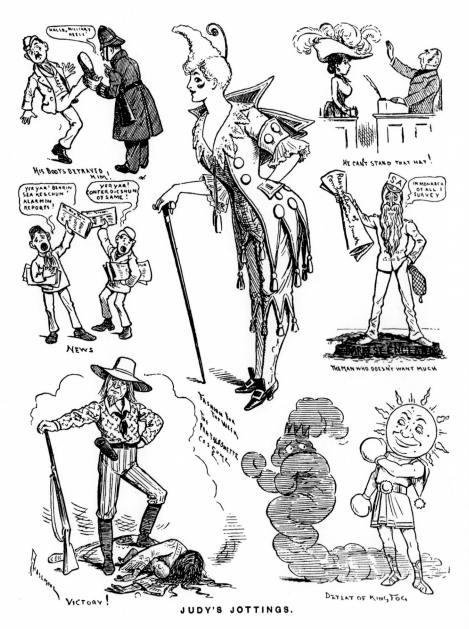

JUDY'S JOTTINGS.

52. A. CHASEMORE

Page from *Judy*, 14 January 1891

of 'On the Brain'. Leslie Willson appeared side by side with the German artist Schlittgen, from whom he derived much of his inspiration. George Roller experimented in wash, the sisters Chris and G. D. Hammond contributed charming pen-drawings, Max Cowper made a modest beginning, Shepperson tried to capture some of the verve of Dudley Hardy, and René Bull proved his capable derivation from the work of Caran d'Ache. Altogether it was a period of delightful youthful experiment, much of which came later to satisfactory fulfilment. Oscar Eckhardt was another artist of the French school; but H. R. Millar was more individual, and Percy Kemp, in his humorous treatment of cycling subjects, was uncompromisingly English and a little influenced by May.

In 1894 W. Dewar appeared with loosely handled skilful pen-drawings, J. W. T. Manuel exploited the humour of the football field, and Max Beerbohm contributed a weekly caricature under the title of 'Personal Remarks'. Other artists of this period were Adolph Birkenruth, F. H. Townsend, masquerading under the title of 'Findeville', with strong virile pen-drawings, Hal Hurst, very much under the influence of Dana Gibson, Frank Richards and A. P. F. Ritchie, who evolved a rather forced humour from straight lines and curves. In 1895 we find Starr Wood, Ernest Goodwin, John Hassall, Lewis Baumer, Will Owen, Maurice Greiffenhagen and Arthur Gill. Edgar Wilson began a very charming set of drawings in imitation of old prints in decorative settings entitled 'London, past and present'. In August S. H. Sime introduced us to 'The happy hunting grounds' and the adventures of the spirits and shades from which he extracted so much fun. Here was a great imaginative humorist with ideas and methods of his own, whose delightful work in black-and-white (now limited to very occasional illustrations to Lord Dunsany's books) disappeared all too soon. A. S. Hartrick, another fine draughtsman, did some good boxing studies in wash.

G. D. Armour, much influenced by Joseph Crawhall, and Hal Hurst, now under the spell of the American, Wentzel, enlivened the early numbers of 1896, in which year Sime took over with

great success the illustration of the Jingle article. George Morrow and Frank Reynolds, both afterwards distinguished in *Punch*, Frank Chesworth and Gurnell Jennis, with small but effective pen-portraits, made their appearance. In 1897 the Beardsley influence was apparent in the work of William T. Horton and later of Hans Reitz, who was also affected by Sime. Phil May was now a regular contributor, with Gunning King, Cecil Aldin, Edward Read, C. H. Taffs and Gilbert James, and in 1898 Tom Browne also appeared. The next year Sydney Hebblethwaite introduced an original method of grotesque fancy in 'Scenes in Mars'. His work showed promise of great possibilities, which was, however, defeated by his early death. Popini was another artist with an individual style of flat tones somewhat in the manner of John Hassall. Dion Clayton Calthrop, who had a pleasant sense of fantasy in delicate line, Thomas Maybank and R. C. Carter, with very simple designs in line and wash, completed the very varied and comprehensive list.

Pick-Me-Up owed very much to the editorial guidance and artistic example of Raven-Hill. The paper developed a new and irresponsible note of humour which set a standard for many imitators. It was interesting from an artistic point of view, as it formed a training ground for so many young draughtsmen who afterwards became famous in a wider sphere. At one early point in its career it had to defend an action brought by some prurient Chadbands whose ingenuity claimed to have discovered indecent transparencies; but these were not apparent to the more normally minded, the case was lost, and the paper received by this means a very valuable advertisement. It had so many qualities of youthful vivacity that it should not have been allowed to languish and die. Apart from the editor, Sydney H. Sime was certainly the greatest artist whose work it encouraged, and for this alone we ought certainly to be grateful.

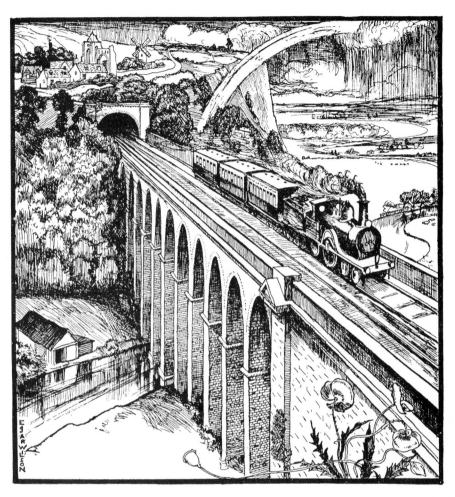

53. EDGAR WILSON

'The Viaduct', from a drawing in the author's collection

54. H. R. MILLAR

Illustration from *The Strand Magazine*

By courtesy of George Newnes, Ltd.

THE PENNY ILLUSTRATED PAPER

The *Penny Illustrated Paper* was started as far back as 1861. Most of its illustrations were merely newspaper records of events and were reproduced either by wood-engraving or process, and in the case of photographs from half-tone blocks. Some were reprinted from old numbers of *The Illustrated London News*. J. James Proctor did many of the new illustrations which dealt generally with sporting events. Raymond Potter, Ralph Cleaver, Alick Ritchie, A. J. Finberg, W. D. Almond and W. B. Wollen also contributed. Dudley Cleaver had many promising pen-drawings, H. Thornely did subjects connected with horses and racing, and there were many good unsigned drawings dealing with affairs in the Law Courts and theatres. Sydney Higham and Fred T. Jane made occasional appearances. Frankly a newspaper, *The Penny Illustrated Paper* contained little that was of interest from an artistic point of view. Many of its old features were retained too long, and its career was probably seriously affected by the appearance in 1890 of *The Daily Graphic*, which was more modern in its methods and supplied the pictorial records of news more promptly and satisfactorily. Much of its success was due to the personal energy and interest of its able editor, John Latey, who later became the first editor of *The Sketch*. Some of its Christmas numbers were interesting as combining the old with the new, survivors of the sixties like Sir John Gilbert (reprinted) and Fred Barnard appearing with the young men of the nineties like J. Bernard Partridge, Raymond Potter and A. J. Finberg.

CASSELL'S SATURDAY JOURNAL

Founded in 1883 in succession to *Cassell's Illustrated Family Paper* at the famous hive of journalistic industry in La Belle Sauvage, *Cassell's Saturday Journal* contained much good work in the way of illustration. Unfortunately it was printed on paper of poor quality, and the wood-engravings also helped to depreciate the merit of many excellent drawings. Gordon Browne, William Hatherell, J. Finnemore and Paul Hardy were capable artists whose illustrations to serial stories suffered in this way. J. F. Sullivan's humorous pages of fantastic fancy and John Proctor's bold designs, being drawn in line, fortunately lost less in reproduction. Charles Harrison, Charles L. Pott, Horace Morehen, G. C. Glover and Jack B. Yeats also contributed humorous drawings, but the illustrations gradually declined in importance and in 1895 appeared only occasionally.

ILLUSTRATED BITS

Founded and edited by T. H. Roberts in the same year as that of Ally Sloper's birth, *Illustrated Bits*, although lacking the artistic taste and influence of the Dalziels, contained much that is worth recording. Well printed on a light pink paper, it gave opportunity to the work of many distinguished and promising illustrators. In 1890, for example, Dudley Hardy, Bernard Partridge, W. Dewar and Albert Morrow appeared regularly. Morrow also designed a very attractive and popular poster of a dancing girl with a gauze scarf carrying the name of the paper. The inner pages generally contained a number of smaller and less distinguished drawings, and some reprinted from foreign papers. Later came Max Cowper, not yet quite at his best, A. S. Forrest, Frank Chesworth and that idol of the editors, Hal Ludlow. Unfortunately about this time some truly terrible coloured

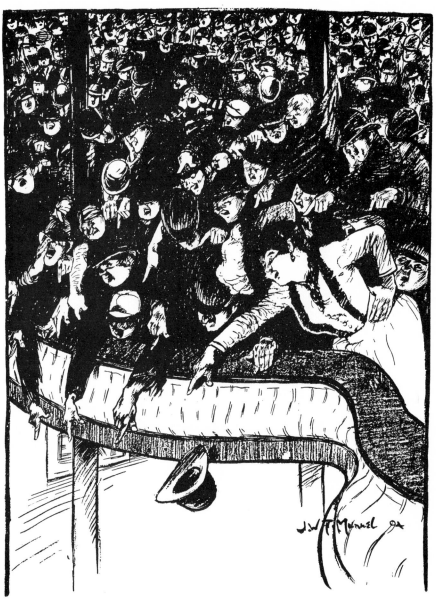

55. J. W. T. MANUEL
'The Gallery'
By courtesy of the proprietor of Géraudels Pastilles

56. S. H. SIME

'Dreams, idle dreams', from *The Sketch*

plates were issued, in which the work of such artists as C. A. Shepperson, for example, were crudely murdered. J. James Proctor contributed illustrations, and Harold Piffard a series of line-drawings in the manner of Caran d'Ache. Another favourite of editors of this period with even less justification was Hal Hurst. In strong and vigorous contrast were the bold line-drawings of John Hassall. Frank Chesworth did the theatrical drawings for 'The Call Boy', and Malcolm Patterson, Sydney Adamson and Rossi Ashton contributed good work. There was also a strong foreign element including the French artist Mars and the Americans Miss O'Neill Latham and Henry Mayer. Lewis Baumer and E. S. Hope were two regular workers, and an interesting illustrated weekly supplement 'The Continong' was issued, with drawings from French and German papers—notably *Jugend* and *Le Journal Amusant*. In 1900 the South African War provided an excuse for a military series by Charles L. Pott, entitled 'The Backbone of England, our Volunteers'. Popini, H. C. Sandy, R. Pannett, Tom Wilkinson and Oscar Eckhardt also contributed to this volume. Although it printed much that was in hopelessly bad taste, *Illustrated Bits* provided a setting for many good drawings, and, as a typical popular English production of the period, certainly justified its publication.

SKETCHY BITS

Started in 1895 by the brothers Shurey, *Sketchy Bits* was a strange mixture of good and bad drawings, old woodcuts, and photographs of actors and actresses. In his introductory address Charles Shurey, who was in charge of the editorial side, modestly states that 'to please everyone is my great ambition'. It may fairly be said that he did his best and was successful with many of his undiscerning readers. In the earlier numbers such distinguished names as Raphael Jones and Colarossi appeared attached to less impressive drawings. Others better known were

Lance Thackeray (very early work), Leighton Waud, Shérie, H. H. Flère, H. C. Sandy, A. P. F. Ritchie, Malcolm Patterson and Oliver Veal, whose pertinacity was more remarkable than his humour or drawing. Later came C. H. Taffs, A. J. Gough, C. Fleming Williams and Savile Lumley—all competent artists —and Frank Reynolds, who for many weeks filled the front page and was the most distinguished in accomplishment and promise of the many young recruits enlisted and encouraged by the editor. Shurey certainly had the business man's faculty of appraising and, when necessary, descending to the tastes of the general public; but he had also discrimination in selecting and encouraging young artists. With them he was extremely popular because he was prepared to buy any drawing that he liked and would supply the necessary 'legend' to be printed below it: but more especially because, by the novel and unusual business methods of the firm, he paid cash for it on the spot. This practical support meant much to many young artists, some of whom afterwards made good, and must surely be accounted to him for righteousness.

THE LONGBOW

The *Longbow* deserves mention if only for the opportunity it afforded to F. H. Townsend to make some of his finest pen-illustrations for Rider Haggard's story *Elissa*. Dignified, well drawn and distinguished, these were among the best work he ever did in this medium. Started on 2 February 1898, with a strong cover-design by Townsend, the paper expired on 16 November of the same year; and when the Haggard-Townsend collaboration finished on 8 June the paper showed very little reason for continuing longer. Dudley Hardy contributed a 'Cartoon of the Week' and some very dashing, lighthearted and experimental little illustrations to the editorial notes. A. K. Macdonald did some very early work in the form of small decorations in pen and ink, and among the other contributors were

57. W. DEWAR

From *Illustrated Bits*

58. F. H. TOWNSEND

Illustration to *Elissa* by Rider Haggard, from *The Longbow*, 1895

G. D. Armour, W. E. Wigfull, T. E. Donnison, Jack B. Yeats, Charles Pears, Max Cowper, F. Newton Shepherd, F. C. Hardy (Dudley's brother), Hutton Mitchell and Frank Reynolds. There were also some interesting and very original line-drawings by Y. A. D. Lluellyn. Of his identity and later progress I know nothing, but these few illustrations gave promise of great possibilities in the future. Although the early numbers were interesting, *The Longbow* never gave one an impression of virility or of any definite policy. It gradually declined in quality, but, if only for the promise of its start, it certainly deserved a longer life.

PUCK AND ARIEL

Puck, a small paper of eight pages, some of which were printed in colour, appears to have consisted largely of a collection of reprinted illustrations from the *St. Stephen's Review*. This paper had acquired fame as the first London publication to encourage the early work of Phil May, whose wonderful illustrations to 'The Parson and the Painter' appeared in its pages in 1890. The reproductions of May's drawings were very badly treated in colour. Tom Merry drew and lithographed the coloured cartoons, which were somewhat crude in humour, although the portraiture was good. Wallis Mackay also supplied some drawings. In March the colour reproduction was restricted to a page supplement, and Stewart Browne, Chris Davis and 'Crow' appeared in black-and-white. On 5 July 1890, under the editorship of Israel Zangwill, the author and dramatist, *Puck* was merged into *Ariel or the London Puck*, with a make-up similar in appearance to that of *Punch* but very distant from it in quality. The new editor's influence was soon felt, and the tone of the paper much improved. George Hutchinson did the cartoons, which were stronger and more powerful. Dudley Hardy, J. Leighton, Mark Zangwill, Starr Wood, Cyril Hallward and the jovial Irish artist Jack B. Yeats contributed drawings. A. J.

Finberg did the theatrical sketches, and in July some satirical cartoons by 'Cynicus' appeared. In September Zangwill's name appeared on the cover title as editor, so that he was evidently and justly proud of his production. A very clever feature at this time was a series of parodies of its contemporaries, that of *Pick-Me-Up* being particularly good. F. H. Townsend illustrated the editor's 'Old Maids' Club', which afterwards appeared in book form. Despite excellent work by Townsend and Yeats, the paper did not long survive and on 6 February 1892 it passed away. For the sake of its clever editor and his encouragement of young contributors its early death was unfortunate, as it certainly gave promise of great achievement.

SCRAPS AND FUNNY FOLKS

These were two weekly publications from the house of James Henderson, of Red Lion Court, which produced much literary and pictorial matter of a very popular character during the nineties. The contents of both papers were distinctly scrappy, and the humour was greatly in excess of the art. Both, however, supplied a useful training ground for many young artists who afterwards became famous. Most of the drawings were very much reduced in reproduction and nearly all were unsigned. It would thus be very difficult, even if it were necessary, to identify their designers. The name of one man perhaps stands out, both because of the vast quantity and regularity of his output and the ingenuity and humour of his invention. The work of Charles Harrison forms one of my earliest recollections of black-and-white. It has appeared at some time or another in nearly every illustrated paper and magazine in the country. Harrison evolved a distinct and characteristic style which has remained consistently the same throughout his long career. Although it cannot be called artistic, it is certainly effective in explaining his ideas and has also the great merit of

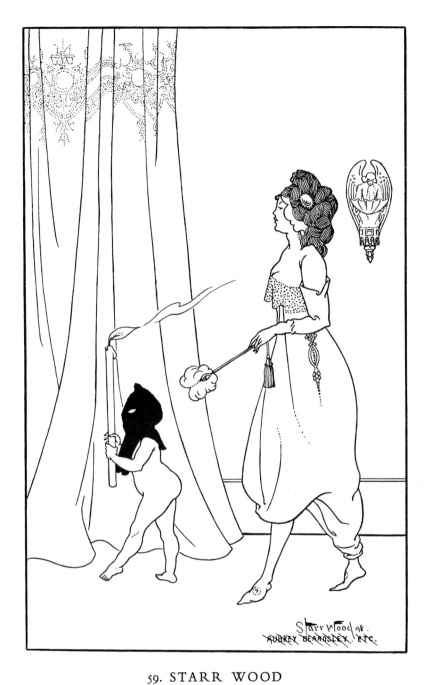

59. STARR WOOD

'A Parody': from a drawing in the author's collection

60. CHARLES HARRISON
'Li Hung Chang', from *Punch's Almanack*, 1897
By courtesy of the Proprietors

61. MAURICE GREIFFENHAGEN

'Wolverden Tower'. Page illustration in wash from *The Illustrated London News*, Christmas Number, 1896. Original 19″ × 12½″

In the Sir William Ingram Bequest, Victoria and Albert Museum

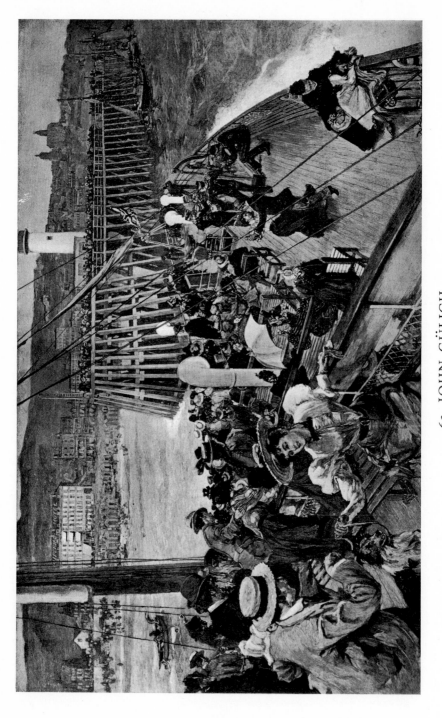

62. JOHN GÜLICH

'The Boulogne Boat'. Wash-drawing. Double page, from *The Graphic*, 10 October, 1896

being extremely well adapted to reproduction. *Funny Folks* described itself as 'The comic companion to the newspaper' and a feature was made of the cartoon, which in 1890 was the work of Stafford. A little later a large part of the paper was given up to the reproduction of drawings by American artists—notably C. Dana Gibson and C. H. Wentzel—and after it ceased publication in April 1894 the policy was continued by the same publisher in *Snap-Shots*. In all probability neither *Scraps* nor *Funny Folks* had any intention or ambition higher than that of pleasing its readers, but in affording a training ground for youthful artists both papers had their uses, and even the publication of American drawings was of instructive value to the student.

CHAPTER IV

SOME MONTHLY MAGAZINES

GOOD WORDS

'Good words are worth much and cost little.'
GEORGE HERBERT.

Founded in 1860, *Good Words* was one of three publications —*Once a Week* and *The Cornhill Magazine* were the others —which were in great measure responsible for the very high standard of black-and-white illustration that marked that period. From the first the editor gave full credit, careful reproduction and sympathetic encouragement to his artists, and was almost alone in supplying detailed mention of their work in the very excellent and complete index to each volume. Such a simple form of courtesy is so obviously beneficial in its influence both on contributors and readers that it is very strange that it has been so very rarely employed.

In 1890, when our survey starts, the magazine's excellent qualities were still in evidence; most of the reproduction was still by wood-engraving, and although many of the early giants had departed, the level of illustration was still high. W. H. J. Boot, who soon afterwards became the first art editor of *The Strand Magazine*, had some very good drawings of Venice, Herbert Railton was, as usual, perfect in his own style, and J. Watson Nicol—particularly on page 111—equally capable and distinguished. Linley Sambourne had two drawings, G. L. Seymour's work was full of artistic quality, and A. S. Boyd had some pleasant landscapes of the Channel Islands. In 1891 J. Watson Nicol illustrated Barrie's *The Little Minister* with excellent full-page drawings, A. Morrow contributed some good impressions of Covent Garden Market, Harry Furniss wrote and illustrated an article on Bournemouth, Linley Sambourne did two— 'Spring' and 'Winter'—of four decorative drawings of the

130

63. GORDON BROWNE
Illustration for 'The Story of a Mazurka',
English Illustrated Magazine, November 1893
By courtesy of Edward Arnold and Co.

PRINCESS ROSETTA

64. H. R. MILLAR
Illustration from *The Strand Magazine*
By courtesy of George Newnes, Ltd.

seasons, C. Whymper had some conscientious studies of birds and J. Fulleylove some elaborate landscapes. Other good work was contributed by Gordon Browne, A. S. Boyd, W. S. Stacey, R. Barnes (a survivor of the early days of the magazine), and by J. Jellicoe and Herbert Railton in collaboration. Sambourne completed his series with 'Summer' and 'Autumn' in the next volume; Lockhart Bogle had some good illustrations in chalk, and W. Rainey in line. W. D. Almond did some clever impressions of the docks, and Fred Barnard of street trades. D. Y. Cameron, the distinguished etcher and painter, appeared with some fine line-drawings of Linlithgow.

In 1893 Gordon Browne, Paul Hardy, W. D. Almond, H. R. Millar, R. Barnes and J. A. M. Symington were among the distinguished illustrators, and in the next year W. H. Overend, A. Jule Goodman (in line), F. H. Townsend (illustrations to an article on 'The Omnibus'), Gordon Browne and H. R. Millar contributed. J. A. Shepherd did twenty-two delightful animal 'zigzags'. 1895 brought C. E. Brock's illustrations to a serial by S. R. Crockett, some more excellent work by G. L. Seymour and a full supply of humour by J. A. Shepherd. Harrington Mann, now a distinguished painter, illustrated his own article on Sicily, and R. B. Lodge drew birds very conscientiously. In 1896 Brock again illustrated the serial—Walter Raymond's 'Charity Chance'; E. J. Sullivan did some pen-drawings of gypsies, which recall his delightful illustrations to George Borrow's *Lavengro*, and Gordon Browne, the faithful ideal of all editors, maintained his well-earned reputation. Sullivan was again prominent in 1897 with some distinguished pen-drawings of 'A Night in the House of Lords', Gordon Browne illustrated the serial, and G. Montbard, L. Daviel and A. Twidle (efficient but ordinary) contributed good work. In 1898 Lancelot Speed did some undistinguished drawings to the serial, A. D. McCormick some good illustrations in line, Cecil Aldin some slight and simple drawings, and H. M. Brock some capable line work. Miss Chris Hammond and W. Christian Symons (well reproduced) also contributed, and A. S. Boyd, in Scottish collaboration with Neil

Munro, was responsible for the illustrations to the serial. Hedley Fitton did some fine colourful pen-drawings of Worcester Cathedral, James Greig some impressions of 'Italy in London', and T. Walter Wilson, G. Montbard and Cecil Aldin were also represented. There were no noteworthy newcomers in 1900 but Gordon Browne illustrated the long story, and A. D. McCormick, James Greig, Chris Hammond and W. Christian Symons again assisted.

With a very high tradition of long standing, *Good Words* fully maintained its prestige, adapting itself successfully and without loss of dignity or intelligence to the new conditions of production and the new character of its readers. It retained its individuality and distinction, content to give its public the best in literature and art and to present it in the best possible way, resisting quietly the cheap, vulgar methods employed by its younger rivals to attract attention. *Good Words* continued until May 1906, when it was amalgamated with *The Sunday Magazine* and issued weekly.

THE QUIVER

Another survivor from the great days was *The Quiver*, founded in 1861, a year after *Good Words*, and published, at first without illustrations, from the house of Cassell. It did not quite reach the excellence of its predecessor, although its list of artists was distinguished and included such great names as A. Boyd Houghton, G. J. Pinwell, Charles Green, William Small, Frederick Sandys and J. D. Watson.

In 1890, where we take up the tale, Gordon Browne, W. Hatherell, M. L. Gow and Sydney Paget illustrated serials, and other contributors were W. H. J. Boot, Sydney Cowell, Margaret L. Dicksee, Paul Hardy, Everard Hopkins, H. M. Paget, Wal Paget, J. Bernard Partridge, W. Rainey, W. Simpson, W. S. Stacey, M. E. Edwards, Percy Tarrant and Lucien Davis. This list of names is sufficient to show that a very high standard

was maintained. W. Rainey was yet another great illustrator whose merit has never been recognised. A capable draughtsman with a fine sense of colour, he was equally effective in illustrating news or fiction. He was never conventional in his designs, had a fine sense of character, and maintained the interest throughout the whole of the drawing. The usual two figures set against the customary background were not sufficient to satisfy his idea of an illustration. We must admire too the gracefulness of Miss M. L. Gow's drawings, and the amazing consistency of Gordon Browne and Holland Tringham, who appeared during 1891. Robert Barnes and John H. Bacon contributed good work in 1892. Chris Hammond had some pleasant drawings to the serial in 1894. W. D. Almond illustrated 'Some unfashionable slums', and Hedley Fitton and Frank Craig were represented by very careful work. John Gülich was well represented in 1895. W. S. Stacey contributed an interesting set of 'six women of the Bible', apparently reproduced from water-colours, in the next volume. Albert E. Sterner did some good line-illustrations to the serial, rather like Rainey but not so strong in drawing. C. H. Taffs made many appearances, with surprisingly good work, and Fred Pegram was well represented, although some of his drawings appear rather stiff and reminiscent of the model. Chris Hammond, A. S. Hartrick and W. D. Almond also added to the attractions of a good volume.

1897 brought H. M. Brock (who was now breaking away from the style of his brother C. E., and using black more freely), F. H. Townsend, Fred Pegram and some fine drawings by Gunning King in line and half-tone, full of painter's quality. A. S. Hartrick had some good humorous drawings to 'Love in the slums' in 1898, and Townsend's illustrations to 'The White Woman' remind one of his work in *The Longbow*. Townsend was again in great form in 1899, the drawings on page 1084 and those that follow being excellent examples of his skill. Max Cowper also did some very good illustrations to a serial. In 1900 capable work was contributed by H. M. Brock, Arthur Garratt, Malcolm Patterson, J. Barnard Davis, Frank Craig, H. R. Millar,

T. H. Robinson, Arthur H. Buckland and H. Piffard. At various times during the ten years James Greig, Arthur Hopkins, W. H. Margetson, G. Sheridan Knowles, A. Fairfax Muckley, Balliol Salmon, Cubitt Cooke, W. Thomas Smith, E. F. Brewtnall, G. D. Hammond, A. J. Johnson, G. G. Manton, S. T. Dadd and A. Twidle also assisted. Most of these and others whose names have been mentioned were artists of established reputation. *The Quiver* did not experiment much with the work of young and untried men but, like the other magazines that survived from the sixties, it maintained that dignity and excellence which inspired the high achievement of their American successors. They in turn developed these methods and improved upon them with such success that by the nineties they had surpassed their masters both in the intelligence of their contents and the excellence of their printing. And now in these later days our lethargic editors are content to derive whatever attraction their pages display from those who were originally our pupils.

The Quiver continues its quiet career and is now the oldest English magazine of its kind.

CASSELL'S FAMILY MAGAZINE

Cassell's *Magazine* dates from as far back as 1853, when it was known as *Cassell's Family Paper*. There were various changes of size and title in 1865, 1867 and 1870. In the sixties many capable illustrators appeared in its pages, notably William Small. In 1890 the page was larger than that of most magazines, being about ten inches by seven and a half. A list of contributors and artists was given, but no index attribution for separate items. At the beginning of the period with which we are concerned Robert Barnes seems to be the only survivor of the old illustrators, but a very competent staff of artists was still working. Most of their names are already familiar in other publications but are given here for purpose of reference. They included James F.

65, 66. W. RAINEY

Two illustrations from *Cassell's Magazine*, May 1897

By courtesy of The Amalgamated Press

67, 68. W. D. ALMOND

Two illustrations for an article, 'London Street Studies', in *The English Illustrated Magazine*, 1892, very like the work of the American pen draughtsmen G. S. Reinhart and R. Birch

By courtesy of Edward Arnold and Co.

Sullivan, W. S. Stacey, a graceful and deft artist with the pen, Paul Hardy, who exemplified Charles Keene's dictum that 'a man who can draw anything can draw everything', Percy Tarrant, W. Rainey, another capable draughtsman with command of character and humour, William Hatherell, Sydney Paget, Walter Paget, Harry Furniss, with parliamentary subjects, S. T. Dadd, and Gordon Browne at his best. F. H. Townsend and Fred Barnard, both contributing excellent work, are for some reason not mentioned in the list. E. H. Fitchew, who apparently translated photographs into line, and A. Fairfax Muckley, who did illustrations of gardening, were new names. Alice Havers and Sydney Cowell were both inclined to be sentimental, and Mary L. Gow and Everard Hopkins were as reliable and interesting as usual.

Other names which appeared later were Hal Ludlow, whose characters like Greek gods and goddesses were unbelievably beautiful, E. F. Brewtnall, T. W. Couldery, with some interesting character studies in pencil, Arthur Hopkins, Chris Hammond, who illustrated a serial, F. C. Gould, the parliamentary caricaturist, Lucien Davis, Holland Tringham, John Gülich, H. R. Millar, W. H. Margetson, J. A. Shepherd, W. D. Almond and W. B. Wollen. The frequency with which some of these names appear in so many of the illustrated papers of the period shows how wide was the field for the black-and-white artists of those years and how amazing was their industry.

In volume twenty-two (1895-6) is an article on 'Four artistic humorists'—Phil May, J. A. Shepherd, E. T. Reed and L. Raven-Hill—the last of whom discloses the fact that he was a student at Lambeth with C. H. Ricketts and Charles Shannon. Other contributors to the same volume were C. J. Staniland and S. Begg of *The Illustrated London News*, Balliol Salmon, S. H. Vedder, Stanley L. Wood, who anticipated the 'headlong dash' and the wild west thrillers of the modern films, Arthur Rackham, Harry B. Neilson, C. A. Shepperson, Fred Pegram, James Greig and Richard Jack, in whose work there is nothing to indicate the future R.A. The next year John H. Bacon, another

future Academician, competent but very literal, and H. M. Brock (rather tentative in manner) were added to the list, and a portfolio of Fred Barnard's excellent studies of Dickens characters was presented.

In 1898 Gordon Browne and Fred Pegram illustrated serials, the latter with highly finished pen-drawings conscientiously drawn but rather too suggestive of the posed model. The full-page reproductions are, however, more interesting and suggest that the others were too much reduced, but one cannot help feeling that a little less restraint and more variety of tone, with an occasional splash of black, would have added to their effectiveness. This is emphasised by comparing them with F. H. Townsend's drawings for Joseph Hocking's *Trevanion* later in the same year, which are stronger and more dramatic. Other contributors to this volume were Alfred Pearse, J. Finnemore, H. G. Burgess, very good both in line and wash, Marie Miles, with delicate illustrations to children's stories, and Byam Shaw, with decorations to a poem which are less conventional than these pages generally are. Frank Craig had some good line-drawings, deftly produced but a little mannered, and T. H. Robinson, one of three gifted brothers, some story illustrations in line which convey a suggestion of colour. Paul Hardy looked into the future with some pictorial forecasts illustrating articles on the end of the world and the time 'when men fly'. The accuracy of the former cannot yet be tested, and the latter have not been so romantically realised, but both series are full of imagination and vigour. Ronald Gray had some story illustrations so carefully lined as to suggest wood-engravings, and Holland Tringham some delightful drawings of the battlefield of Waterloo.

In the last volume with which we are concerned there are few new names. A. S. Hartrick was as satisfying as usual, Harold Piffard did some photographically dramatic drawings with rather forced tone values, and Edward Read was stronger and more virile than usual. *Cassell's Magazine* certainly maintained a distinctive individuality and a high standard of illustrations

through these ten years, and showed a judicious encouragement of some of the younger artists.

THE ENGLISH ILLUSTRATED MAGAZINE

The English Illustrated Magazine was first published in 1883 by the firm of Macmillan, with Joseph Comyns Carr as its able and sympathetic editor. It started with a very distinguished list of contributors, including among the authors such names as Austin Dobson, Henry James, A. C. Swinburne, Andrew Lang, R. L. Stevenson, Walter Besant, William Morris, Thomas Hardy, Stanley Weyman and Edmund Gosse. The artists were Alfred Parsons, Napier Hemy, Randolph Caldecott, R. W. Macbeth, Walter Crane, George du Maurier and Harry Furniss. Many of these were still contributing in 1890, when our brief survey begins, but by that time there had been many additions.

First and foremost among the illustrators was Hugh Thomson, who joined the artistic staff in 1884 and had so much to do with the great popularity to which the magazine attained. To this volume he contributed some illustrations of cabs and their drivers. W. J. Hennessy—a little like Fred Barnard—illustrated in line F. Marion Crawford's *The Witch of Prague*, John Cash had two pleasant little pen-drawings of 'Dartmoor Rediscovered', and George Reid ten well designed impressions of Edinburgh. Other topographical drawings were contributed by H. W. Brewer (Ham House), Philip Norman (London Inns and Taverns), Reginald Blomfield (Dutch Architecture), Herbert Railton (Westminster) and Harold Oakley (Winchester). Charles J. Watson, George Lambert and Harry Furniss were also represented. Most of the illustrations were engraved on wood, and both the artists' and the engravers' names were given in the index. The drawings were all very conscientiously and carefully done and Biscombe Gardner, the most distinguished survivor of the wood-engravers, contributed the frontispiece.

H. Oakley had some pleasant drawings of Boston (Lincoln-shire) in the next volume, F. G. Kitton illustrated 'Doncaster' in the Railton manner, and Alfred Parsons was, as usual, sound and charming in 'A Hampshire Moor'. L. Leslie Brooke, with pen-drawings in the manner of wood-engravings, Walter Paget, in half-tone, and W. Douglas Almond, in line, illustrated stories. E. J. Sullivan was represented by some very much reduced line-drawings, R. Anning Bell by rather conventional line-decorations, and E. H. New by two of his neat and capable pen-drawings. William Hatherell and G. D. Armour both suffered some-what by the wood-engraver's translation. Thomson had three illustrations to 'Old Village Life', freer in style and full of that knowledge and interest which made his work always so delightful.

In the volume for 1892-1893, C. M. Gere and E. H. New con-tributed pen-drawings very similar in character, and R. Anning Bell, Herbert Railton and E. J. Sullivan were represented. Ed-mund H. New was an artist whose work combined with a strong personal line the accuracy of the architect's drawing and great decorative charm. He illustrated many books of a topo-graphical interest, and always so truthfully and delightfully as to make one wish to see the places he had drawn. W. D. Almond illustrated the Bret Harte serial with pen-drawings very like those of the American artist, Reginald Birch. Miss Chris Ham-mond and Laurence Housman appeared in the next volume, the latter with some strangely distorted figures as decorations for a ballad. Robert Sauber illustrated a story and a poem by Herrick. In looking through these old magazines it is interesting to notice how often Herrick supplies a theme for a page drawing, and considering this popularity, it seems strange that so few fully illustrated complete editions of his poems have been published. E. A. Abbey did some exquisite designs for a selection issued by Harpers (1882), but it is a great pity that Hugh Thomson did not use his delightful pencil for this purpose. Cecil Aldin made drawings for many of the less sentimental verses.

E. J. Sullivan had some crisp light line-drawings for Stanley

Weyman's travel notes, and Fred Barnard, Douglas Almond, Dudley Hardy, Caton Woodville, Adolph Birkenruth, James Greig, Holland Tringham and his twin soul Herbert Railton, Lancelot Speed and Julius Price were among the other illustrators. Paul Renouard had two masterly drawings of Monte Carlo, and Phil May broke in like a breath of fresh air with bold line-drawings to a monthly *causerie* by L. F. Austin and A. R. Ropes called 'The Whirligig of Time'.

Volume twelve contained only six instead of twelve issues, with separate page-numbering for each month. E. T. Reed had one of his excellent studies of lawyers, Fred Barnard a fine drawing of 'A Meeting of the Parish Council', and Chris Hammond appropriately illustrated 'The Sisters'. Railton, Melton Prior, Sauber, René Bull, Gilbert James, Douglas Almond, Cecil Aldin and Forestier were among the other contributors. C. A. Shepperson and J. Walter West appeared in volume thirteen. In volume fifteen Almond had a good drawing on page 194, and Gunning King some fine illustrations to five stories by George Gissing. With volume sixteen the old decorative and pleasant cover by Walter Crane was abandoned for a weak and conventional pictorial design. It is a strange feature of English magazines that the editor's policy so often consists in imitating his competitors. Individuality is sacrificed for a dull uniformity, which makes it difficult for the reader to distinguish them. William Simpson, the veteran war-correspondent, illustrated an article written by himself, but in this and succeeding volumes there are few features of outstanding interest. In volume twenty colour is introduced, sometimes effectively, as in the case of the illustrations by Almond and Forestier, sometimes unnecessarily for reproductions of photographs of actresses (that inevitable feature of English magazines) which would have been just as interesting in black-and-white. In volume twenty-two Charles D. Ward illustrated several stories with promising but uneven drawings, and W. E. Wigfull had some good bold sketches of ships and sailormen. In volume twenty-three Malcolm Patterson illustrated a series of 'Adventures of Archibald P. Bates' with con-

scientiously correct line-drawings, which would have been more interesting with a little more elimination and freedom in handling. This, however, is a failing that is less annoying than the slick, superficial cleverness that so often attempts to conceal incompetence. G. Henry Evison had some promising half-tone drawings, and Campbell Taylor some that were pleasant but rather ordinary. To volume twenty-four, the last with which we are concerned, William Hatherell contributed the frontispiece, and Warwick Goble and Will B. Robinson were represented. But by now the magazine had descended far from its original high level and assumed the uniform mediocrity which characterizes so many of these productions. Much of the later work was very weak, and many distinguished painters must have blushed later for some of their early indiscretions in illustration. The first ten years of *The English Illustrated Magazine* were the best, and it is sad to see a venture which started with such a fine promise fall away from its high standard and in consequence disappear.

Comyns Carr gave up the editorship in 1889, but he and the magazine and the proprietors will always be kindly remembered for the encouragement which they gave to the work of Hugh Thomson, one of the greatest of English illustrators and a delightful and unassuming personality. Most of Thomson's work in the magazine—'Days with Sir Roger de Coverley' and 'Coaching Days and Coaching Ways' in particular—was completed before 1890, although much of it was republished later in book form. In fact he resigned his engagement with the firm when Carr gave up the editorship. His last contribution was in January 1892, and thereafter, except for occasional appearances in the *Graphic*, his work was confined mostly to books.

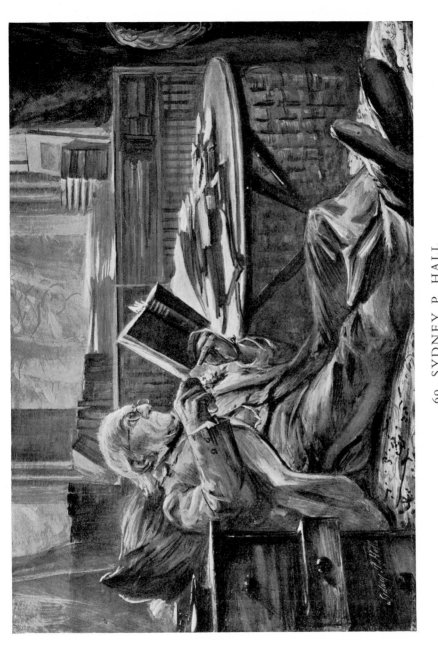

69. SYDNEY P. HALL

'Portrait of Gladstone'. Double page, from *The Graphic* Special Supplement, 19 May, 1898
Original 14¼" × 21"
By permission of the National Portrait Gallery

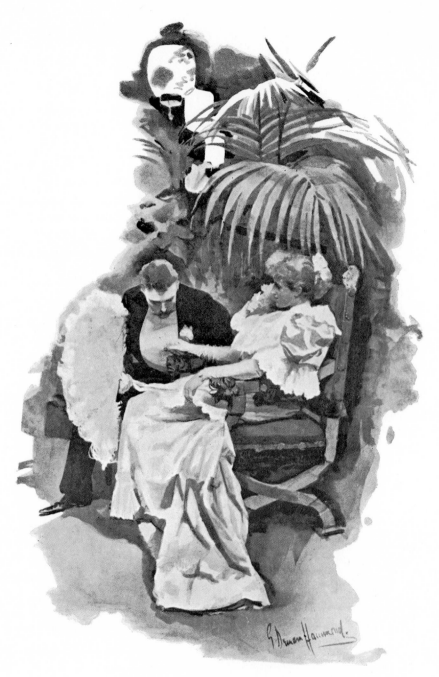

70. G. DEMAIN HAMMOND
Wash-drawing for story illustration from *The Lady's Pictorial*

THE BOYS' OWN PAPER

Although there was a weekly issue of *The Boys' Own Paper*, it made a more imposing monthly appearance, with these parts bound in a decorated brown cover and preceded by a highly-coloured frontispiece. These pictures were a very popular and successful feature, especially when they dealt with such thrilling subjects as the flags of all nations, medal ribbons or army uniforms. They were produced by lithography or by a development of the Baxter process and generally had a shiny and sticky surface which often impaired their permanence under the pressure of the bound volume. *The Boys' Own Paper*, founded in 1879 by the Religious Tract Society, celebrated a very distinguished jubilee five years ago and still flourishes, despite much competition during its long career, as the best of all papers for the amusement and instruction of boys. Most of its illustrations were attached to stories and were reproduced by wood-engraving. Alfred Pearse (to whose moral excellence the title 'Punctual Pearse' testifies) and Paul Hardy were the two artists who supplied most of these drawings in the volume for 1890. But there were many other regular contributors of equal eminence; Fred Barnard, Stanley Berkeley, who specialised in galloping horses, W. H. T. Boot, Gordon Browne, Randolph Caldecott—a posthumous assistant—Frank Dadd, Thomas Downey, who supplied most of the drawings for humorous stories, G. H. Edwards, J. T. Nettleship (animal studies), W. H. Overend, W. S. Stacey, R. Caton Woodville, J. A. Shepherd, Louis Wain, Cuthbert Bradley (horses and the science of riding), J. Finnemore, Fred Miller, J. L. Wimbush and Arthur J. Wall. This is as distinguished an array of illustrators as ever graced a volume of any English publication. In addition to this list of more or less regular contributors there were many others who made occasional appearances.

In those days, before the coming of motor-bicycles, scooters and cinemas, many boys derived much sound and instructive

enjoyment from copying the drawings in the *B.O.P.*, and for their edification and encouragement the editor commissioned a series of 'Artistic Studies for Boys of Taste' by many representative draughtsmen. Such a feature to-day would probably either be totally ignored or greeted with yells of derision. In 1892 and 1893 there were several new additions to the consistently regular staff: Cecil Aldin, W. B. Wollen, H. C. Seppings Wright, H. M. Paget, that excellent illustrator of serial stories, S. F. W. Burton, C. J. Staniland (with some fine drawings of lifeboats for his own articles) and B. E. Minns. S. H. Sime had an interesting but unusual page drawing 'Fallen among Thieves', a group of women and children on a pirate ship. The subject is conscientiously worked out with the greatest attention to detail, and proves once again what a fine draughtsman Sime was. Later names included T. E. Donnison, J. S. Crompton, T. C. Heath, Ernest Prater, George Soper, W. Thomas Smith, A. Chasemore, Powell Chase, Alec C. Ball, P. B. Hickling and P. V. Bradshaw, with some very stiff line-drawings.

Apart from the juvenile appeal of its contents, *The Boys' Own Paper* merits attention from the student of illustration by reason of the excellence of the work contained in its pages and the well-earned reputation of its artists. It is a sign of the intelligence of the editor that he reproduced the best drawings available, instead of attempting to engage his readers' support by less competent and cheaper work. The artists too gave of their best, and their combined success is proved by the enthusiastic continued support of their young admirers.

THE GIRLS' OWN PAPER

Founded also in 1879 by the same publishers, *The Girls' Own Paper* was never quite so fully illustrated as its male companion. The bright particular patch in its artistic history was its association with Kate Greenaway, who contributed coloured

drawings for much-esteemed frontispieces. The last of these appeared in 1890 and thus enables her name to be included in our record. An account of her life and work, so much appreciated by John Ruskin, was compiled by M. H. Spielmann and G. S. Layard in 1905. Two other ladies supplied many of the illustrations, particularly those for the serial stories, M. Ellen Edwards and Marcella Walker; and Amelia B. Edwards, Margaret L. Dicksee and Blanche Offer also contributed occasionally. W. J. Hennessy and Paul Hardy illustrated some of the serials. H. W. Brewer did many excellent drawings in 1897 and 1898. Other names of artists who appeared between the years 1890 and 1900 were Fred Barnard, Sydney Cowell, G. H. Edwards, J. Finnemore, A. Forestier, Arthur Hughes, Herbert Johnson, R. Catterson Smith, Percy Tarrant, Alan Wright, H. R. Millar, Leonard Linsdell, W. S. Stacey, Alfred Pearse, John H. Bacon, Gordon Browne, A. Jule Goodman, Ernest Jessop and Harold Copping. This is a distinguished list which represents a high artistic standard, and although perhaps it does not reach the level of that of *The Boys' Own Paper*, it was quite sufficient to ensure the justified popularity of the magazine.

THE STRAND MAGAZINE

Founded by George Newnes in 1891, *The Strand Magazine* achieved an early success by reason of some distinctive features, rather than by any great artistic merit. An interesting series of illustrated interviews, portraits of celebrities at various ages, and, above all, Conan Doyle's introduction of that original amateur detective, Sherlock Holmes, who left readers awaiting with breathless interest the arrival of the next month's issue— these were some of the factors of its immediate popularity. George C. Haité designed an effective and appropriate cover, which in the course of years has been more and more mutilated by advertisements until now little if any of it remains. The

illustrations were all very small, and most of them were engraved on wood. A. Forestier's drawings, despite this great reduction, were still charming, Paul Hardy was as ingenious, dashing and melodramatic as usual, and Gordon Browne and W. B. Wollen were as competent as ever. Sydney Paget illustrated the Sherlock Holmes series very literally but without much imaginative interest. Such themes as 'he opened the door', 'he sat down at the table', 'she gazed out of the window' were drawn accurately enough but did not provoke much enthusiasm. Among a certain disrespectful group of art students of the period, 'illustrated by Sydney Paget' was synonymous with anything obvious and banal. H. R. Millar was more successful with the drawings for E. Nesbit's children's stories, which became a regular and delightful feature. These showed excellent fancy, were well drawn, and generally contained a cunningly placed and effective patch of black. John Gülich's contributions were probably done from photographs and are not his best work. J. L. Wimbush too, although good, was rather reminiscent of the camera; A. Pearse and George Lambert were competent without showing much personality; but W. S. Stacey's pen-drawings were interesting, well-drawn and splendidly adapted for reproduction. In volume two J. F. Sullivan, in his illustrations of 'Celebrities at Play', produced some wonderfully good portraits, and in 'The Queer Side of Things' humour which was wild but not exaggerated, and did not rely for its effect on large heads, bulging eyes or other distortions. J. Finnemore and Forestier contributed story illustrations, and an interesting newcomer was W. Christian Symons, who did some drawings for a Clark Russell yarn of the sea. Symons was a *protégé* of W. H. J. Boot, the capable art editor, and anathema to the proprietor, whose judgment of a drawing was based on the nearness of its resemblance to a photograph. So that Symons's appearance in the pages of the magazine generally led to a wild discussion on art between the two. Symons had a knowledge of the sea, ships and sailors, which was useful for certain stories, and an originality of conception and style which atoned for occasional weakness in drawing. His

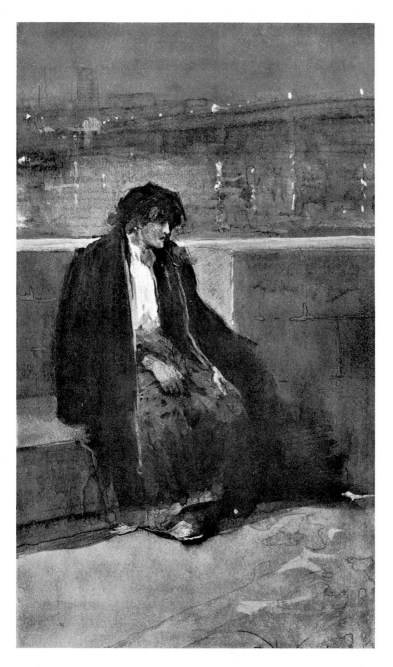

71. DUDLEY HARDY, R.I.
Illustration to 'The Inevitable Thing', by Edwin Pugh. Wash-
drawing from *The English Illustrated Magazine*, 1896
Original 12″ × 7″
In the Sir William Ingram Bequest, Victoria and Albert Museum

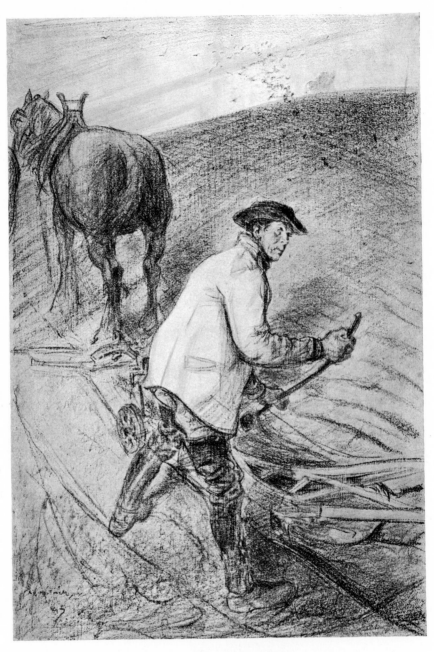

72. A. S. HARTRICK
'The Ploughman : Bill Fry'
Drawn in black and red chalk. One of a series of country types
from *The Pall Mall Magazine*
Original 14″ × 9¾″
In the Print Room at the British Museum

work suffered from the great reduction in size and the vagaries of the wood-engraver. In volume three the apt collaboration of Arthur Morrison and J. A. Shepherd began in 'Zigzags at the Zoo' and formed yet another popular monthly attraction, in which the artist showed that humour and good drawing could be mutually helpful. Hal Ludlow produced some more of his godlike heroes.

John Gülich's illustrations in volume four marked a great improvement both in style and charm. In volume five another interesting dual contribution started with Henry Lucy's parliamentary recollections 'From Behind the Speaker's Chair', illustrated by F. C. Gould of *The Westminster Gazette*. W. L. Alden's 'Among the Freaks', in volume six, supplied a great opportunity for the display of J. F. Sullivan's humour. J. A. Shepherd's illustrations to his selection of Fables were perhaps even better than those for the 'Zigzags at the Zoo'. Max Cowper's line-drawings were also effective, like H. R. Millar's, by reason of the simplicity of the treatment and from the deft placing of the black spot. In volume nine Max Beerbohm contributed some small pen-drawings to 'Oxford at Home'. Symons's regular appearances formed a strong testimony to the persuasive powers of the art editor and to the steady improvement in his work. C. A. Shepperson, W. D. Almond, Frank Craig and A. S. Hartrick made interesting appearances in the next few volumes. In 1899 W. W. Jacobs began 'A Master of Craft', the first of many contributions illustrated by Will Owen, which ran through two volumes. Owen's drawings were very obviously influenced by Phil May, but he had a robust and simple humour which combined well with Jacobs's amusing types and situations. Oscar Eckhardt and Charles M. Sheldon completed the list of illustrators.

Any artistic merit attached to *The Strand Magazine* was entirely due to the judgment and determination of its art editor, W. H. J. Boot, who maintained a high level of excellence under restricting conditions of space. To him we owe a debt of gratitude if only for J. A. Shepherd's drawings. Most of the repro-

ductions were too small to give any value to the technique of the artists, and these were most successful when they kept to a simple method which withstood the drastic results of over-reduction. But if George Newnes's views on art were circumscribed, he did know in an almost uncanny way what the magazine public liked and also realised that this need not be rubbish. In this latter fact he proved his superiority to many of the modern caterers of public entertainment and reaped the consequent reward.

THE LUDGATE MONTHLY

The Ludgate Monthly began very quietly in May 1891, with a modest, unsophisticated introductory appeal by its editor, Philip May. Enclosed in a primrose-coloured cover were the usual illustrated stories and articles and also some songs and music. Another excellent feature which some of its more important rivals might have imitated with advantage was an effective index of authors, artists and composers. The magazine was at first rather an amateurish affair, and the half-tone reproduction was distinctly bad. But its list of contributors was fairly representative, and as the contents improved it gained a certain measure of success. Among the artists who illustrated the first volume were Chris Davis, Louis Gunnis, G. D. and Chris Hammond, C. G. Harper, G. Hutchinson, Gilbert James, B. le Fanu, F. V. Poole and S. H. Sime, who contributed a decorative heading. Much of their work was good, but some was distinctly poor, and all suffered at the hands of the block-maker and printer. For volume two Sime did two good page decorations to poems, Enoch Ward some small pleasant illustrations, and A. Hitchcock several unnecessary drawings.

Volume three had some unrepresentative work by A. J. Finberg, G. Hutchinson, Cecil Aldin and S. H. Sime and some very poor pen-drawings by G. A. Storey, A.R.A., which added nothing to the glory of his title. G. G. Fraser, of *Judy*, with some

humorous illustrations, and Raymond Potter also contributed. Some of this immature work, in the light of later and fuller accomplishment, is, however, encouraging to the young student. In volume four a Dalziel woodcut of a Millais drawing was printed, as if to show what good illustration should be. A. P. F. Ritchie, H. Granville Fell and the printer helped to exemplify the opposite view. Volume five had some interesting but badly reproduced illustrations by J. Barnard Davis and A. Scott Rankin. The former also contributed to volume six, which contained some plain straightforward drawings by J. St. M. Fitzgerald and probably the worst illustration by Cecil Aldin ever published. In volume eight were some political caricatures by 'Grip,' many of which showed good portraiture, and some uneven drawings by Nell Tenison and Bernard Higham. Under its original management the *Ludgate*, which had produced perhaps the worst illustrations ever printed in any magazine, came to an end in October 1895, but was taken over, without a break in its monthly appearances, by the *Black and White* publishing company.

Under their auspices the size of the page was increased, and the contents and production very greatly improved. To the first volume of the new series Dudley Hardy ('The Penny Theatre'), Chris Hammond, John H. Bacon and Charles M. Sheldon contributed good illustrations both in line and wash, D. Y. Cameron some drawings of Glasgow, and 'Grip' some more portraits. Some material, literary and pictorial, was reprinted from *Black and White*, and this may account for the appearance of the three delightful pen-drawings by Hugh Thomson illustrating 'The Valentine'. In the two succeeding volumes appeared competent work by René Bull, Adolph Thiede, W. Rainey, P. F. S. Spence, J. Barnard Davis, O. Eckhardt, W. Dewar and Paul Hardy. Volume three also contained a comprehensive series of four articles on 'English black-and-white artists of to-day'. In volume four James Greig had some charming pen-drawings of J. M. Barrie's country, A. Thiede the illustrations to the serial story, J. F. Sullivan some comments on the umbrella, and T. Ley Pethybridge—a too infrequent contributor to magazines—a de-

lightful Dartmoor fishing subject. E. J. Sullivan, Ernest Prater, Reginald Savage, Robert Brough, Bernard Gribble and A. S. Hartrick were other distinguished contributors. S. H. Sime did some very good illustrations to 'Stuff and Nonsense' in volume five, which also contained a reprinted article, with drawings by L. Raven-Hill, and illustrations of varying merit by Frank Gillett, G. Greville Manton, H. R. Millar, D. Macpherson and J. M. B. Salmon. The last three volumes which come within the scope of our survey were published by F. V. White and Co., with a very ugly cover in red and bilious green, and shew a sad falling-off in quality. Among the artists who contributed drawings were Louis Kight, M. Barstow, Hutton Mitchell, Sydney Aldridge, J. E. Gillingwater, A. Wallis Mills, Frank Wright, Charles Pears (nothing if not original), E. Fairhurst and L. E. Bates. In volume eight were some more drawings by Y. A. D. Lluellyn, whose work, which is mentioned elsewhere in connection with *The Longbow*, anticipated much of the unrestrained freedom from tradition of many of the present-day draughtsmen.

It is difficult to say much in favour of *The Ludgate Monthly*. The first five volumes published under the *Black and White* auspices were good, but before and after that period the quality of the illustrations was uneven and often poor. The composition of the magazine was haphazard and lacked any definite progressive programme or distinction of policy. Probably there were already sufficient publications of a similar type. In 1900 *The Ludgate* was incorporated with *The Universal Magazine*.

THE IDLER

Founded by two popular novelists, Jerome K. Jerome and Robert Barr, *The Idler* first appeared in February 1892, with a buff cover printed in dark red. Edited with intelligence, it sought to combine the excellence and quality of the old magazines with more modern methods and conditions, both in the selection of its contributors and in the presentation of their

work. The illustrations were at first very small, in some cases so small as to make their artistic quality almost unappreciable. The half-tone reproduction was very muddy, destroying any tone value that the original drawing possessed.

The first volume opened with a Mark Twain serial—'The American Claimant' with drawings by Hal Hurst. Bernard Partridge supplied an illustrated artistic parable, and George Hutchinson the first of a series of literary portraits. A. S. Boyd, J. F. Sullivan, Dudley Hardy, A. J. Finberg, Ernest M. Jessop, Sydney Cowell, 'Cynicus', John Gülich—whose work suffered badly from the poor reproduction—the Misses Hammond and Richard Jack made up a strong and representative list of illustrators. 'Cynicus' was a Scotchman, Martin Anderson, who produced satirical cartoons—somewhat crude in drawing but popular in their direct appeal—and published them, hand-coloured, from a studio in Drury Lane. They were to be seen in most of the print-sellers' windows. To volume two Fred Pegram, Ronald Gray, Louis Gunnis, James Greig, G. G. Fraser and A. Hugh Fisher contributed, and Scott Rankin began a series of interesting caricature portraits of 'People I have never met'.

Volume three contained drawings by Adolph Birkenruth, J. St. M. Fitzgerald, Ernest Prater, Frederick Villiers, the war-correspondent, and S. L. Wood, whose vigorous style alone withstood the drastic reduction and bad printing. C. O. Murray, with some adequate pen-drawings of Mont St. Michel, was the principal newcomer to volume four, and Dudley Hardy, the Misses Hammond and Richard Jack, with some half-tone illustrations, rather weak in characterisation, also contributed. A. S. Boyd's experience on *The Daily Graphic* made his drawings more successful in reproduction. Volume five contained work by J. F. Sullivan, Stanley L. Wood, Hal Hurst and G. D. Hammond. In Seppings Wright's illustrations the drawing of the ships was more successful than that of the figures. Lewis Baumer's drawings were promising but too small to prove their full merits. To volume six Max Cowper, in line, T. S. C. Crowther, with some plain simple illustrations in wash, and W. H. Marget-

son contributed. In volume seven were some drawings of 'An ocean flyer', so good that one suspects them of being American. Walter Sickert had five scratchy pen-sketches of music-hall subjects, and Frank Brangwyn some good illustrations of the sea. Bernard Higham, Florence K. Upton (both rather poor), J. Barnard Davis, W. H. Margetson and Sydney Adamson also contributed.

So far *The Idler* page had been rather small, but with volume eight it was increased with advantage to the same size as *The Windsor*. There were very good illustrated appreciations of the work of the Beggarstaff Brothers, L. Raven-Hill, Melton Prior, H. R. Millar, G. du Maurier and Louis Wain. J. F. Sullivan and 'Yorick' supplied humorous pages, Lewis Baumer and Penryn Stanley some small 'thumbnails', J. Kerr Lawson eight pleasant chalk drawings, and R. Sauber a page illustration to a poem. H. R. Millar, A. S. Forrest, T. Walter Wilson, F. H. Townsend and Max Cowper also contributed, and there were ten fine drawings by Frank Brangwyn. The enlargement of the page had been accompanied by a corresponding increase in interest and *The Idler* was now at its best period. In volume nine the series of illustrated interviews with artists was continued with articles on A. Jule Goodman, who contributed to the volume as frontispieces six chalk drawings of 'Women of the Bible', Dudley Hardy, Hal Hurst, R. Sauber, E. T. Reed and T. Walter Wilson. W. Dewar did some good illustrations in chalk and wash, only spoilt by a peculiar tendency to make his girls very short in the leg. H. R. Millar's illustrations to Anthony Hope's 'Phroso' were not so successful in their realism as his work in more fanciful subjects. John Hassall had a humorous page and drawings were contributed by Dudley Hardy, Charles Pears, B. E. Minns, Lewis Baumer and Ernest Goodwin. There were also a delightful wash drawing by Walter Bayes at page 560, some illustrations in an original vein by S. H. Sime, and an example of the well-known collaboration between George Morrow as artist and E. V. Lucas as writer. An interesting and creditable volume!

R. Caton Woodville, Solomon J. Solomon, Phil May and

73. C. A. SHEPPERSON

From *A London Garland* (1895)

By courtesy of Gerald Shepperson, Esq.

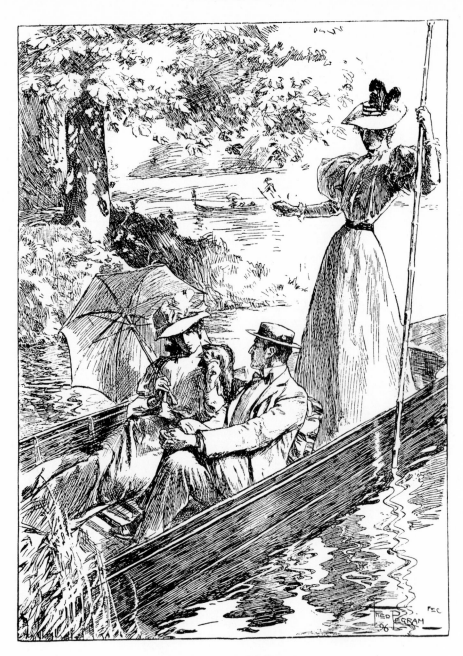

74. FRED PEGRAM

'Punting—the ideal', from *The Idler*

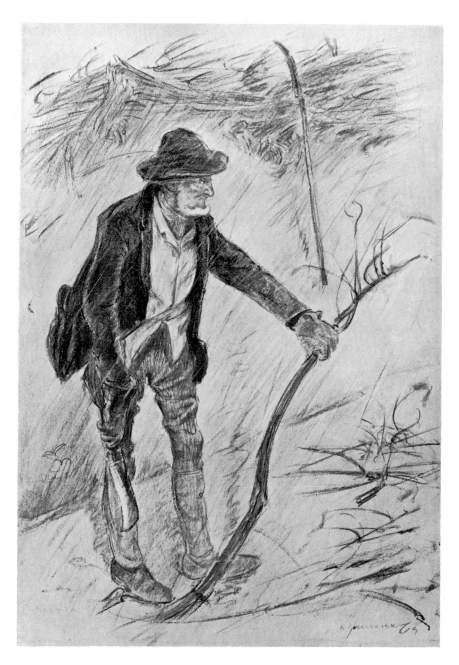

75. A. S. HARTRICK

'The Hedger'

Another of the series of country types from *The Pall Mall Magazine*

Original 15″ × 10½″

In the Print Room at the British Museum

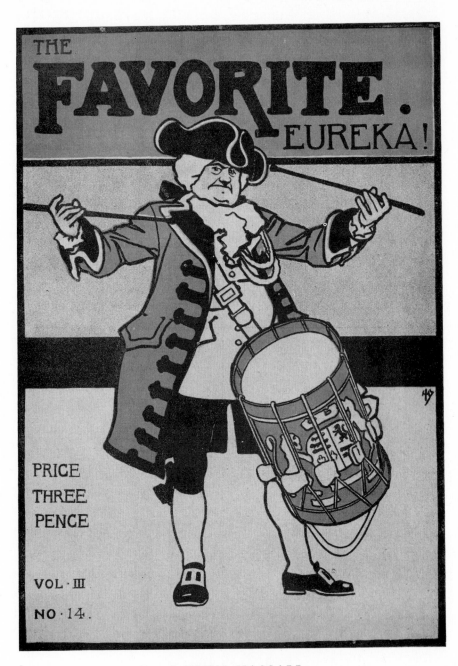

76. JOHN HASSALL
Cover design in blue and red on grey paper
By courtesy of A. R. Naumann

George C. Haité were the subjects for the interviewer in volume ten. A. S. Forrest and D. B. Waters (both with rather poor wash-drawings), Joseph Skelton, Frances Ewan, B. E. Minns (good pen-drawings), Starr Wood and Frank Gillett contributed illustrations. In volume eleven C. A. Shepperson's excellent colourful pen-and-ink drawings for Stanley J. Weyman's 'Shrewsbury', distinguished in themselves, showed a certain derivation from Vierge. Frances Ewan, Martin Stainforth and Malcolm Patterson also had some good illustrations. The series of interesting interviews was continued with Bernard Partridge, Aubrey Beardsley, Seppings Wright, Fred Pegram and Walter Crane as subjects. There was an excellent appreciation of S. H. Sime's work in volume twelve, and the 'Shrewsbury' illustrations continued and improved. Stephen Reid had three pen-and-ink illustrations to Herrick verses, in which the influence of E. A. Abbey is very marked. Leonard Linsdell and A. Campbell Cross (reminiscent of Greiffenhagen) also contributed.

Volume thirteen appeared with the imprint of J. M. Dent and Sons as publishers and without any index reference to artists. Max Beerbohm wrote appropriately on the work of Aubrey Beardsley. S. H. Vedder and Malcolm Patterson contributed good illustrations, A. S. Forrest was more in evidence, and George Morrow, T. H. Robinson, H. James (architectural drawings), Bernard Gribble and Thomas Downey appeared. Walter Raymond's charming series 'The Idler out-of-doors' was illustrated throughout with some good landscapes by W. A. Rouse. W. R. Russell and Co. appeared as the publishers of volume fourteen, and A. S. Forrest, as the designer of a delightful cover. Herbert Railton did some good drawings of Hampstead, Val Davis some pictures of Richard Jefferies' Coate, Stephen Reid three more Abbeyish designs, W. Cubitt Cooke some delicate and dainty illustrations, and H. A. Hogg some headings in line. S. H. Sime supplied some interesting drawings from the theatres.

With the May issue of volume fifteen *The Idler* passed to the joint editorship of Arthur H. Lawrence and S. H. Sime. No

publisher's name is given. Lawrence was a capable journalist with a keen interest in, and appreciation of, black-and-white art. Sime was one of the ablest and certainly the most original of the illustrators of the period, and together they produced some artistic and charming numbers of the magazine, despite the introduction of photographs. P. G. Konody wrote a short article on 'Some Modern Caricaturists', Lawrence an appreciation of the drawings of Edgar Wilson, and S. H. Vedder again illustrated a Walter Raymond story, 'No soul above money'. Other drawings were contributed by C. Dudley Tennant, J. L. Wimbush, Carton Moore Park and W. D. Almond, and there was a certain flavour of the Langham Sketch Club about the artistic side of the production. Sime himself appeared in varied mood and was always excellent. Something he may have derived from Doré and Beardsley, but his outlook was wider and his sense of humour much more highly developed. His methods of work, which were never monotonous, were entirely his own and not restricted in any way by fear of reproduction. Pattern and colour were introduced not as a cover but as an aid to capable draughtsmanship. His humour depended largely on a well-developed sense of the ridiculous and a healthy hatred of the conventional smugness and respectability of the great mass of his fellow-countrymen. Some of his drawings of the world of shades and spirits and his conception of the 'Woman of Char' have become classics among those who appreciate originality and quality in black-and-white art. A judicious collection of the best of his work would make an interesting book, which should be assured of popularity even in these restless and unsympathetic days.

Volume sixteen had much in common with *The Butterfly* and shared the work of many of its contributors. J. W. T. Manuel, O. Eckhardt, Max Beerbohm, F. C. Cowper, Gilbert James, Dion Calthrop, Carton Moore Park, Charles Pears and the editor contributed to both. Drawings were published for their merit and interest as drawings, without the need of literary connection. W. E. Wigfull, Philip Connard (very mannered and

77. OSCAR ECKHARDT
'Les Planches, Trouville', from *The Idler*

78, 79. WARWICK REYNOLDS

Nos. 1 and 2 of a series of four drawings from *Ally Sloper's Half Holiday*

80. WILLIAM HATHERELL, R.I.
'Between the acts at the Opera'
Double page illustration in wash, from *The Graphic*, 14 July, 1894. Original $15\frac{1}{4}'' \times 25''$
From the author's collection

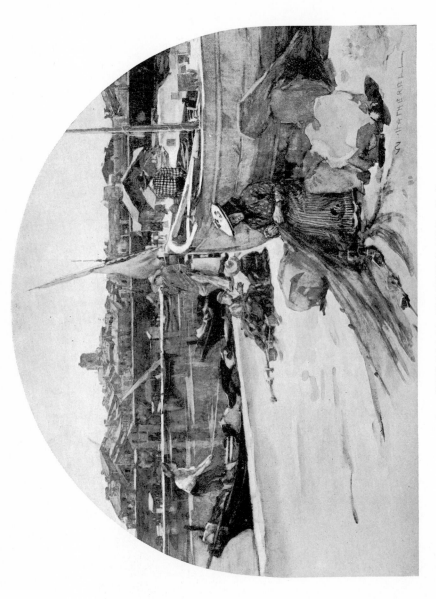

81. WILLIAM HATHERELL, R.I.

'Antibes'. Book illustration, from *The Picturesque Mediterranean*. Original $7\frac{1}{4}'' \times 9\frac{5}{8}''$

By courtesy of Charles Emanuel

very like Reginald Savage), J. J. Guthrie, H. Foley, E. T. Gurney and Dudley Hardy contributed some good work. Sime's work alone, and Gilbert James's excellent drawings, would have been sufficient to make this one of the most interesting magazine volumes ever issued. Volume seventeen, of which Horace Marshall appeared as publisher, contained some fine distinguished illustrations by F. C. Cowper, Norman Wilkinson (ships and the sea), Dion Calthrop, Max Beerbohm, Charles Pears, E. T. Gurney, F. Stahl, and another artist of originality of outlook with some of the feeling of the great men of the sixties—Henry Ospovat. Ospovat was a Russian who came to this country about 1897. He made some fine illustrations to Matthew Arnold's poems, Shakespeare's Sonnets, and Browning's 'Men and Women'. But he was also a very brilliant caricaturist, one of the greatest whose work has been done in this country. Unfortunately he died in 1909 at the early age of thirty-one, leaving a record of work which gave promise of very brilliant future achievement. In volume eighteen, the last with which we are now concerned, Sime did some burlesque novelette illustrations, Jasper Weird some good pencil-drawings, and Warwick Reynolds some studies of animals. Norman Maclean and Ernest Goodwin also contributed. Warwick Reynolds was a very capable young artist who did some excellent free pen-drawings in the pages of *Ally Sloper's Half Holiday*. Later he produced some finely-patterned illustrations—mostly for stories concerned with animals—particularly in *The Windsor Magazine*, and some notable etchings.

The development of *The Idler* from what was principally a good literary magazine with poorly produced illustrations to its artistic excellence under Sime's editorship is very remarkable. Unlike most English magazines, its record was one of steady and gradual improvement, particularly after the eighth volume. In its literary contents and illustrations it showed a strong sympathy and encouragement for black-and-white art, a sympathy reciprocated, as it usually is, by the excellent work of its contributors. In its later years it certainly reached the highest stan-

dard, and from an artistic point of view is worthy to stand with *The Pall Mall Magazine* and *The Butterfly* as one of the few examples of the best achievement of English magazine production during the nineties.

CHUMS

Founded by the house of Cassell, the first number of *Chums* appeared on 14 September 1892. Although it was an obvious attempt to capture some of the public of *The Boys' Own Paper*, it was more modern in character and in no sense an imitation. Its staff of artists was representative and capable, and included such excellent illustrators as Paul Hardy, William Small, H. C. Seppings Wright, Fred Barnard, J. Finnemore, C. J. Staniland, Gordon Browne, George Hutchinson, H. R. Millar and W. B. Wollen. W. S. Stacey and John Gülich supplied some excellent examples of pen-drawings, one by the latter on page 129 of the first volume showing a masterly manipulation of line. Humorous subjects were very capably dealt with by J. A. Shepherd, Jack B. Yeats, Charles L. Pott and René Bull, and in this respect *Chums* rather surpassed the older paper.

Holland Tringham, W. H. Overend, Stanley Berkeley, Frank Feller and Hal Ludlow also supplied drawings; and many fathers and uncles will still remember those wonderful accurate drawings of military uniforms by R. Simkin, who, among the boyish readers, was perhaps the most popular artist of them all. In addition to this wealth of illustration there were excellent stories by approved authors, and interviews with cricketers, footballers, athletes and experts in every subject of juvenile interest. There was no excuse for ignorance of the best methods of acquiring skill and proficiency in any of those enthralling occupations which appeal to boys. In volume two Tom Browne made an appearance with small drawings in humorous series, and other important accessions to the ranks were Ernest Prater, W. H. C. Groome, W. Hatherell and George Soper, among the illus-

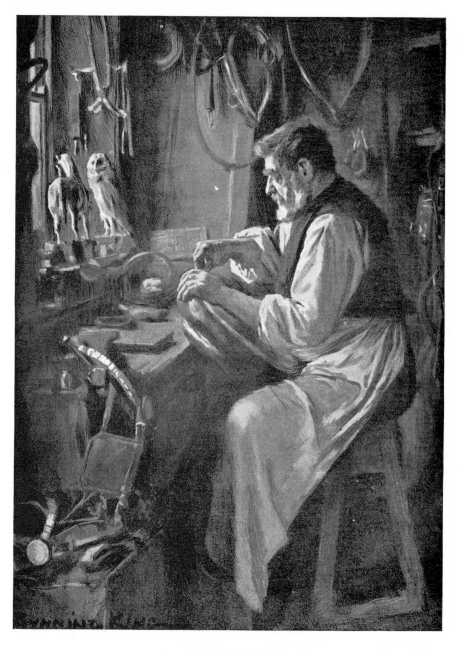

82. GUNNING KING

'The Saddler', from 'Life in Our Village': Drawn in wash
and body-colour. *The Sketch*

By courtesy of Alan Mackay

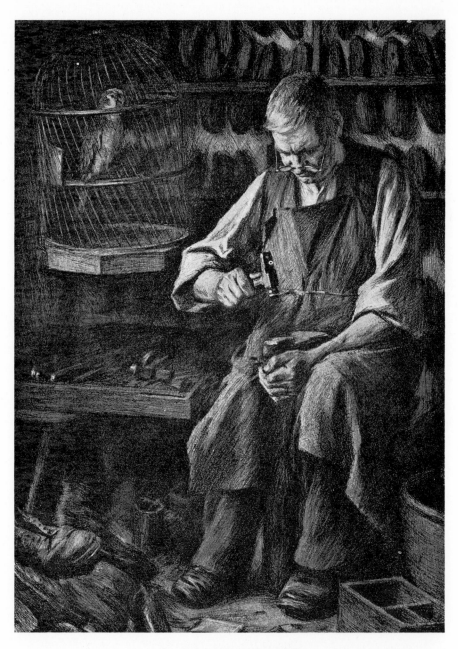

83. GUNNING KING
'The Cobbler', from 'Life in Our Village'. Drawn in wash
and body-colour. *The Sketch*
By courtesy of Alan Mackay

trators, and Thomas Downey, Charles Harrison and Starr Wood, among the humorists. In volume three Robert Louis Stevenson's *Treasure Island* appeared as a serial with illustrations by George Hutchinson, which were hardly worthy of the text. W. Rainey, G. C. Glover, T. W. Holmes, S. T. Dadd, W. G. K. Browne and A. Monro also contributed. The last became a very regular contributor. His work resembled that of Gordon Browne, and, considering its efficiency, it seems strange that it did not appear elsewhere.

To volume four H. M. Brock contributed drawings rather like those of his brother C. E. Arthur Rackham also appeared with illustrations surprisingly full of dramatic action. J. Ayton Symington and J. H. Roberts were other newcomers. Tom Browne and Jack B. Yeats continued to contribute regularly, and the former's work showed marked and rapid improvement. He was soon promoted to large story illustrations and even to frontispieces in colour, and his success produced the usual crop of imitators of his style. Louis Gunnis and Charles M. Sheldon contributed to later volumes. Gordon Browne disappeared after the first few numbers and Paul Hardy became the principal illustrator.

In its first eight volumes *Chums* maintained a high level of excellence in its illustrations and is interesting for its production of A. Monro and its encouragement, with such splendid results, of the work of Tom Browne.

THE PALL MALL MAGAZINE

T*he Pall Mall Magazine* was founded in 1893 under the joint editorship of Lord Frederick Hamilton and Sir Douglas Straight, with the evident intention of supplying a magazine which would appeal to readers of intelligence and, for the quality of its contents, would be worth keeping. The first number appeared in May with a dignified cover-design by Linley

Sambourne. Lewis Baumer illustrated with tiny thumbnail drawings a monthly *causerie* 'Without Prejudice', by Zangwill, Aubrey Beardsley contributed two pages which were not his best work, C. E. Fripp some half-tone drawings from China, and G. H. Boughton some wood-engraved designs for his own article. John Gülich did some charming story illustrations, Lawrence Housman some decorative borders in line for a Kipling poem, and Herbert Lindon some pleasant landscapes of Southwold. G. L. Seymour had three good full-page designs, and Sydney Adamson some accomplished illustrations. Other contributors were Sydney Cowell, T. H. Robinson (some rather weak line drawings), R.A.B. (Brownlie) and Hal Hurst, two artists whose work would have been much improved by occasional reference to a model. It was not artistically a very strong volume compared with some of those that followed. A novel feature of some modern magazines—derived, as so many are, from America—is the printing of page illustrations without margins. It will perhaps come as a surprise to some of these daring innovators to know that this was done in this first volume of *The Pall Mall Magazine* just forty-one years ago.

In a bulky second volume (November to April) Sydney Adamson maintained his good reputation, and G. H. Boughton contributed another illustrated article. Newcomers were Cecil Aldin, Abbey Altson (very photographic), R. Anning Bell, with two charming page decorations to a Norman Gale poem, A. L. Bowley, A. S. Boyd (some good drawings in wash and pen-and-ink), J. Barnard Davis, Biscombe Gardner (wood-engravings), A. Jule Goodman, with five full-page military studies and some good illustrations to a story by Thomas Hardy, James Greig, Arthur Layard, G. E. Lodge (natural history subjects), and W. H. Margetson. John Gülich did some very excellent illustrations for George Meredith's *Lord Ormont and His Aminta* quite in his best manner. In volume three H. Granville Fell contributed some conventionally decorative borders in the approved William Morris style, John Gülich was brilliant as ever, Thomas Macquoid had some very careful line-drawings for 'Hildesheim',

84. E. H. NEW

Illustration from *The Compleat Angler* by Izaak Walton

By permission of John Lane, The Bodley Head, Ltd.

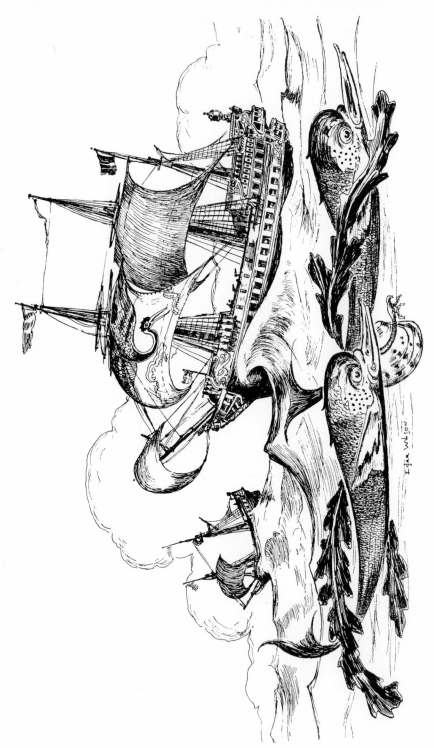

85. EDGAR WILSON

'Ships and dolphins', from a drawing in the author's collection

and G. Montbard illustrated two stories with excellent land-scapes and weak figures. C. A. Shepperson and Fred Pegram had some fine line-drawings but the latter was less successful in wash. Other contributors were G. H. Jalland, W. H. Overend (Gardens of Gray's Inn), R. Sauber and Alan Wright.

Volume four was not very distinguished artistically. Patten Wilson illustrated Walter Besant's 'Westminster', and F. S. Wilson a story by Rider Haggard ('Joan Haste'). Joseph Pennell did some fine drawings of the Embankment, 'Out of Our Window', and Balliol Salmon and Miss Sambourne contributed. In volume five there was a very generous allowance of illustrations. J. Walter West had some very charming drawings and R. Anning Bell two decorative designs, Edward King five illustrations, Geo. Roller a series of highly finished wash-drawings of fox-hunting, and E. H. New some small designs in line and wash. There were also some decorations by B. Mackennal, but history does not relate whether this was the sculptor who later became famous. Walter Russell contributed four pages of drawings, rather in the manner of Hugh Thomson, to volume six. Bis-combe Gardner supplied an excellent wood-engraving for the frontispiece, but truth compels the admission that this was *not* of the pretty girl so dear to the heart of the English magazine editor. In volume seven W. D. Almond had a nice line-drawing of 'Pierrot in half mourning', William Hyde some half-tone impressions of London, R.A.B. (Brownlie) an excellent drawing of 'An afternoon concert', S. H. Vedder some good story illustrations in grey body-colour, and Bernard Evans some rather elaborate landscapes. A. D. McCormick, W. Cubitt Cooke and F. S. Wilson were other contributors.

In the next volume Frank Chesworth, Herbert Cole, Max Cowper (effective but rather mannered and angular), C. J. de Lacy (drawings of barges), Hanslip Fletcher (good line-work), Frances Ewan (half-tone drawings of Knole), P. F. S. Spence (good half-tone decorations) and Enoch Ward made their appearance. In volume nine G. Rossi Ashton did some half-tone illustrations to Adam Lindsay Gordon, H. W. Brewer

some competent drawings of Dickens topography, and A. H. Buckland some rather detailed photographic designs. Volume ten contained some drawings by Biscombe Gardner to an article on 'Schlangenbad', some rather photographic illustrations by G. Greville Manton to R. L. Stevenson's *St. Ives,* and some very conscientious studies of birds—complete to the last feather—by Archibald Thorburn. H. W. Brewer had some interesting and masterly line-drawings of Old London Bridge in volume eleven; and A. Jule Goodman (army types in pencil), Frank Craig (line illustrations) and Hounsom Byles contributed to volume twelve. Frank Craig was also represented in the next volume but had not yet reached his best form, and Henry Mayer did some drawings in vivacious line.

In 1897 G. R. Halkett, who was already known as an art critic and the caricaturist of *The Pall Mall Gazette,* became art editor, and his judgment and selection undoubtedly improved the artistic side of the magazine. Three years later he took over the full duties of editor. G. D. Armour contributed a drawing in halftone and tint, symbolic of March, for volume fourteen. Sydney Cowell illustrated Anthony Hope's *Rupert of Hentzau* very accurately but rather soullessly; and Hanslip Fletcher as 'an artist in Antwerp' did some excellent drawings, very intricate and full of detail. H. W. Brewer, in succession to his 'Old London Bridge' in volume eleven, now had some equally interesting designs of Old St. Paul's, and Percy Wadham some placid pencil-drawings of South London for an article by Walter Besant.

For volume fifteen Armour did some line-drawings of Spanish scenes, Edgar Wilson a charming design of old Kensington Palace, and Balliol Salmon some tightly drawn figure subjects. Gordon Browne illustrated Evelyn Nesbit, and A. S. Hartrick and L. Raven-Hill did similar service for Indian stories. F. H. Townsend's drawings in wash were interesting and conscientious, but the lighting seems rather forced. Volume sixteen introduced Frank Brangwyn, and Raven-Hill illustrated no less than four stories. Volume seventeen also is strong on the artistic side. G. D. Armour, Frank Brangwyn, Frank Craig and Hanslip

Fletcher are names sufficient in themselves to justify this claim. Hartrick illustrated a story in his individual and unmannered method, Raven-Hill did three more, of which the first is the best, and Seppings Wright found a job after his own heart in making excellent drawings for Clark Russell's 'The Ship: her story'. S. H. Sime appeared, somewhat in the Beardsley manner. Volume eighteen contained worthy contributions by many of those we have already mentioned, with some pencil-drawings by Herbert Cole, some half-tones in the painter's method by John da Costa, some very good work by Hartrick in chalk and charcoal and some fine pen-drawings by E. J. Sullivan and Patten Wilson. Sime illustrated with thumbnails the monthly *causerie* 'From a London attic'.

Volume nineteen contained Flora Annie Steel's 'The hosts of the Lord', a serial with an Indian setting, for which Raven-Hill did some masterly illustrations. These, done in wash, loosely and skilfully handled, are as fine as anything he ever produced and representative of his best work. To those who know Raven-Hill's work only in these later days I would suggest reference to these drawings to prove what a great black-and-white artist he was then. Frank Brangwyn, F. H. Townsend and J. Walter West also made some excellent illustrations. In volume twenty we have some fine drawings by Joseph E. Crawhall—an infrequent contributor to magazines—reminiscent of Japanese wood-cuts and illustrating an article on pig-sticking. There were also some drawings by Cyrus Cuneo, of which that on page 502 is a beauty. To volume twenty-one Hartrick contributed two interesting studies in coloured chalk of real country types, Hanslip Fletcher some wash-drawings of Oxford, E. J. Sullivan some excellent imaginative illustrations in line, and Edgar Wilson a fine double-page decoration to a poem. As Raven-Hill's drawings were continued, this was a very strong period. The high level was well maintained in the last volume of 1900, in which 'The hosts of the Lord' was finished. Hartrick had two more country types, Arthur Garratt some fine illustrations, and E. J. Sullivan some excellent drawings for two stories. These drawings of

country types were made in Gloucestershire. Maurice Hewlett was interested in them and, with the aid of the National Collection Fund and some friends, bought most of them and presented them to the British Museum. Some others are in galleries in Australia and New Zealand.

It is difficult to write of *The Pall Mall Magazine* without enthusiasm. It was ably and intelligently edited, and gave its readers the best available fare, whether it was 'what the public wanted' or not. The standard of contributions, literary and artistic, was high and well maintained, each monthly issue containing a well-produced frontispiece of interest and merit, and each volume a very efficient index. The illustrations displayed great variety in method and treatment, and although some approached very nearly to the photograph, the best of them were brilliant and artistic. Those volumes which we have considered reached the very highest level in English magazine production, and made the *Pall Mall* one of the greatest we have ever had in this country and worthy to rank with the best of American publications. Unlike so many English magazines, it gave its readers credit for intelligence and discernment.

THE BUTTERFLY

After much that was frankly commercial, it is refreshing to turn to *The Butterfly*, 'a humorous and artistic monthly', edited by L. Raven-Hill and Arnold Golsworthy, who had already been associated—particularly in the theatrical criticisms—in *Pick-Me-Up*. The first number appeared in May 1893, with a long narrow page, and a delicate primrose cover, bearing a design by Edgar Wilson, which was replaced in number two by one more effective. There was at the outset a delightful feeling of irresponsibility about the conduct of the new magazine. One feels that the editors, who were also the proprietors, printed what they themselves appreciated, without having to keep a nervous

eye on a soulless dividend-seeking board of directors. All the work was contributed without payment by enthusiastic supporters who wanted to produce something better than the work they had to do for editors.

To the first number Raven-Hill contributed no less than twenty-three drawings, but this was probably due more to a necessary sense of economy in expenditure than to any spirit of self-assertion. Oscar Eckhardt had three illustrations and Maurice Greiffenhagen a distinguished frontispiece. The other artistic feature of the production consisted of some charming decorations by Edgar Wilson, whose work has never received the recognition that it deserves. Wilson showed that it was possible to make decorative drawings that owed nothing to the anaemic convention and tradition of the art schools. They were entirely the product of his own invention and fancy, sound and virile in drawing and design, with a fine sense of distribution of black and white, stimulated probably by a study and love of Japanese prints. Wilson was also a delightful and original etcher, whose prints are treasured by a few discerning collectors.

In the June number Greiffenhagen had some very beautiful illustrations richly suggestive of colour, and Wilson some more delightful decorations. Raven-Hill and Eckhardt supplied the remainder of the drawings. The same four artists contributed in July, with a definite advance in quality in Eckhardt's drawings and some fine 'Stone Age' illustrations by Raven-Hill. In the next number Greiffenhagen had some luscious drawings for 'Apamé' which suggest that he might have made a good illustrator for Omar Khayyam[1]. Paul Renouard contributed a fine study of an old man, and J. F. Sullivan some illustrations to his own story. Raven-Hill was as diversified and satisfactory as ever, and in the September number he did some amazingly original drawings of gladiators. On page 314 is an unsigned wood-engraving which suggests Sauber, but it would not surprise me to learn that Raven-Hill did this too. In October Eckhardt set out to do some Renouards and nearly suc-

[1] He did illustrate an edition published in 1909.

171

ceeded. Greiffenhagen had two interesting impressions of Polperro.

Volume two opened with some excellent Ghetto studies by the art editor, which were continued through several numbers. Greiffenhagen had some graceful story illustrations, and Reginald Savage and Adolph Birkenruth made undistinguished appearances. Paul Renouard contributed two more fine studies of old men. And then at the end of the tenth monthly number came the sad announcement that, owing to insufficient support, *The Butterfly* could no longer continue to flutter. Perhaps, from the point of view of the public, a wider range of contributions and a little more variety in the contents might have lengthened its life. But the sad truth was proved once again that the art of black-and-white drawing which was so delightfully exemplified in its pages has very few admirers in this country—too few, at any rate, to support a magazine devoted principally to displaying its attractions.

The explanation here suggested appears to have occurred to the two editors, for when five years later, in March 1899, another venture was made, a more diversified programme was presented, and to the five or six men who were responsible for the first production many more were now added. Arthur Morrison, H. D. Lowry, Walter Emanuel, Barry Pain, and Adrian Ross strengthened the literary side, and J. W. T. Manuel, Max Beerbohm, S. H. Sime and Joseph Pennell added to the artistic attraction of the first number. Greiffenhagen and Raven-Hill were as charming as ever, Edgar Wilson continued his decorations, although not quite so often as before, and Max's caricatures and Sime's weird and wonderful fancies were delightful features. Smaller in bulk than the earlier numbers, the new production fully maintained the high standard set in 1893. Joseph Pennell's work was decidedly 'Whistlery', and was rather outdistanced by Edgar Wilson's more definite drawings. Manuel's football studies were full of action and colour, but with cricket subjects he was not so successful. Wilson's little etchings of George Street, Strand, on page 133 and The Point, Portsmouth,

on page 161 are very delightful. Hartrick had a nice chalk drawing on page 174, Maurice Greiffenhagen's frontispiece opposite page 186 is delightfully decorative and colourful, and Raven-Hill's study of Liza (page 245) is a little masterpiece.

Volume two opened with another beautiful drawing by Raven-Hill and a study of bull-fighting by G. D. Armour very much under the influence of Joseph Crawhall. Dion Clayton Calthrop had delicate little pen-drawings on page 43 and page 69, Raven-Hill an exquisite study of 'Honesty' on page 77, and Gilbert James a nice drawing on page 91. F. C. Cowper appears on page 146, and on page 155 Manuel's death is lamented. Joseph Pennell's 'White and Grey', a wintry study of the Thames, is very beautiful. Frank L. Emanuel had an interesting drawing of Dieppe on page 219, and Carton Moore Park a drawing of a leopard on page 228 and another of a panther (not so good) on page 259. G. R. Halkett's caricature portraits are interesting, but suffer by comparison with Max Beerbohm's more imaginative creations. Throughout the volume are reproductions of Japanese prints, the inspiration of so many of the drawings.

And so after twelve numbers *The Butterfly* once more disappeared, this time without any explanation or expression of regret. The enterprise was magnificent, the production excellent throughout. It was just too good for the public. In a delightful introductory 'apology' to the first number the editor stated frankly that they had no 'mission'. But, unconsciously perhaps, they most certainly had. Their mission was to try to convince the dear old British public that a magazine need not necessarily be exactly like all its predecessors, that it was possible to be frivolous and lighthearted and yet produce excellent work, and that a good drawing was worth printing, even if it had no joke or quotation from a story beneath it. And right worthily they strove. No magazine, in England at any rate, has contained in a short life of twenty-two months such a wonderful collection of fine black-and-white work. From this point of view it is undoubtedly the most artistic periodical publication we have ever

had, fully representative of the best work of the nineties, and its failure is a reflection on the deplorable lack of intelligence and appreciation in this country. For Raven-Hill it was a consummate triumph, and proves him to have been one of our best art editors as well as one of the greatest black-and-white artists—perhaps actually the greatest—that England has produced. No one in this medium has ever equalled him for versatility, invention, design, humour, variety of method and artistic feeling. Considering his amazingly large output, it is wonderful that he should have produced so little that was unworthy and so very much that was excellent. A very great artist!

THE WINDSOR MAGAZINE

As a result of the success of *The Strand Magazine* the *Windsor* was founded in 1895 by the publishing firm of Ward, Lock and Co. It had a pleasant green cover with a delightful drawing by Herbert Railton embodying a view of the royal castle from the river. It is difficult to imagine why these characteristic and distinctive cover-designs are abandoned for the usual portrait of a grinning female, which is the modern editor's only idea of attractiveness. This quaint custom reduces them all to a monotonous uniformity, which makes it much more difficult (even if it is necessary) to distinguish them on the bookstall.

The illustrations in the early numbers of the *Windsor* were larger than usual and in some instances filled the page. They were generally badly reproduced, particularly the half-tones, which were often unnecessarily and badly vignetted or engraved. The line drawings were more successful. Many of the artists in the early numbers were already connected with *The Daily Graphic*. T. S. C. Crowther, G. K. Jones, R. B. M. Paxton, Herbert Johnson, James Greig, A. Kemp Tebby and Oscar Eckhardt may be mentioned as examples. These, so long as

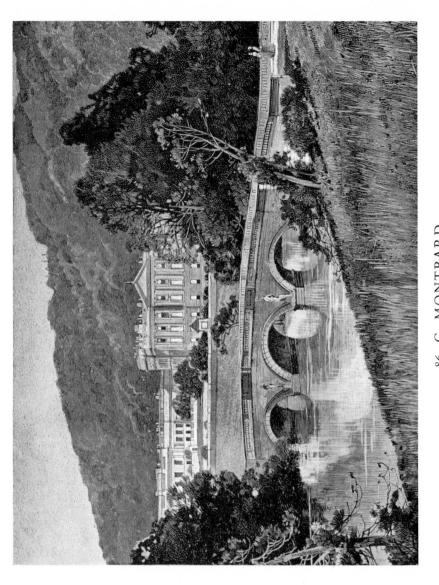

86. G. MONTBARD

Double page wood-engraving from *The Illustrated London News*,
29 October, 1892

87. WILLIAM NICHOLSON
Woodcut illustration in black, brown and red, from *An Alphabet*
(Heinemann, 1898)
By courtesy of the Artist

they kept to pen-drawings, were successful, but their wash-drawings lost considerably in half-tone reproduction. Stanley L. Wood's strong designs for *Dr. Nikola* were to some extent proof against this drawback, and Cecil Aldin was also successful. Richard Jack, J. Jellicoe, J. Ayton Symington, Bertha Newcombe and Herbert Railton were also contributors to the pictorial side, and, as a concession to the strange sentimental love of the public for human animals, Louis Wain had some drawings of cats. Phil May was represented by a study of a monk. Instead of Conan Doyle's 'Sherlock Holmes', Arthur Morrison produced 'Martin Hewitt'.

The second volume showed great improvement in reproduction. F. H. Townsend had some good illustrations in chalk and wash and Ernest G. Beach some line drawings of fishing. Sydney Cowell (rather photographic), P. F. S. Spence, Lancelot Speed, W. Cubitt Cooke and Warwick Goble were other artists whose work calls for no special description. Later came Montague Barstow (even more photographic), Raymond Potter, Oscar Eckhardt (much improved) and A. C. Gould, a weak solution of his father, 'F.C.G.' To volume four Harold Copping contributed some good honest drawings in wash, broadly handled and effective in reproduction, James Greig some competent Parisian scenes and types, and J. Barnard Davis some sound illustrations. F. S. Wilson, Will Owen, George Morrow and St. Clair Simmons were also adequately represented. J. Barnard Davis illustrated Hall Caine's serial *The Christian* in the next volume (1897) with some very satisfactory drawings in line, wash and pencil. C. A. Shepperson made a rather undistinguished appearance, R. W. Arthur Rouse, an artist who deserved to be better known, did two interesting landscape drawings of Cambridge, and Will Owen illustrated W. W. Jacobs's *The Skipper's Wooing*. Harold Piffard and Frances Ewan also contributed.

With volume seven (1898) we have a distinct advance in the prestige of the illustrators. E. J. Sullivan, S. H. Sime, Maurice Greiffenhagen, G. D. Armour, Edgar Wilson, A. Forestier and

R. Sauber all contributed drawings. There was an illustrated appreciation of Raven-Hill, and G. Montbard demonstrated conclusively that a man who can draw landscape very well may draw figures very badly. In June, Arthur Hutchinson became editor, and with wide knowledge and sympathy successfully directed the fortunes of the magazine until his death in August 1927. Volume eight was not very distinguished on the artistic side. Harry Furniss illustrated his own article on Australia, John H. Bacon supplied drawings for Guy Boothby's *Pharos the Egyptian*, and A. H. Buckland, Adolph Thiede and Victor Prout, in half-tone, and W. D. Almond, in line, were represented.

In volume nine appeared Rudyard Kipling's *Stalky and Co.*, and Raven-Hill's illustrations showed him at his best, although some of them lost considerably by being printed in coloured and anaemic ink. Frank Dadd did some competent drawings for Crockett's *Joan of the Sword*, and Abbey Altson, Frank Richards, whose work was now stronger, and R. Caton Woodville also contributed.

In volume eleven H. M. Paget adequately illustrated the serial by Robert Barr, and there were good drawings by Cecil Aldin, and others by Malcolm Patterson, Edward Read and Harry Furniss (Canadian sketches). Some very ordinary illustrations by J. Finnemore and Warwick Goble in volume twelve suffered by comparison with some excellent drawings by an American artist—Henry Hutt—to a story imported from *McClure's Magazine*. Stephen Reid, very much under the influence of E. A. Abbey, illustrated Herrick (in Georgian setting and costumes!), Charles Pears had some humorous eccentricities, Bertha Newcombe some pleasant realistic drawings, J. A. Symington some sentimental, rural types, and Gunning King some fine honest work in wash.

Unlike the *Strand*, *The Windsor Magazine* had no art editor to direct this side of its contents, but if it produced no sensational discoveries during the period under review, the general level of the illustrations was satisfactory. It relied mainly on artists of

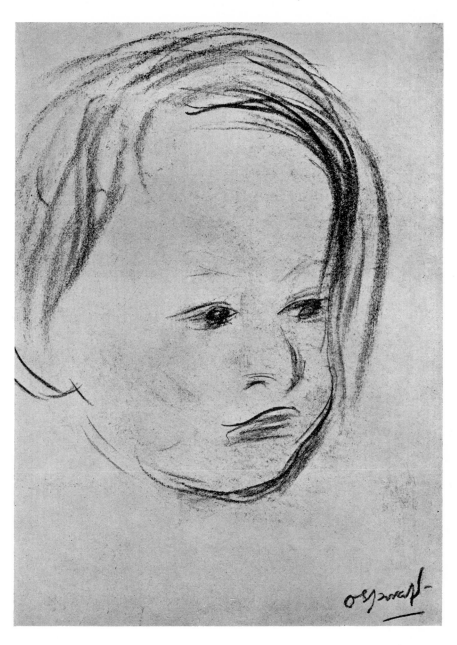

88. HENRY OSPOVAT
Study in chalk
Original $5\frac{3}{4}'' \times 4\frac{1}{4}''$
In the Victoria and Albert Museum, Bequeathed by Hans Velten

89. HENRY OSPOVAT
Study in chalk
Original $5\frac{1}{4}'' \times 3\frac{3}{4}''$
In the Victoria and Albert Museum, Bequeathed by Hans Velten

established repute without attempting to seek out and develop young and promising men, and of those who worked regularly for the magazine the greatest was L. Raven-Hill.

THE MINSTER

Founded in January 1895, and published by A. D. Innes and Co., *The Minster* had originally a certain ecclesiastical flavour which was reflected in the design of its cover. To the first volume Linley Sambourne contributed a cartoon and two much condensed but well informed articles on 'The Progress of Black-and-White'. His daughter, Miss Maud Sambourne, had some simply handled wash-illustrations, uneven but promising, Miss G. D. Hammond some pencil-drawings, and Warwick Goble some rather unworthy examples of his work. Volume two contained the third and concluding article of Sambourne's short review; Sydney Cowell illustrated the serial, and J. F. Sullivan had some very tiny drawings for Barry Pain's *causerie*. Hal Hurst, Florence White and A. Jule Goodman also contributed. Volume three appeared under new management with a pleasant, simple cover and nothing of the original character apart from the title. L. Raven-Hill contributed joke drawings and illustrations, R. Sauber some page drawings, and Dudley Hardy some good illustrations in wash. Max Cowper, Lewis Baumer, J. Kerr Lawson, Hal Hurst, with some more meaningless smartness, Walter Wilson, H. R. Millar, Sydney Adamson, 'Yorick', S. H. Sime, J. W. T. Manuel, B. E. Minns, G. Montbard, Gordon Craig and Fred Pegram were other artists in a very promising volume. There was also a symposium of artists' types of female beauty, but some of the examples were not, I hope, sincere. Unfortunately even these distinguished names were not sufficient to ensure the continuance of *The Minster*.

PEARSON'S MAGAZINE

This was another sequel to the remarkable success of Newnes's *Strand Magazine*. It appeared in January 1896, in an unpleasant light yellow cover with a photographic design, and its first volume contained illustrations by many of the artists whose work we have already noticed in other publications: R. Caton Woodville, Robert Sauber, G. G. Manton, Sydney Cowell, A. Forestier, Chris Hammond, A. Jule Goodman, J. F. Sullivan (with a masterly satire, 'The Great Water Joke'), Harold Piffard, Trevor Hadden, Kemp Tebby, George Rossi Ashton, Cecil Aldin, Shérie, Stanley L. Wood, Holland Tringham, Warwick Goble, Abbey Altson, J. Barnard Davis and Harry Furniss. An imposing enough list, but the reproduction was often unsatisfactory, and the illustrations were too small. Many of these also approached too nearly the close photographic resemblance so dear to the editorial mind of the period. Half-tone blocks were 'deep etched'—the whites cut away with a sharp edge, thus destroying the relation of the tone values—or vignetted, without any discretion or artistic supervision. No mention was made, either under the drawings or in the index, of the names of illustrators. Volume two was memorable as containing twenty pages of verse and drawings by J. F. Sullivan, and Charles May (elder brother of Phil) illustrated W. L. Alden's 'Wisdom let Loose' with thumbnail drawings. H. G. Burgess and A. S. Hartrick also contributed. Stanley L. Wood visualised 'Captain Kettle' in volume three, and A. J. Gough (not at his best) did some drawings. Kettle, with his trim pointed beard, his invariable expression of alert surprise, cap tilted over one eye and vertical cigar stuck in the end of his mouth, remained a very popular feature during several years both in the pages of the magazine and in the outside world.

In volume four E. J. Sullivan and L. Daviel were introduced, as well as a disastrous system of printing some of the illustrations in coloured inks—brown and green—when black would have

been far more effective. B. E. Minns, Lawson Wood (some immature pen illustrations) and Raymond Potter were newcomers to volume five, and there were some very refreshing drawings by E. J. Sullivan. The editorial indifference to the merits of his artists' ability is shown by the introduction of illustrations to stories and articles from specially taken photographs. Apart from the regrettable admission of lack of artistic taste, the experiment cannot be considered a success. The monotony of the repetition of two identical figures—there were seldom more —carefully and stiffly posed, with no attempt at an appropriate setting, was sufficient to convince anyone but an editor that the novelty was a failure.

In volume six Raven-Hill did some excellent drawings for Rudyard Kipling's 'Stalky' stories. The index announces this fact by the stark entry 'In Ambush: Fiction'! If the merit of the contributors was unrecognised, surely the commercial value of two such distinguished names was worth exploiting. J. G. Millais contributed some conscientious drawings of South African animals, D. Murray Smith some poor wash-illustrations and Powell Chase some modifications of S. L. Wood's style of work. Ernest Prater, W. Dewar and Arthur Garratt were more successful. In some of the illustrations coloured inks were again used, and in volume eight these were applied with even more ghastly effect to the printing of photographs. The inspired selection of Raven-Hill as Kipling's perfect illustrator was neutralised by the substitution of G. Montbard's efforts, which were signally unsuccessful. The serial was adorned with more photographic illustrations of very modern figures in period costume, and A. H. Buckland had some drawings which must have given the editor almost equal joy. The two bright spots were the small drawings by Tom Browne to W. L. Alden's 'Life's Little Mysteries' and those by A. S. Hartrick. E. J. Sullivan's illustrations suffered severely from over-reduction. W. D. Almond and W. Dewar contributed to volume ten, and Lawson Wood made some drawings of prehistoric monsters. Later he developed this vein of humour with such success that he

was generally credited with the honour of its invention, which really belonged to E. T. Reed of *Punch*.

From an artistic point of view *Pearson's Magazine* in these early years formed an almost perfect example of how not to do it. Many of the more glaring indiscretions have been indicated already, but even when excellent illustrations were supplied these were often ruined by over-reduction, carelessly made or mutilated blocks and the use of unpleasant coloured inks. The whole production cried aloud for the supervision of a competent art editor with taste and discrimination. Yet *Pearson's Magazine* flourished and continues, and *The Butterfly* died. Further comment is needless; but *The Butterfly* had no Captain Kettle!

THE TEMPLE MAGAZINE

Volume one appeared in October 1896, with no mention of artists' names either in its pages or in the index. Chris Hammond, Harold Copping, A. Twidle, Frank Craig (some very early work), St. Clair Simmons, Sydney Cowell, J. Barnard Davis in both line and wash, James Greig, W. S. Stacey and Bertha Newcombe (honest, homely illustrations) were some of the principal contributors. W. Rainey had some good line-drawings of Holland in volume two, and there were others by Adolph Thiede, L. Daviel, J. Ley Pethybridge and Herbert Railton. In volume three Will Owen, W. Dewar (wash-drawings), Ralph Cleaver, Stephen Reid, David Wilson (some very early work in line) and James Aylward appeared. John Foster Fraser is credited with the editorship of the fourth volume, to which Frances Ewan, James Durden, T. S. C. Crowther, Stephen Reid (some poor line-illustrations), F. Reason and Frank Hart contributed. In volume five Charles D. Ward had some capable illustrations to the serial story, and Sydney Cowell some others, soundly drawn but lacking in personality. R. Pannett showed considerable dash but not much drawing.

90. J. BERNARD PARTRIDGE
Henry Irving as 'King Lear'. Wash-drawing. 1892
By courtesy of the artist

91. JOSEPH PENNELL
'White and Grey', from *The Butterfly*, vol. ii, 1899-1900
By courtesy of Mrs. Joseph Pennell

There was little to justify the appearance or survival of *The Temple Magazine*—little originality or excellence either in contents or production—and so it inevitably joined the many other examples of the great unwanted.

THE QUARTIER LATIN

This was a small magazine, in shape rather like *The Butterfly*, published monthly from July 1896 by the American Art Association in Paris and by the firm of Iliffe and Co. in London. It was largely the work of art students, who not only supplied illustrations but made charming designs in black and red for the cover and the advertisement pages. Among the principal contributors of drawings were Henry G. Fangel, William Shackleton, H. H. Foley, H. O. Tanner, Alfred Garth Jones (very distinguished both in line and wash), Campell Cross, G. Oliver Onions (later more famous as a writer), Charles Pears (with various impressions in mist), James J. Guthrie and H. A. Hogg (now better known as a skilful engraver). In May 1898 Messrs. J. M. Dent and Co. took over the publication in London, and a number of more experienced English artists contributed drawings. A. S. Forrest did four excellent 'Last studies of Gladstone' in the March number. Gilbert James, Philip Connard (pen-drawings reminiscent of Reginald Savage), W. Edward Wigfull (illustrations of ships and the sea), Dion Calthrop, W. E. Webster, James Durden and Jack B. Yeats (with very spirited pen-drawings) also contributed. Unfortunately *The Quartier Latin* received little publicity, and its appeal was very limited, with the result that it passed away quietly in March 1899. It was a very pleasant and charming little magazine and deserves credit for giving introduction and encouragement to many young artists. Garth Jones in particular developed later into a very skilful decorative illustrator and embellished several books with his designs.

EUREKA

This was a curious little magazine which, started in April 1897, contained full programmes of all the London theatres and a strange mixture of photographs and old-fashioned drawings in its illustrations. It is of importance because of the appearance in its pages of that very distinguished and original artist S. H. Sime, who was at one time in its career owner and art editor. His interest seems to have started with number four, to which he contributed 'The Felon Flower', 'Sal' and an un-named drawing on page 43. In number five he had a portrait of Beerbohm Tree in a series of 'Men and Women of To-day', 'The Mermaid' (page 31), and 'Death and the Woman'. J. W. T. Manuel and O. Eckhardt also contributed to this issue. Number six contained 'Melancholy', 'The Blue Anchor' and 'H. D. Lowry' by Sime.

With volume two an addition was made to the title which appeared as *Eureka: The Favorite Magazine*. Later the first part of the title was dropped and it was known as *The Favorite Magazine*. The pagination is very erratic, and in the bound volume at the British Museum pages 256 to 323 are apparently missing, but eventually appear much later as the number ten issue. The first part of the new volume contains a dozen or more of Sime's drawings as well as contributions by Tom Browne, John da Costa, O. Eckhardt, Dudley Hardy, J. W. T. Manuel and Alick P. F. Ritchie and a caricature of Arthur Roberts by Max Beerbohm. Sime was also the principal contributor to number eight, but then he disappeared, after having designed covers for September, October, November and December, and there is little of interest in the subsequent numbers. Phil May had a drawing of Courtice Pounds and Norman Salmond in number eleven, to which H. R. Millar also contributed. John Hassall did some cover designs, notably one of a burly drummer, and the illustrations were supplied, apparently in a great hurry, by Tom Wilkinson. Even these were poor substitutes for Sime. A strangely

muddled and irresponsible production, *Eureka* would have been completely forgotten but for the intervention of its one distinguished contributor.

THE ROYAL MAGAZINE

Published by the firm of Pearson in November 1898, *The Royal Magazine* was apparently a quite unnecessary effort to produce a cheaper form of *Pearson's Magazine*. It appeared in a horrible red, yellow and black photographic cover, and was preceded by announcements of a first edition of a million copies which, placed end to end, would cover a shameful length of road, and piled one on another would make St. Paul's Cathedral and even the Eiffel Tower blush for shame. But this hardly seems to be the real mission of a magazine! It contained a series of 'Snapshot Interviews' and examples of the 'Art of the Camera', which were sufficient in themselves to disprove their titles.

Those illustrations which were less offensive were supplied by Alec C. Ball. M. Barstow (grimly photographic), Lewis Baumer (conscientious line work), Tom Browne (broad comedy), Harold Copping, J. Barnard Davis (both excellent), G. H. Edwards, Arthur Garratt (with good half-tone), A. J. Gough (with something of Gülich's manner but less of his charm and refinement), Louis Gunnis, J. Macfarlane, Marie Miles, Leslie Willson (humorous pages), Edward Read and F. H. Townsend.

Volume two contained some good illustrations in wash by Victor Prout, some very conscientious pen-drawings by Sydney Aldridge, dramatic seascapes by Henry Austin, and capable work by Harold Copping, Leonard Linsdell, C. H. Taffs, Wallis Mills, Raymond Potter and E. F. Skinner. Volume three showed a slight improvement, with a designed cover of no great merit. Victor Prout made many appearances as an illustrator, and C. Lawson Wood did a series of drawings of battle scenes the merit

of which was spoilt by absurdly exaggerated reduction. Other contributors were Ralph Cleaver, J. Barnard Davis, Frances Ewan, R. P. Gossop (a page line decoration to a poem), Wallis Mills (careful and stiff wash-illustrations), E. F. Shérie, E. F. Skinner and C. Dudley Tennant. In volume four were illustrations by J. J. Cameron, Norman Hardy and R. Pannett (very slick but without much sound drawing). The statistical article with diagrams was a very frequent and prominent feature. J. J. Cameron was the principal illustrator in volume five, with even more appearances than Victor Prout, and Clement Flower, Wilmot Lunt, Malcolm Patterson and Popini were other contributors.

It cannot be said that *The Royal Magazine* supplied any want, long felt or otherwise, nor was its appearance justified by the novelty or quality of its contents. It was simply another item in that flood of imitative publications, many quite unnecessary, that resulted from the success of *The Strand Magazine*. In 1930 it changed its title to *The New Royal Magazine* and in 1932 to *The Royal Pictorial Magazine*.

THE WIDE WORLD MAGAZINE

The first number of this magazine, devoted to true stories of adventure and published by Newnes, appeared in April 1898. Its list of illustrators included W. S. Stacey, W. Christian Symons, J. Finnemore, Alfred Pearse, C. J. Staniland, Warwick Goble, W. B. Wollen, Norman Hardy, C. A. Shepperson and J. L. Wimbush—all competent men for this sort of work. In an early number the record of the amazing adventures of Louis de Rougemont was begun, and twenty-four pages were devoted to the first instalment. Fuller reference is made to these in Chapter VI, in connection with Phil May. For a long time they were by far the most important feature of the magazine, whose editor was in great measure responsible for instigating

some of the most surprising features of the narrative. The motto of the magazine was, 'Truth is stranger than fiction', and, as a literary contemporary added, De Rougemont was stranger than both.

Volume two introduced A. J. Johnson, Charles Kerr and Charles M. Sheldon as illustrators, and Paul Hardy appeared in volume three. Most of the illustrations were necessarily literal records of the events described, with a slight addition of artistic invention. Gradually drawings were superseded, as usual, by photographs, and in volume six (1900) of one hundred and seven contributions mentioned in the index only thirty-four are illustrated by drawings.

CHAPTER V

SOME QUARTERLIES AND ANNUALS

THE HOBBY HORSE

This was a quarterly started in 1886 and published by the Century Guild. The initials and tail-pieces were the work of Herbert P. Horne, but with the exception of occasional lithographs by C. H. Shannon, a page of studies by Frederick Leighton and some embroidery designs by Selwyn Image in volume five, the illustrations consisted of reproductions of paintings and are therefore not eligible for inclusion in our record. It appears to have disappeared after volume eight, which was dated 1893.

THE QUEST

Published by Cornish Brothers, of Birmingham, and printed at the press of the Birmingham Guild of Handicraft, the first number appeared in November 1894 in a limited edition of 300 copies. The illustrations, which reflect the William Morris influence, consisted principally of decorations and initials, and architectural and topographical drawings in line. Of these the best work was contributed by Edmund H. New, who was always interesting, Charles M. Gere, Henry A. Paine and G. T. Tarling. In later numbers, which appeared at intervals of four months, were drawings by Sheldon Williams, Evelyn Holden, Sydney Meteyard, M. J. Newill, J. Southall and F. W. Faux. The magazine, which showed a pleasant page and type, seems to have died after the sixth issue in July 1896.

186

THE YELLOW BOOK

Few publications have attained a wider notoriety, both before and after the event, than *The Yellow Book*, published by Elkin Matthews and John Lane at the height of the Aubrey Beardsley boom in April 1894. The preliminary announcements, of which there were many, were designed to prepare us for something daring and possibly even shocking; but looking back through the volumes, it is difficult to imagine that any of the contents could have brought a blush or tremor to the most fastidious of Victorian spinsters. Beardsley acted as art editor, and Henry Harland was in charge of the literary side, and under the anxious supervision of John Lane they produced a magazine with a certain novelty of design and arrangement, but without much claim to any special or sensational brilliance.

For the first volume a very ordinary study in chalk of a draped figure by Sir Frederick Leighton, P.R.A., formed the frontispiece. Beardsley's own contributions were original in the bold use of masses of black but weak in drawing and not very attractive. The 'Night Piece' is poor and uninteresting, and the portrait of Mrs. Patrick Campbell has no particular merit. Joseph Pennell's 'Le Puy en Velay' is very like an old Italian drawing. Walter Sickert's 'The old Oxford Music-hall' is interesting but not remarkable, and the 'Lady reading' is weak and shapeless. Will Rothenstein's 'Portrait of a Gentleman' is better than his 'Portrait of a Lady', which lacks grace. Laurence Housman's 'The reflected Faun' is very conventional and unconvincing; Charles W. Furse's 'Portrait of a Lady' is pleasing, but the chair back is ugly and unnecessary. J. T. Nettleship's 'Head of Minos' does not seem to matter.

Volume two opened with a reproduction of a painting by Walter Crane. A. S. Hartrick introduced a note of refreshing sanity with 'The Lamplighter' on page 60. Each artist's drawings were grouped together, and at page 85 we have six by Aubrey Beardsley. The three of the Comedy-Ballet are badly

balanced, the study of the three 'Garçons de Café' is weak in drawing and quite lacking in character, 'The Slippers of Cinderella' is spoilt by the straight lines bounding the two formal bushes, and the 'Portrait of Madame Réjane' is poor. P. Wilson Steer's first study is good, but the other two are unworthy. John S. Sargent's pencil drawing of Henry James is strong and simple. Sydney Adamson has a good study of a girl resting. Walter Sickert contributed another interesting music-hall interior and a clever portrait impression of Aubrey Beardsley. W. Brown Macdougall's 'An Idyll' is weak and silly. E. J. Sullivan's two drawings, one in line and one in wash, are clever, but not very interesting. Bernhard Sickert's study of a man's head is strong and simple. The drawings mark a distinct advance on those of the first volume, and the regular black-and-white artists—Hartrick, Adamson and Sullivan—show to good advantage.

Beardsley designed for volume three a very effective cover and contributed over his own name four drawings of which 'The Wagnerites' and ' La Dame aux Camélias' were very fine. He was also responsible for the portrait of Mantegna and the pastel attributed to Philip Broughton and Albert Foschter respectively. Walter Sickert's usual music-hall study of 'Collins's' is hopelessly vague, 'The Lion Comique' is better, but the impression of 'Charley's Aunt' is very poor. P. Wilson Steer's 'The Mirror' is interesting, but the figure in 'Skirt-dancing' is not very convincing. George Thomson's lithograph is badly drawn and William Hyde's sunset is weak and theatrical, not by any means representative of his ability. Max Beerbohm's 'George IV.' is very enigmatic and lacking in drawing. There are fewer drawings, and these are not up to the standard of the previous volume. Beardsley's cover design for volume four is again good, perhaps his best so far; William Hyde's 'Sussex landscape' is again disappointing. Walter Sickert's three contributions are delightful—'Hotel Royal, Dieppe', a good portrait of Richard le Gallienne, and a fine head of George Moore. Patten Wilson's pen-drawing contains much fine work but is too

92. JAMES PRYDE
'Portrait of Sir Henry Irving'. Original 20" × 30"
By courtesy of Mrs. H. Hippisley-Coxe

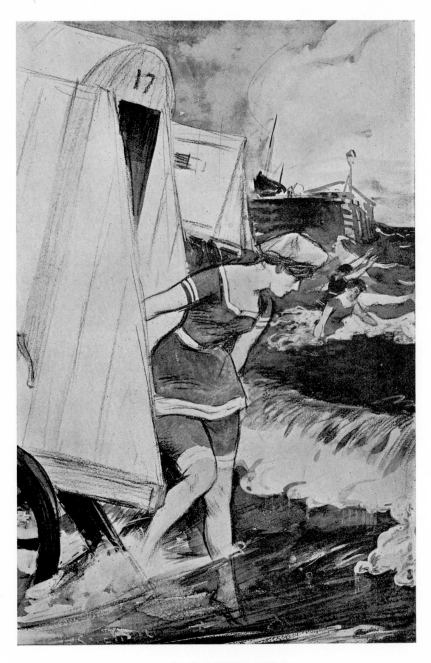

93. L. RAVEN-HILL
Wash and pencil illustration
Original 14¼" × 9¼"
In the Sir William Ingram Bequest, Victoria and Albert Museum

complicated in pattern. W. W. Russell's delicate drawing of a Westmoreland village is pleasant without being very distinguished. A. S. Hartrick's boxing subject is not so good or interesting as usual, and Charles Conder's design for a fan is unimpressive in the reproduction. Will Rothenstein has a portrait of John Davidson, and P. Wilson Steer one of a lady in grey, rather 'Whistlery'. Of Beardsley's four contributions 'The Mysterious Rose Garden' is spoilt by the ridiculously small heads on the two figures. But he was no portraitist.

In volume five Beardsley has disappeared from the scene, and with him appears to have departed much of the character of the magazine. Wilson Steer's 'The Mirror' is effective, but his other two drawings are unworthy. A. S. Hartrick has a delightful child study—'The Prodigal Son'—but Walter Sickert's two drawings are undistinguished. A poor number on the artistic side, with a disappointing collection of illustrations. Patten Wilson has two line-drawings in volume six, but in the second the detail is again very involved; and a decorative drawing can so easily become comic. Wilson Steer's 'Star and Garter, Richmond' is apparently a much reduced reproduction of an oil-painting. Gertrude D. Hammond, Charles Conder, A. S. Hartrick and William Strang were other contributors. The glory has departed, and the much boomed *Yellow Book*, except for the quality of its production, has become a very ordinary publication. Volume seven is a Newlyn number, but most of the contributions are reproductions of pictures and cannot therefore be considered as illustrations. Elizabeth Stanhope Forbes has a charming study of 'Marie' and another, Stanhope A. Forbes two interesting reproductions of paintings, T. C. Gotch a picture and a charcoal study, John da Costa a charcoal study, Fred Hall a humorous drawing with the mysterious title 'Fairplay', Frank Richards a heavy-handed pen-drawing and A. Tanner a reproduction of a painting. Frank Bramley, Walter Langley, A. Chevallier Taylor and Norman Garstin also contributed.

D. Y. Cameron designed the cover and title-page for volume eight, but in neither case is the result very striking. 'The pictures

are by members of the Glasgow School' and, as most of these again are reproductions of paintings, they cannot fairly claim notice in this record. There is even a photograph of sculpture! What would Aubrey Beardsley have thought of this new development? Cameron has a finely drawn etching of a girl's head, but otherwise the number bears a strong resemblance to the *Royal Academy Souvenir*. Volume nine is given over to the members of the Birmingham School and is very reminiscent of *The Quest*, but here we do get line-drawings by E. H. New, C. M. Gere and A. J. Gaskin, and others more conventionally and self-consciously 'decorative', in the manner of Walter Crane or William Morris or someone else, and smelling strongly of the Art School. Having exhausted the list of art centres, an attempt is made in volume ten to recapture some of the character of the early volumes. D. Y. Cameron has two competent pen-drawings. Volume eleven has three ultra-Japanese designs by Charles Pears which are not very convincing; and Patten Wilson contributes three more of his very elaborate pen-drawings. Max Beerbohm's 'Yellow Dwarf' is little more than childish. There is little to call for notice in volume twelve, and some things that are frankly bad. And so we come to volume thirteen 'which ends this strange, eventful history', and is to some extent redeemed by drawings from D. Y. Cameron, Muirhead Bone, Patten Wilson and E. J. Sullivan.

From a very sensational and promising beginning *The Yellow Book* gradually sank almost to the artistic level of a Victorian young lady's album. Its short career rather suggests a naughty boy who set out full of a grim determination to be really wicked and then was suddenly seized with fright at his own daring temerity. His later respectable probity was thus made more conspicuous by the memory of his earlier devilish intentions. The fact that this decline dates from the departure of Aubrey Beardsley seems to suggest that his personal inspiration as contributor and art editor was responsible for the quality of the first four numbers. Undoubtedly Beardsley was one to whom the term 'genius' can be justly applied. Without any of

the conventional training of the artist, he rapidly developed his own personality in an entirely original sense of bold decoration in masses of black and thin unhesitating sweeping lines. Mainly from this standpoint of design is he to be judged, and now, nearly forty years after the unnatural glamour which surrounded him in his lifetime has subsided, he must still be accounted one of the great masters and one of the strong influences in English black-and-white art.

THE SAVOY

When Aubrey Beardsley left Henry Harland, John Lane and *The Yellow Book*, he started, with Arthur Symons as literary editor and Leonard Smithers as publisher, *The Savoy*. Both editors enjoyed greater freedom under Smithers than Beardsley had under the apprehensive direction of John Lane, and the result is seen in a much more artistic production. The size of the page was more generous, and Beardsley again designed the covers, which were more in the nature of the old engravings than the bold woodcut style of *The Yellow Book*. In addition to the drawings for the cover, title-page and contents page, he also contributed seven illustrations and a large detached Christmas card to the first number. But what a tremendous advance he had made in less than two years! Here was the artist, accomplished and complete, with all the boyish extravagances and weakness in design forgotten. These Savoy drawings were delightful, the work of a master and the finest that Beardsley did. The first number also included a lithograph by C. H. Shannon, a wood-engraving of a water-colour by Charles Conder, a line-drawing of Regent Street by Joseph Pennell, a pencil-study and an etching by William Rothenstein, and a caricature of Beerbohm Tree by Max Beerbohm. Volume two, in addition to a new cover design and the same title-page, contained three Beardsley illustrations and reproductions of the

two covers; also drawings by C. H. Shannon, Joseph Pennell, William T. Horton (five), Walter Sickert (a very ordinary pen-drawing of Venice), and Max Beerbohm's caricature of Beardsley. Beginning with number three, *The Savoy* was issued every month. This contained, in addition to the cover, a new title page and four drawings by Beardsley and a Max Beerbohm caricature (Arthur Roberts). In number four were a lithograph by T. R. Way, and drawings by Conder, Pennell and Horton and 'The Woman in White' by Beardsley. Number six contained a puerile early drawing by Phil May, which should never have been reproduced, one by Beardsley and one each by Horton and W. B. Macdougall. The next month Beardsley had two contributions, one described as a 'drawing' and the other as a 'sketch', although the distinction is not obvious, and Fred Hyland, Horton and A. K. Womrath were also represented. In number eight, the last issue, Arthur Symons wrote all the letterpress, and Beardsley did all the illustrations, fourteen in number, and thus *The Savoy* disappeared in a blaze of glory. As in the case of *The Yellow Book*, the feverish energy of the early numbers could not be maintained, the brilliant sprinters lacked staying power for a long course, and the fireworks died out. Perhaps a capable and sympathetic business man to control the irresponsibilities of genius might have ensured a longer life. For Beardsley was always a boy, with all the boy's love of excitement and breathless adventure, and the boy's inability to settle down to the commonplace drudgery of regular production. *The Savoy*, like *The Butterfly*, was a brilliant adventure.

THE EVERGREEN

This Christmas book of University Hall, Edinburgh, was published in 1894 with paper covers, unnumbered pages and no index. The illustrations consisted mainly of decorative drawings, a reproduction of a water-colour by James Caden-

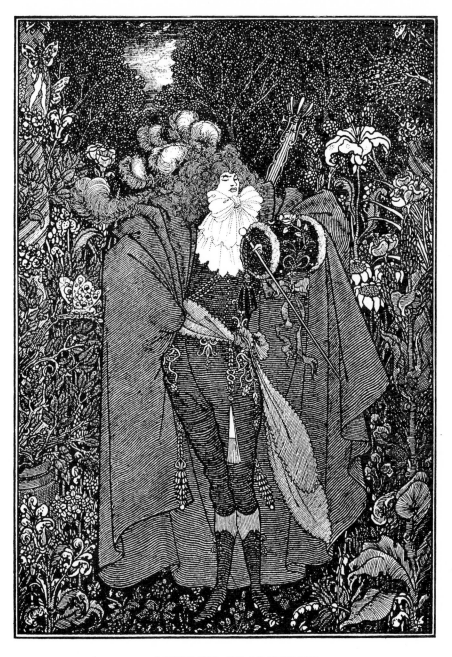

94. AUBREY BEARDSLEY

The Abbé from 'Under the Hill', in *The Savoy*, Volume One

By permission of John Lane, The Bodley Head, Ltd.

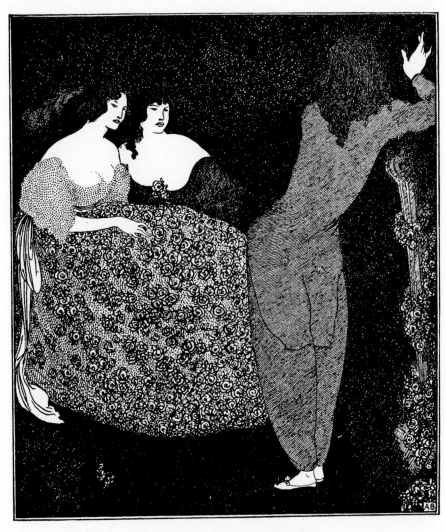

95. AUBREY BEARDSLEY

A Répétition of 'Tristan und Isolde', from *The Savoy*, No. 8

By permission of John Lane, The Bodley Head, Ltd.

head, and contributions by Louis Weierter and W. B. Macdougall. In the next year the first two—'Spring' and 'Autumn'—of four numbers were issued under the description of 'A Northern Seasonal', published in Edinburgh by Patrick Geddes and in London by T. Fisher Unwin. The illustrations have the appearance of students' work and were contributed by C. H. Mackie, Helen Hay, E. A. Hornel, John Duncan, W. Smith, Robert Burns, W. G. Burn Murdoch, J. Cadenhead, W. Walls, Alice Gray, and last, but by no means least, Pittendrigh Macgillivray! Part three, 'Summer', came in 1896 and added J. B. Lippincott to the list of publishers and Robert Brough and Andrew K. Womrath to the roll of artists. The fourth number, 'Winter', was dated 1896-7. The production was rather dour and very Scotch, printed on uncompromising cartridge paper and seasoned with the grim earnestness of the art student.

THE DOME

The first number of *The Dome*, a quarterly containing examples of 'All the Arts', was published 'at the Unicorn Press XXVI Pater-Noster Square on Lady Day mdcccxcvii'. *The Dome* certainly took itself seriously and instead of an index gave an 'Inventory of the Works of Art', divided into Architecture, Literature, Drawing, Painting and Engraving, and Music. To the first section H. W. Brewer contributed a pencil-drawing of 'The City Gate', and A. van Anrooy a pen-and-ink drawing of the 'Water-Gate, Hoorn'. In the third section are a charcoal drawing by Frank Mura, a pencil study of a nude by W. L. Bruckman and reproductions of drawings and paintings by the old masters. Number two appeared on Midsummer Day and contained pen drawings of Monnow Bridge by R. James Williams (very like Edmund New's work), and of the Château de Vitré by Percy Wadham. There were also a line-drawing by Laurence Housman and a wood-engraving in colour by William

Nicholson. The third volume had drawings by Laurence Housman, Beresford Pite, Alan Wright, Charles Pears, Dion Calthrop, and J. J. Guthrie. Volume four contained work by Percy Wadham, Alan Wright (a fine pen-drawing), and Malcolm Patterson. Volume five had drawings in black-and-white by W. T. Horton and Byam Shaw and in colour by H. A. Paine.

It was then decided to issue *The Dome* as a monthly instead of a quarterly magazine, and in August a free issue of twenty-four pages was made, explaining the transition and apologising for the non-appearance of the sixth quarterly. This contained two new illustrations, an etching of Courtrai by William Strang and a poor drawing of Mozart by W. L. Bruckman. The first volume of the new series contained a woodcut title-page by Gordon Craig, architectural pen-drawings by H. W. Brewer, woodcut portraits by Craig, two etchings by William Strang and some symbolic drawings by Althea Gyles. There were also some unnamed drawings whose origin I have been unable to trace.

In volume two were a wash drawing 'The Pedlar', by W. Scrope Davies, a lithographed portrait by William Rothenstein, a coloured woodcut by Gordon Craig, an architectural fantasy by H. W. Brewer, a William Strang etching, a charcoal drawing by Frank Mura and three designs for 'A Memorial College' by Frank L. Emanuel, H. W. Brewer and H. M. J. Close. Volume three had a portrait of Paderewski by Burne-Jones, drawings by Laurence Housman, Will G. Mein, A. H. Fisher, Alan Wright, H. W. Brewer and Frank Mura, and an etching by William Strang. In volume four were six woodcuts by Bernard Sleigh, another Strang etching, and drawings by A. Hugh Fisher, H. W. Brewer, W. T. Horton, Charles Pears, Philip Connard and G. M. Ellwood. Volume five contained woodcuts by Bernard Sleigh and drawings by Will G. Mein, Percy Bulcock, Stewart Carmichael, F. O'Neill Gallagher and H. W. Brewer; and volume six included drawings by Alice Munsell, A. Hugh Fisher, William Strang (a fine woodcut), Philip Connard and Hanslip Fletcher.

The Dome devoted as much attention to the past as to the

present, and its reproductions of paintings, drawings and engravings by the old masters were excellent. In the development of black-and-white art of the period it was not a powerful factor, although it gave encouragement to some of the younger designers. It was an interesting and excellent magazine with a sane outlook and a sense of humour.

THE PAGE

During the year 1898 appeared a modest little magazine with brown paper covers, published in a limited edition and edited by Edward Gordon Craig 'at the Sign of the Rose, Hackbridge, Carshalton, Surrey', in aid of the League of Pity. This contained little in the way of letterpress—excerpts from Walt Whitman, cookery recipes and scraps of nonsense—but several woodcut designs by the editor. At the end of the year appeared the announcement that 'the new series for 1899 will be published in a less heroic spirit and will try to aid itself before attempting to be of use to others'.

In this new arrangement as a quarterly, original literary contributions were printed, like the woodcut illustrations, on one side of the paper only. Charles Conder, J. J. Guthrie and Oliver Bath, whom one suspects of being closely related to the editor, assisted with the illustrations. To number two William Rothenstein contributed a portrait of Coquelin, Craig and Oliver Bath supplying the other illustrations. In number three were two pen drawings by J. Bastien Lepage, and William Rothenstein and Max Beerbohm caricatured one another. Number four contained a design for a theatrical costume by Sir Edward Burne-Jones, three little designs by Charles E. Dawson and a portrait of John Peel in black-and-red by James Pryde.

The Page was a bright, cheerful affair, and some of Craig's little designs were very interesting. It is to be regretted that it did not have a longer life.

SOME QUARTERLIES AND ANNUALS

THE WINDMILL

This was one of many followers of *The Yellow Book* and *The Savoy*, and appeared first in the autumn of 1899 under the joint editorship of Paul Creswick and Starr Wood. Although Gleeson White gave it his blessing, it received a very mixed reception from the critics. *The Star*, in particular, was very severe, and it may not be out of place to print its remarks—which have a touch of characteristic Pennellian venom—as they apply to much of the other alleged artistic production of the period:

'A Tilt at "The Windmill"

'*The Windmill: an illustrated quarterly* (Simpkin, Marshall), price one shilling net; 126 pages. Good paper, wide margins, noble type; "letterpress", excellent in parts; "pictures", mostly execrable. There is a deal of twaddle in some of the prose, but it is outweighed by stories so excellent as "The Prince's Pity", by Mr. H. D. Lowry, and "The Repentance of Watton", by Mr. Frederick Grover. And in the poetry, the work of Mr. Laurence Housman and Mr. Percy Hemingway is excellent. But as a whole this new quarterly falls far short, in point of literary merit, of its two prototypes, *The Yellow Book* and *The Savoy*. In point of artistic merit, it cannot for a second be compared to them. Mr. Starr Wood's cover is passably good, but most of the other illustrators are ingeniously banal, where they are not amateurish. "A Passing Cloud" is a pencil drawing of an ugly little girl whose anatomy is worthy of Barnum and Bailey's freak museum. "Golden Fetters" is pretentiously inane. "Experimental Erotics" is a masterpiece of ignorant drawing. The railing of the bridge is ludicrously bulged out, and the penny steamer, with its preposterous paddle-boxes and funnel, is shriekingly absurd, to say nothing of the feeble folly of the figure drawing. "Experimental rot" would be a better title. "Snake Poison" is babyish Beardsleyism. The bow-legged golfer in kilts might

198

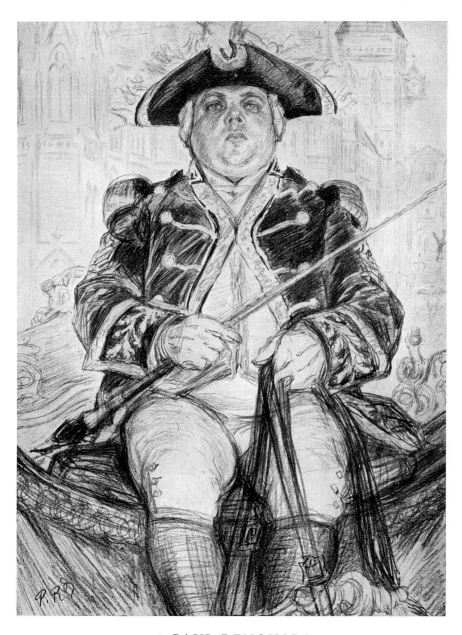

96. PAUL RENOUARD

' The Lord Mayor's Coachman '. Chalk drawing. Original 14″ × 10⅜″
By courtesy of Charles Emanuel

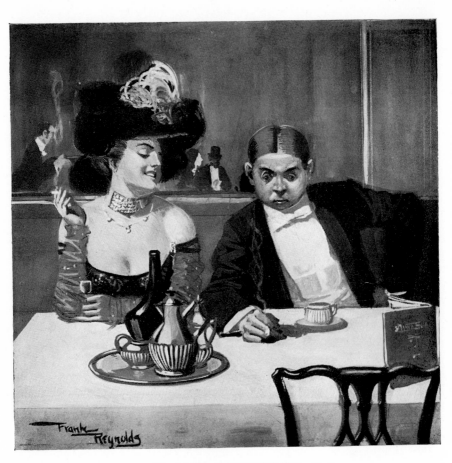

97. FRANK REYNOLDS, R.I.
An early drawing in wash and body-colour for *Sketchy Bits*
Original $8\frac{1}{2}'' \times 8\frac{3}{4}''$
From the author's collection

possibly raise a foolish smile in *Comic Cuts*, but we fail to see the humour of associating warped limbs with the links. "A Summer Night" is more like a "Summer Nightmare", and the various tail-pieces have the musty savour of the stock horrors of a jobbing printer. To enable our readers to judge for themselves as to the sorry rubbish shot into this imposing "quarterly", we reproduce by photography, same size, what Mr. Laurence Housman is pleased to call "Marionettes", which look as if they had been scratched with a bad pen by a blind man.'

As a piece of outspoken criticism this is decidedly frank, but as a modest contributor who has been fortunate to escape attack, I must admit that it was deserved. Beside those named, other artistic contributors were Amy Sawyer, Estelle Nathan, Granville Fell, Charles Genge, F. L. Bell, W. G. Johnson, Geoffrey T. Stephenson, J. J. Guthrie and Sydney Aldridge. To number two, which had a more favourable reception at the hands of *The Star*, E. Holinger, C. H. B. Quennell, T. M. R. Whitwell, John Baillie, Georgina Waddington, Sydney Westwood and R. H. Buxton were new contributors. Number three introduced R. J. Williams, T. H. Robinson, E. J. Sachse, A. Hugh Fisher, Leonard Patten, Minnie Clarke, L. Edwardes-Jones and Alan Wright. P. F. Maitland was the only new contributor to volume four. In volume five the number of illustrations was much reduced, and Woodbine K. Hinchliff and Ethel Kendall were the only newcomers. In volume six again there were only eight page illustrations, and H. A. Eves, Nelly Morris and I. J. J. Symes made their first and last appearances.

On the artistic side *The Windmill* was to a great extent the production of young and inexperienced enthusiasts, many of them still in the student stage. If it gave them encouragement and confidence it partially justified its production, but the general public had little use for it. For a long time stacks of unsold copies remained in the editorial office, and, draped with rugs, served as settees and even in emergency as beds. Many of the illustrations shewed a certain amount of promise, not always

fulfilled, but many were frankly bad, as the writer already quoted in *The Star* so justly observed.

THE DIAL

The Dial was the production of those twin artistic souls, Charles H. Shannon and Charles Ricketts. The first number was published 'at the Vale in Chelsea', in 1889, with a note to the effect that 'all the woodcuts have been printed *from the wood* to ensure the greater sweetness of the printing'. The second number was not issued until 1892, with a cover designed and engraved on wood by Ricketts. Shannon contributed lithographs and Reginald Savage, Lucien Pissarro and Ricketts were represented by wood-engravings. Number three appeared in the next year with the same contributors and T. Sturge Moore; number four came in 1896, and number five in 1897 without any contribution by Savage. Each issue consisted of thirty to forty large quarto pages. The index gave the names of the artists (but no page reference) at the end of the description of their contributions, so that they appeared to belong to the next item.

THE PAGEANT

This was another production (published annually by Henry and Co.) with which C. Hazlewood Shannon was concerned as art editor in association with J. W. Gleeson White. In the first volume, which appeared in 1896, many of the illustrations consisted of reproductions of paintings, and with these we are not here concerned. But there were also a Whistler lithograph and contributions by Charles Ricketts, Sir J. E. Millais, William Rothenstein, Reginald Savage, Laurence Housman

and the art editor himself. In an article on the work of Ricketts four of his pages from *The Dial* are reproduced.

In the 1897 volume Shannon, Savage, Housman, Rothenstein and Ricketts again appear and also Walter Crane. There is a note on wood-engraving with ten examples. Both numbers were beautifully printed and produced, and the list of acknowledgments of printers, ink-makers, block-makers, etc., rivals the programme of a musical comedy.

THE QUARTO

This was an annual (although two numbers appeared in 1896), published by Virtue and Co. The illustrations were principally reproductions of studies and drawings by Slade School students with a few contributions from outside hands. To the first volume Robert Spence, P. V. Woodroffe, Joseph Pennell, Ambrose McEvoy (an ordinary decorative pen-drawing), Margaret Fisher (a chalk drawing of a farmyard), John da Costa (a poor study of a head), Arthur Briscoe, Alfred Hayward and Alice B. Woodward contributed. Pennell, who had been lecturing to the students on illustration, was also represented in the second volume in the same year. Others who sent drawings were H. Tonks (a chalk study), Nellie Syrett, Cyril Goldie, T. C. Gotch, D. Y. Cameron (an etching), G. P. Jacomb-Hood (a pencil study), Frank Potter, Harrington Mann and Alfred Garth Jones.

The third volume appeared in 1897 and included work by Robert Spence, George Clausen, Alfred Garth Jones, V. Burridge, Paul Woodroffe, Miss M. M. Fisher, Max Balfour, A. J. Gaskin (a pencil study), A. Campbell Cross (a good tone-drawing), Miss C. M. Watts, G. Oliver Onions, Arthur Briscoe (a nice line-drawing) and Miss R. M. M. Pitman. The fourth volume in 1898 contained contributions by Augustus E. John, W. W. Russell, Walter Crane, William Rothenstein (a litho-

graph of Ricketts and Shannon), F. C. Dickinson, Nellie Syrett, Arthur Briscoe (now well known as an etcher), E. Calvert, R. Spence, Maxwell Balfour, Dora Curtis, Laurence Housman and Elinor Monsell.

Strictly speaking, *The Quarto* hardly comes within the scope of this survey because most of the illustrations were not drawn for that purpose but were reproductions of studies and experimental sketches. It is difficult, however, to draw a definite line of distinction, and many of the names are those of artists who afterwards became famous as illustrators, painters or etchers. These early examples of their work may therefore be of interest to students.

PHIL MAY'S ANNUAL

Among so much that was artificial, affected and self-conscious it is refreshing to come upon a production so eminently healthy and sane, and yet artistic, as *Phil May's Annual*. The first number was produced in the summer of 1892, under the editorship of Francis Gribble, who has related the difficulties with which he had to contend in collecting material from the irresponsible artist. The literary contributors, who were presumably more amenable, included at various times Barry Pain, Gilbert Parker, Israel Zangwill, Morley Roberts, James Payn, Clement Scott, Conan Doyle, George Augustus Sala, E. F. Benson, H. G. Wells, Eden Phillpotts, Kenneth Grahame, Walter Besant, Walter Raymond, Grant Allen and Richard le Gallienne. So that, apart from May's delightful drawings, the fare provided was eminently attractive, and it is not surprising that fifty-three thousand copies of the first number were sold. In this May's contributions numbered about fifty-seven pen-drawings, some of them illustrations to the stories and articles. All are marked by the sound assurance of drawing, economy and strength of line, delightful humour and light-hearted spontaneity of accomplishment that distinguished his work. There are some

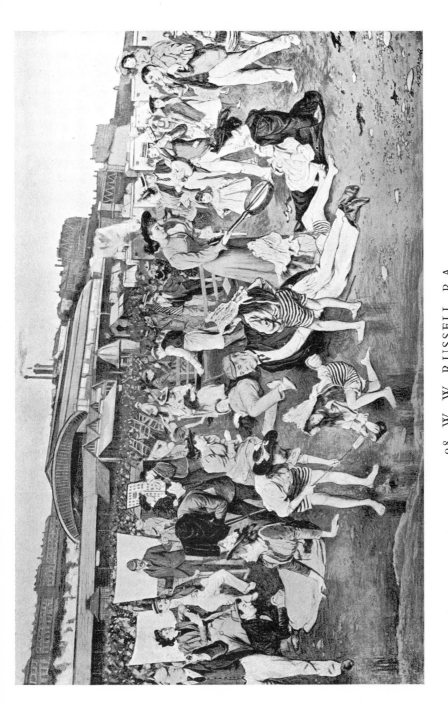

98. W. W. RUSSELL, R.A. Double page wash-drawing, *Illustrated London News*, 4 August 1894

'Ramsgate Sands'.

99. REGINALD SAVAGE

Full page wood-engraving, *Black and White*, 11 April, 1891

good portrait studies for 'Newmarket' and 'A Philistine in Bohemia', including an excellent group in the Trocadero. The illustrations to Sala's reminiscences of Dickens and Clement Scott's story are excellent.

The second appearance was in the winter of 1892, and I can still remember the thrill with which a long, cold, train journey was beguiled as I made my first acquaintance with the *Annual* and revelled in its pages. There were some masterly portraits of characters in the Franco-Prussian War, Bismarck, Wilhelm I. and Moltke, and some vivid and varied impressions of 'Types I have met'; also the famous drawing of the lion-tamer's wife addressing her husband who has been out late and taken refuge in the den. The conversation consists of two words 'You coward!' and such was May's regard for simplicity that he would have omitted the first of these as unnecessary. The winter *Annual* for 1893 contains on page 28 the finest portrait May ever drew, the 'Gladstone', which is a masterpiece of economy in line. This, as he told G. R. Halkett, was drawn from a photograph, and only happened after several unsuccessful attempts. There are some other excellent portraits, a glorious drawing of a nigger on page 23, some delightful Newlyn notes, more types, and 'Some things I see when I come out without my gun'. This was the best number of a very excellent sequence. That for 1894 hardly rises to its distinction, but contains some amusing impressions of the New Woman and character studies of Bohemian Paris. Chalk and pencil are used in some of the drawings and add variety to those in line. In the issue for 1895 are some excellent experimental portrait studies in chalk or charcoal of 'Brother Brushes' and some interesting sketch-book notes. The *Annuals* for 1896 and 1897, although full of good things, produced nothing calling for special mention. The first five numbers were published by Walter Haddon, these two by Neville Beeman and those that followed by W. Thacker and Co. Unfortunately Thacker increased the size of the page without any advantage and thus spoilt the uniformity of the set. The summer number for 1898 had two good pencil portraits of

Frank Brangwyn and William Nicholson, but the line-drawings were not quite up to May's best standard. The winter number had a fine double-page drawing of a procession in Picardy, and an interesting pencil study of a Dutch interior made in Volendam; but some poor illustrations done by other artists were introduced and these suffered by the inevitable comparison. The winter *Annual* for 1899 reverted to the old size, and although the illustrations numbered only twenty-six, they were all done by May. The last, a study of a Dutchman, 'Made in Holland (Park Road)', was excellent. In 1900 the list of drawings was still further reduced to twenty-two, and although some were good, they lacked the brilliance of those in the earlier issues.

The *Annual* continued to be published until the winter number of 1904, a year after May's death. The sixteen volumes of the series contain the best of his work, and some of the finest that was produced during the nineties. In the selection of the drawings he was not under any editorial control, and this freedom is reflected in their variety and excellence. May enjoyed a unique popularity both with the general public and with his more discriminating admirers, including many of his fellow-artists. He was undoubtedly the greatest and most distinctive personality in the black-and-white art of his time.

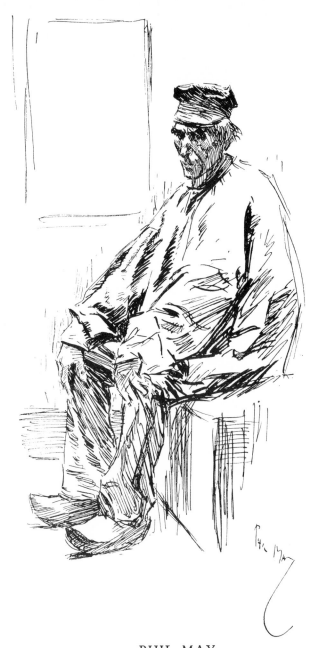

100. PHIL MAY

'A sketch in Picardy': exhibited at the Leicester Galleries, 1908

From the author's collection

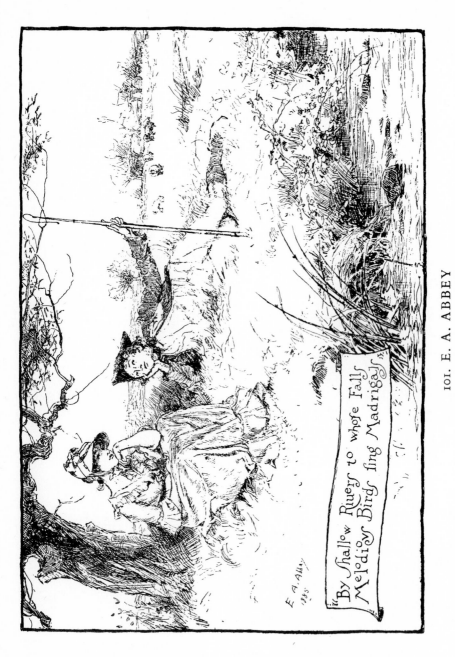

"By Shallow Rivers to whose Falls Melodious Birds sing Madrigals"

E. A. Abbey
1885

101. E. A. ABBEY

Part of an invitation card for an exhibition of Alfred Parsons' work. A characteristic example of his early delicate manner. Original 9½ by 6½ inches

By courtesy of Clement Parsons, Esq.

CHAPTER VI

SOME ILLUSTRATED BOOKS

An illustrator's work is generally seen to much greater advantage in books than in newspapers or magazines. It has been done with fuller time at his disposal and under more generous conditions as to choice of subject and freedom of treatment. The knowledge that his drawings will receive more careful reproduction, more spacious setting and probably greater permanence adds interest to his task and encourages him to produce better results. In many cases the author's fancy has evolved the best of the illustrator's accomplishment. Some artists have devoted all their time to book illustration, preferring its more leisurely methods to the rush and hurry of newspaper or magazine work. Others have regarded it as a pleasant form of relaxation from more regular and profitable, but less congenial, employment. Some have preferred to develop their own conceptions rather than to translate the inventions of others.

The output of illustrated books between 1890 and 1900 was no less remarkable and vigorous than the torrent of newspapers and magazines. The old Christmas gift-books of the sixties, with their elaborately embossed and decorated covers,—anthologies of very moral poems, selections from the work of contemporary poets and writers and new editions of the English Classics—had already suffered from the competition of the magazines, whose bound volumes contained equally good work by the same artists and were published at a smaller price. The lower cost of reproduction and the increasing number of illustrators enabled the publishers of the nineties to produce many new and cheaper editions of standard works, books of travel and topography and picture books invented by the artists themselves. It would be obviously impossible to present here anything like a complete bibliography of the illustrated books of the period, but a repre-

sentative list has been compiled, sufficient to prove the variety and wide scope of the illustrators. Although these books were in every way far less elaborate in appearance than the productions of the earlier period, they contained some excellent work, different in treatment, to accord with the new methods, and with a fresh and original outlook. Many contained page decorations, borders and typographical embellishments modelled on those of William Morris's Kelmscott Press and the earlier illuminations, but in most of them the illustrations were printed separately as in the magazines and had no relation, except in subject, to the printed page.

In an alphabetical arrangement of the illustrators' names that of E. A. Abbey comes appropriately first. Although Abbey was an American by birth, most of his work, which was done mainly for American publishers—and particularly for Harpers—was produced in this country, from which he derived most of his subjects and inspiration. Much of his early reputation was made with his illustrations to a selection of Herrick's poems in 1882, and in 1889 he produced with Alfred Parsons, to whom he dedicated the Herrick drawings, a delightful volume of old songs. Both were reprinted from *Harper's Magazine*, but unfortunately neither, by reason of date, is strictly eligible for inclusion in this summary. In 1890 the two men collaborated in *The Quiet Life*, a collection of 'certain verses by various hands', with a prologue and epilogue by Austin Dobson, published in this country by Sampson Low. The drawings were reprinted from the same magazine and were excellently reproduced on a large page of good quality. Both artists were masters in the use of the pen, and both used it to express tones which other artists would have accomplished with a brush. In other words, they painted with the pen. The value of the line itself is lost in the association with others which produces the tone. Whether this is the real function of a line-drawing, or whether the effect would not be gained more directly and effectively with a brush is a matter of opinion, but the results in this case are so brilliantly delicious that the settlement of the question can be overlooked. Abbey used a very

fine line with which he contrived to suggest form, light and colour in a way that no other draughtsman with a pen has ever equalled. His drawing was always accurate, his knowledge of costume and accessories was complete, and he was always in perfect sympathy with his author, to whose work he added much of the charm of his own enjoyment. It is unnecessary to select any particular drawing, for all are excellent, but those for 'Quince' and 'The Vicar' show all his many good qualities at their best. As that of one of the great masters of pen-drawing, Abbey's work is of importance and interest both to the student and the connoisseur, and his direct influence can be traced in much of the work of his younger contemporaries and successors.

A pen draughtsman of quite a different character was Cecil Aldin, whose drawings to Winthrop Mackworth Praed's *Everyday Characters* (Kegan Paul, 1896) are some of his earliest in book form. Although they are immature compared with his later work they show much of his skill in design, his keen firm line and his very English humour. Aldin derived much from Randolph Caldecott, and although he lacked some of Caldecott's delicacy of imagination and drawing, he surpassed him later in his sense of design and in his strength of line. Most of these illustrations are in outline with very little attempt to suggest colour, but most are well drawn—the animals, dogs and horses better than the human figures—and are interesting in promise of later fulfilment. Three years later he illustrated one of *Two Well-Worn Shoe Stories* (Sands and Co., 1899), and these drawings in outline and flat colour mark a great advance in confidence and strength. A year or so after this the same publishers issued *A Sporting Garland* consisting of three old poems on hunting, shooting and fishing, with drawings in strong outline and colour. Here again there is a distinct improvement in design and drawing, although the colour is very badly printed. Even in these early days Aldin had a fine sense of composition, a keen interest in sporting subjects and a love and appreciation of the costume and period of Georgian and early Victorian days. His

drawing of animals was characterised by practical knowledge and sympathy, and no draughtsman has ever rendered the charm of dogs and puppies more successfully. Later Aldin did some fine coloured prints of hunting subjects, well informed by his practical experience as a M.F.H.

Most of Fred Barnard's book illustration was done in an earlier period, but he claims inclusion in this list by reason of twelve drawings to Sir Walter Besant's *Armorel of Lyonesse* (Chatto and Windus, 1890).

J. D. Batten was one of the leaders of the Birmingham School of artists, and did many decorative line designs for books, one of which—*Fairy Tales from the Arabian Nights* —was published by J. M. Dent and Sons in 1900. Batten also illustrated several anthologies edited by Joseph Jacobs: *Celtic Fairy Tales* (1892), *More Celtic Fairy Tales* (1894), *English Fairy Tales*, *More English Fairy Tales* (1894), and *The Book of Wonder Voyages* (1896).

Aubrey Beardsley, one of the great men of the period, came suddenly into fame with his fine designs for the *Morte d'Arthur* (Dent, 1893). In 1894 he illustrated Oscar Wilde's *Salome*, and these drawings represent some of his most characteristic work; the fine sweeping line, bold masses of black and daring originality of design, although not always pleasing, are definitely remarkable and arresting. The drawings to Pope's *The Rape of the Lock* (1896) are among the most charming and pleasant of all his work. Design, pattern, and decoration are all displayed at their best, and there is less of that boyish desire to shock the beholder. Beardsley also made four beautiful illustrations for Ernest Dowson's *The Pierrot of the Minute*, published in 1899. His work has been discussed already in connection with *The Yellow Book* and *The Savoy*, and the succession of these volumes tends to confirm the impression that he was gradually outgrowing his youthful flaunting indiscretions and developing a sounder, more intellectual and more delightfully decorative style. He was certainly one of the greatest and most original influences in black-and-white art of the period.

Max Beerbohm's first collected book of drawings—*Caricatures of Twenty-five Gentlemen*—was published by Leonard Smithers in 1896. It contains a strange mixture of character portraits, as in the 'Beerbohm Tree', and pure figments of his gay imagination, as in the 'Right Hon. Joseph Chamberlain, M.P.', which are not always quite so successful. As Mr. L. Raven-Hill points out in his appreciative preface, these caricatures must not be judged as drawings of figures but as the representations of the impressions formed on the artist by his subjects. In this respect they are generally very remarkable in their revelation. Raven-Hill goes on to say that, 'Since "Ape" there has been no one with such an awful instinct for the principal parts of a man's appearance'. Something of the same idea was evidently in the artist's mind when he dedicated the book 'to the shade of Carlo Pellegrini'. But Pellegrini could draw, and in considering Max's early work there is an inevitable feeling that some of this ability would have improved the ease of its accomplishment without lessening its sting. He was undoubtedly a great caricaturist, and his definite departure from tradition and complete independence of outlook and method certainly affected much of the work of his contemporaries.

A very strong feature of the art of the nineties was the work of the Beggarstaff Brothers—James Pryde and William Nicholson. Most of this took the form of designs for posters, very simple, very strong, very English and very strikingly effective. The bold flat masses of which they were composed were not painted but were cut out of coloured paper. Contemporaries will still remember with joy their Beefeater in black and red for *Harper's Magazine*, the 'Cinderella' for Drury Lane and the advertisement for Rowntree's cocoa. They were by far the most original and arresting designs of their time, and the neglect by advertisers to make fuller use of this Beggarstaff talent is one of the most incomprehensible errors of taste of that strange period. Probably this inexplicable failure had an intensive effect on those few of their posters that did appear, for they certainly sang out gaily and boldly from the hoardings on which they were dis-

played. Most advertisers, then as now, could not consider any merit in a design that did not include a facsimile representation of the bottle or tin containing their wares. The undoubted fact that these Beggarstaff designs irresistibly compelled attention to the existence of those wares, far more effectively than any other form of advertising, did not occur to them. In 1898 that enterprising publisher William Heinemann commissioned the Brothers to make ten illustrations to Edwin Pugh's *Tony Drum*. These were, like the posters, entirely original in design and unlike any other book illustrations. Drawn apparently on coarse absorbent sugar-paper with a pencil or a brush, their effect was heightened by slight, deftly placed touches of colour, and they were eminently appropriate to the text. It is difficult to distinguish the hands of the two artists, although much of the work suggests Pryde. If any outside influence can be traced, and this is not obvious, it would be that of the Japanese woodcuts and of the French artists Toulouse-Lautrec, Steinlen and Forain. Nicholson afterwards made some very distinguished portraits, which were printed in colour from woodblocks and issued by *The New Review*. The 'Sarah Bernhardt', the 'Whistler' and the 'Kipling' are in their way masterpieces, and the 'Queen Victoria' is magnificent, far finer than any of the full-length paintings of that eminent lady. Both the 'brothers' later became very distinguished painters, whose work even now is strangely limited in its appeal, and deserves much fuller recognition and appreciation. Perhaps a personal artistic reserve and dislike of blatant publicity is to some extent responsible, but it will always remain a bad blot on the discrimination of those who professed to love art that the work of the Beggarstaffs in the nineties is so little known or almost completely forgotten. The beautifully drawn windmill which still forms the trade emblem of the firm of Heinemann was designed by Nicholson.

In its delicate fancy the work of R. Anning Bell forms a complete contrast. It shows a very beautiful sense of good drawing, decoration and design, is much less conventional than most of the illustrations labelled 'decorative', and is marked by the use of

102. R. ANNING BELL

From *The Tempest*, published by Freemantle and Co.

Apollyon casteth down to the grovnd the Christian

103. H. M. BROCK

From *The Pilgrim's Progress*

By courtesy of C. Arthur Pearson, Ltd.

a strong sensitive line and a discriminating disposition of black. For J. M. Dent and Co. he made some delightful illustrations of *Jack the Giant Killer* and *Beauty and the Beast* (1894), and some charming decorations for the *Poems by John Keats* (George Bell, 1897). For Methuen he illustrated John Bunyan's *The Pilgrim's Progress* (1898), and John Keble's *The Christian Year* (1898). Some of his best work, with all the quality of the old woodcuts, is seen on the more generous page of *The Tempest* (Freemantle and Co.).

G. H. Boughton illustrated Washington Irving's *Rip Van Winkle* and *The Legend of Sleepy Hollow* for Macmillan in 1893.

A. S. Boyd illustrated many books in his angular style of pen-drawing, of which R. L. Stevenson's *A Lowden Sabbath Morn* (Chatto and Windus) and Ian Maclaren's *The Days of Auld Lang Syne* (Hodder and Stoughton) come within our record.

Most of Frank Brangwyn's best drawings for books have been made since 1900, but a few examples before that date may be mentioned: twelve illustrations for two volumes of *The Exemplary Novels of Cervantes* (Gibbings and Co.), and others for *The Wreck of the Golden Fleece*, by Robert Leighton (Blackie, 1893), *The Cruise of the Midge*, by Michael Scott (1894), *Tales of Our Coast*, by S. R. Crockett (Chatto and Windus, 1896), *The Life of Admiral Lord Collingwood*, by W. Clark Russell (Methuen, 1890), and Frances Hodgson Burnett's *That Lass o' Lowrie's* (Warne). The first are in Brangwyn's best manner, done apparently in oil-colour and admirably reproduced (two, as frontispieces, in photogravure) by the Art Reproduction Company. They were probably much reduced, but have suffered little in consequence, and have all the masculine vigour and richness of tone values of Brangwyn's paintings.

The brothers C. E. and H. M. Brock were very popular illustrators. Both were excellent draughtsmen, but the former's work is a little reminiscent of Hugh Thomson and Caldecott, and occasionally a little laboured; the latter's is more original, stronger and more charming, with a very satisfying ease and

certainty. The two combined to illustrate a set of Jane Austen's novels for Dent in 1900, and C. E. Brock also did some drawings for Charles Lamb's *Elia* for the same publisher. In Nisbet's English Illustrated Library he was responsible for Oliver Goldsmith's *The Vicar of Wakefield* (1898), Sir Walter Scott's *Ivanhoe* (1897) and *The Lady of the Lake* (1899), and Defoe's *Robinson Crusoe* (1898). For Macmillan he illustrated Hood's *Humorous Poems* in 1893, *Gulliver's Travels* in 1894, Charles Kingsley's *Westward Ho!* in 1896 and Mrs. Edwin Hohler's *The Bravest of Them All* in 1899. In the same publisher's excellent series of Illustrated Standard Novels he provided drawings for Jane Austen's *Pride and Prejudice* (1895), John Galt's *Annals of the Parish* (1895), and J. Fennimore Cooper's *The Pathfinder* and *The Prairie* (1900). The Gulliver illustrations are conscientiously drawn but lack the robust vigour for which the book calls. He is more at home with Jane Austen but does not get into the period so completely as does Hugh Thomson, and the characterisation is rather forced.

Most of H. M. Brock's illustrations were done for books in the same series, and it is interesting in these days to note that these excellent volumes, each containing about forty drawings by the best black-and-white artists, could then be bought for half-a-crown! Quite worthy books in paper covers, with eight or ten excellent illustrations, could be bought for sixpence. Captain Marryat's *Japhet in Search of a Father* and *Jacob Faithful* (1895), Samuel Lover's *Handy Andy* and J. Fennimore Cooper's *The Deerslayer* and *The Last of the Mohicans* (1900) supplied his subjects, and he also provided drawings for W. M. Thackeray's *Ballads and Songs*, for *The Drummer's Coat* by the Hon. J. W. Fortescue (1899), for Mrs. Gaskell's *Cranford* (1897) and Sir Walter Scott's *Waverley* (1898), both in Nisbet's English Illustrated Library, and for *The Little Browns* by Mable E. Wotton (Blackie, 1899).

L. Leslie Brooke was another competent and popular illustrator, particularly of children's books. He supplied drawings for two of Mrs. Molesworth's—*The Nursery Rhyme Book* and

Nonsense Lays, published by Warne—and for others by the same writer, published by Macmillan.

Gordon Browne, son of Hablot K. Browne—who, as 'Phiz', will always be associated with Charles Dickens—was one of the most prolific illustrators of the nineties. His industry was amazing, his output enormous, and all his work was characterised by careful and competent drawing. If he failed to achieve greatness it was because of a monotonous sameness in many of his illustrations, particularly in facial character. In addition to his regular contributions to most of the papers and magazines he also found time to make drawings for many books, including a complete edition of Shakespeare. For Wells, Gardner, Darton and Co. he illustrated *Grimm's Fairy Tales* (1894), *National Rhymes of the Nursery* (1894), S. R. Crockett's *Sweetheart Travellers* (1895), *Sintram and His Companions* and *Undine* (1896), *Dr. Jolliboy's A.B.C.* (1898) and *Stories from Froissart* (1899); for Frederick Warne and Co., S. K. Hocking's *One in Charity*; for Methuen, W. C. Collingwood's *The Doctor of the Juliet* (1897), G. Manville Fenn's *Syd Belton* (1892), Mrs. Molesworth's *The Red Grange* (1892), W. Clark Russell's *Master Rockafellar's Voyage* (1890) and L. B. Walford's *A Pinch of Experience* (1891); for A. and C. Black, *Ivanhoe* and *Count Robert of Paris* in their edition of Sir Walter Scott's novels; and for Cassell, R. L. Stevenson's *Island Night's Entertainments* (1893). These, however, represent only a small part of his production. The *A.B.C.* shows invention and humour, and should have been popular with children, but there is a lack of design and a suggestion of hurry about the drawings. In the Stevenson book some of the illustrations are by William Hatherell, and although all are badly reproduced, these emphasise by comparison the difference in the work of the two artists: Hatherell's—well designed, dramatic and suggestive of colour; Browne's—the conventional product of the competent but uninspired draughtsman. One can admire Browne's industry but is not charmed nor deeply interested by the results.

Harold Copping's work too, capable and honest as it was,

does not inspire any great enthusiasm. There were so many artists doing illustrations equally satisfactory in literal translation and equally lacking in strong personal individuality. His drawings, which were always pleasant and admirable, were generally made in wash with a suggestion of the quality of water-colour. For Blackie he illustrated *Hammond's Hard Lines* by Skelton Kuppord (1894) and *A Newnham Friendship* by Alice Stronach. For Frederick Warne and Co. he illustrated two of S. K. Hocking's stories, *Rex Raynor* and *Where Duty Lies*, and also a *Toy Book*. Later he did some very competent drawings of Biblical subjects.

Walter Crane was one of the older artists of the period and in a long professional career of fifty-two years decorated a great number of books. The following list, compiled from Miss Massé's excellent bibliography, comprises most of those published between 1890 and 1900.

1890. *The Children of the Castle.* By Mrs. Molesworth. (Macmillan.) 7 illustrations and a title-page.

1891. *Queen Summer.* (Cassell.) 40 coloured plates.
Renascence. (Elkin Matthews.)

1892. *The Scottish Widows' Fund Diary and Almanack.* 12 designs, one for each month.
A Wonder Book for Girls and Boys. By Nathaniel Hawthorne. (Osgood, McIlvaine and Co.) 60 illustrations.

1893. *The Old Garden.* By Margaret Deland. (Osgood McIlvaine and Co.) In colours.
The Tempest. By William Shakespeare. (J. M. Dent.) 8 illustrations.

1894. *The History of Reynard the Fox.* By F. S. Ellis. (David Nutt.)
The Merry Wives of Windsor. By William Shakespeare. (J. M. Dent.) 8 illustrations.
The Story of the Glittering Plain. By William Morris. (Kelmscott Press.) 23 illustrations.
Two Gentlemen of Verona. By William Shakespeare. (J. M. Dent.) 8 illustrations.

1894–ℸ *The Faerie Queene* (six volumes). By Edmund Spenser. (George
1897. Allen.)

1895. *The Book of Christmas Verse.* By H. C. Beeching. (Methuen.) 10 illustrations.

1896. *Cartoons for the Cause.* 12 drawings.

104. WALTER CRANE

In memory of the Commune of Paris. Page drawing from *Black and White*, 4 April 1891

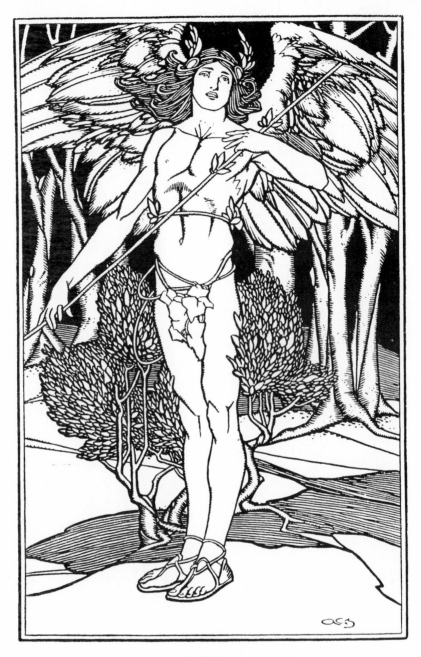

105. A. GARTH JONES

Illustration for *The Minor Poems of John Milton* (1898)

By permission of G. Bell & Sons, Ltd.

1898. *A Floral Fantasy in an Old English Garden.* (Harper.) 46 full-page illustrations.
The Shepheard's Calendar. By Edmund Spenser. (Harper.) 12 drawings.

1900. *Don Quixote of the Mancha.* By Judge Parry. (Blackie.)

Crane's work has been unrestrainedly praised by many eminent critics, so that it will perhaps savour of heresy to suggest that much of it appears to be affected and uninspired, clumsy and laboured in drawing and produced by formula. There was a strong tendency among many people at the time and later to regard any drawing that could be described as 'decorative' as consequently beyond criticism. If it was drawn in an archaic manner and surrounded by a heavy elaborate border it became *ipso facto* excellent. Even now this form of artistic snobbery is not extinct. That such work can be accomplished with greater charm and sincerity and more personality may be seen by comparing with it the designs of Anning Bell, Aubrey Beardsley and Byam Shaw, to take only three examples.

George du Maurier, who satirised this sort of pose so effectively, did many drawings for books. In the period we are considering these were mostly for his own novels, *Peter Ibbetson* (1891), *Trilby* (1894) and *The Martian* (1896). All three books were remarkably successful. *Trilby* was dramatised and produced amid tremendous applause by Beerbohm Tree and established the reputation of Miss Dorothea Baird, who played the title part. In the usual English way the name was applied to every sort of commodity, and by deposing 'Homburg' as the title of a hat, has found its way into the dictionary. Most of these book illustrations were in his later and rather cramped manner, far less interesting than his earlier work in *Once a Week* and *The Cornhill Magazine*, or in his drawings for Owen Meredith's *Lucile* (1868), nearly thirty years before. Then he was a great artist; later he became a '*Punch* artist', which is not necessarily the same thing. In 1898, two years after his death, *Punch* published a collection of his literary contributions, with illustrations, under the title *A Legend of Camelot*. In these he parodied delicately and

with skill some of the wood-engraved drawings of the sixties. Whether the decline in his work resulted from the restricted nature and repetition of his subjects or from the weakening of his sight, which resulted in the loss of the service of one eye, cannot be decided. Probably both causes exercised some effect, but his later drawings gave the impression of the result of hard work. They did not appear to flow easily from his pen as did those of Charles Keene or Phil May, whose facility he admired so much. The drawings lacked variety of tone; the lines were heavy and appeared too black. There was also a lack of character in his figures. His beautiful ladies, whom he justifiably idealised, were reduced to a very pleasant formula, but his attempts to represent ugliness or vulgarity were spoilt by obvious and deliberate exaggeration. His *Punch* work will be remembered more for its delicious satire—and here he did much excellent and necessary service—rather than for its artistic merit. These personal opinions are offered, not in any spirit of general disparagement, but rather with the purpose of drawing fuller attention to the excellence and superiority of his earlier and less known work, which is often forgotten.

H. Granville Fell was another artist of the academic decorative school, deriving much of his inspiration from the work of William Morris and Walter Crane. His best work was done in *The Book of Job* (Dent, 1900), and for the same publisher he also illustrated many of the old nursery stories, *Jack and the Beanstalk*, *Cinderella* and others.

Henry J. Ford's name will always be associated with the series of Fairy Books, Poetry Books and Story Books published by Longmans, for the compilation of which Andrew Lang was responsible. Without being in any way exciting, his drawings were always competent and admirably suited for their purpose. He also illustrated F. W. Bourdillon's *A Lost God* (Matthews and Lane).

A. Forestier illustrated many books but I have only been able to trace the titles of four in our period: *Blind Love*, by Wilkie Collins (1890), *Paul Jones's Alias*, etc., by D. C. Murray and

5 So into the midnight we galloped apace, and after many perilous adventures and hairbreadth 'scapes we reached the Albert Hall. There were big posters, and my name on them in large red letters—"Thomas Noddy, Esq." Fame at last!

6. There were miles of carriages, and we had quite a difficulty in getting in. Officious policemen, and all that. We rode over them.

7. Lots of people came by as I waited, and looked at me with sympathetic curiosity and wonder—just the sort of thing I like. Such lovely women, too, but none so lovely as Vera. Presently who should come by but the Prince and all his equerries.

8. I was presented, and His Royal Highness was most kind and courteous. He had come all the way to hear me sing "The Lost Chord." [Continued at p. 20.

106. GEORGE DU MAURIER

Four drawings from a series, 'The Lost Chord', from *Punch's Almanack* for 1894

By courtesy of the Proprietors

170. GEORGE DU MAURIER
'The Curate's Egg', from *Punch*, 9 November 1895
By courtesy of the Proprietors

108. S. H. SIME
'The King's Taster'. Drawn in pen and ink
Original 9½″ × 13″
Victoria and Albert Museum

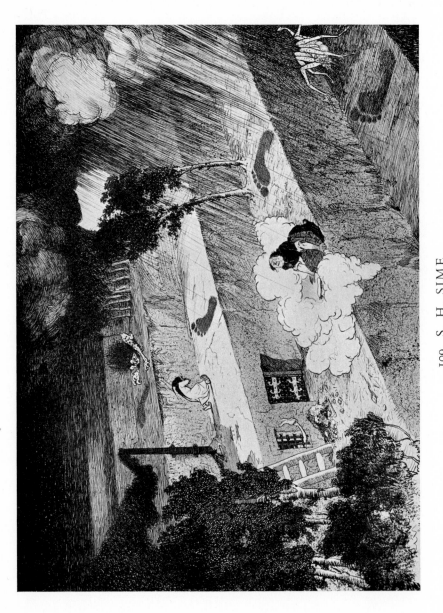

109. S. H. SIME
'The Woman of Cha', Pen and ink and pencil.
Full page from *The Sketch*
Original $10\frac{1}{2}'' \times 14\frac{1}{2}''$

Henry Herman (1890), *Barker's Luck,* by Bret Harte (1896), all published by Chatto and Windus, and S. Baring Gould's *Pabo the Priest,* by Methuen (1899).

A. J. Gaskin was one of the most distinguished products of the Birmingham school and decorated many books of fairy stories, including those of Hans Andersen for George Allen (1894).

F. C. Gould, the famous caricaturist of *The Pall Mall Gazette* and *The Westminster Gazette,* and his son A. C. Gould collaborated in illustrating Grant Allen's *Michael's Crag* (Leadenhall Press, 1893). Most of the drawings were in silhouette and are not very interesting. Alec Gould was more successful later as a well-known landscape painter.

Charles Green was a very distinguished artist, most of whose work belongs to the earlier period of the sixties, when he contributed freely to the best of the magazines and illustrated papers. In the Household Edition of Charles Dickens's books he did thirty-nine delightful drawings for *The Old Curiosity Shop,* full of humour, excellent drawing, fine realisation of character and that sound knowledge of costume, accessories and setting that characterised all his work. He continued to work on into the nineties, contributing to *The Graphic* and many of the leading magazines and also illustrating many books. In Black's edition of Scott he did the drawings for *Waverley.*

Chris Hammond, whose delicate and charming pen-drawings were very popular, has a long list of books to her credit. Among those for which she made illustrations were Maria Edgeworth's *Popular Tales* (1895), *The Parents' Assistant* (1897), *Helen* (1896), *Belinda* (1896) and *Castle Rackrent* and *The Absentee* (1895), all in Macmillan's series of Illustrated Standard Novels. For George Allen she illustrated J. R. Richardson's *Sir Charles Grandison* (1895), Jane Austen's *Emma* and *Sense and Sensibility,* both in 1898, and Oliver Goldsmith's *Comedies.* She also did some of the illustrations to *The Charm and Other Drawing-room Plays,* by Besant and Pollock (Chatto and Windus, 1896). In Nisbet's English Illustrated Library she was responsible for the drawings for Thackeray's *The History of Henry Esmond*

(1896), *The History of Pendennis* (1897), *The Newcomes* (1897), and *Vanity Fair* (1897), Lord Lytton's *The Caxtons* (1897), and Mrs. Craik's *John Halifax, Gentleman* (1898). Her sister, Miss G. D. Hammond, illustrated *Mona St. Clair* and *My Ladies Three*, by Annie E. Armstrong, for Frederick Warne and Co.; and for Blackie and Son, *Nicola*, by M. Corbet Seymour, *The Clever Miss Follett*, by J. K. H. Denny, *A Fair Claimant*, by Francis Armstrong (all in 1893), *The Handsome Brandons*, by Katharine Tynan (1898), *A Girl of To-day*, by E. D. Adams (1898), and *Cynthia's Bonnet Shop*, by Rose Mulholland (1900). These illustrations were all in wash, but for the latter firm she contributed colour drawings to some of their school books.

Charles G. Harper's topographical drawings, accurate and conscientious, are seen to best advantage in his series of books on the main coaching roads of England, of which *The Portsmouth Road* (1895) and *The Bath Road* (1899) are good examples. For the same publishers—Chapman and Hall—he also illustrated *The Marches of Wales*.

A. S. Hartrick, to whose work we have already referred with admiration, does not appear to have illustrated many books during our period, but his drawings for Kipling's *Soldiers' Tales* (Macmillan, 1896) are very distinguished. These were done in oil for half-tone reproduction, and the smaller drawings for head-pieces and tail-pieces in pen and ink.

John Hassall was responsible for one of the *Two Well-Worn Shoe Stories* (Sands, 1899) which we have already noticed in connection with Cecil Aldin. He also illustrated *A Cockney in Arcadia*, by H. A. Spurr (1899), *An Active Army Alphabet* (Sands and Co., 1899), *Nursery Rhymes* (1899), and *My Darling Clementine* (1900). The drawings are characterised by his well-known sense of humour and invention, but the colour is often unpleasant in the reproductions. He also illustrated *Grimm's Fairy Tales* for the same publisher.

William Hatherell's excellent drawings for R. L. Stevenson's *Island Nights' Entertainments* (Cassell, 1893) have been noticed already. Those for J. M. Barrie's *Sentimental Tommy* (Cassell,

1897), twelve in number, although badly reproduced, are sufficient to show the charming qualities of good water-colour drawings which the originals must have possessed. Hatherell also did some drawings for Bradley's *Annals of Westminster Abbey* (1895).

Laurence Housman, whose delicate pen-drawings recall the illustrations of the woodcut period, did two books for Macmillans, *The End of Elfintown* (1894), by Jane Barlow, and Christina Rossetti's *Goblin Market* (1893). His other books were *Jump-to-Glory Jane*, by George Meredith (1892), *Weird Tales from Northern Seas*, by J. L. I. Lie (1893), *The Were Wolf*, by C. Housman (1896), *The Sensitive Plant*, by P. B. Shelley (1898), and three of which he was also the writer: *A Farm in Fairyland* (1894), *All Fellows* (1896), and *The Field of Clover* (1898). The last three were published by Kegan Paul.

In sharp contrast are the powerful decorations of A. Garth Jones for *Milton's Minor Poems* (Bell, 1898), and for Tennyson's *In Memoriam* (Newnes), which are in every sense worthy of the text, to which they add much charm. Garth Jones, who graduated in the pages of *The Quartier Latin*, where his work has been already admired, derived much of his style from Albert Dürer —the strong crisp lines following the surface shapes in parallel clearness. His work differs from that of many of the contemporary decorative artists mainly by reason of his strong masculine method; there is nothing weak or effeminate in any of his designs. His drawing is generally sure and sound, his sense of decoration simple and original, and he shows, too, a fine feeling for colour and the judicious use of black. In this respect he may have learnt something from Beardsley, as did so many of the younger artists of the time, and from R. Anning Bell and Byam Shaw. The books are very charming examples of the best decorative illustration of the period.

Charles Keene is included in this brief record by reason of the eight illustrations to a new edition of Charles Reade's *The Cloister and the Hearth* (Chatto and Windus, 1890). Seven of these, with eight others, appeared in the first volume of *Once*

a Week, through which the story ran as a serial in a shorter form with the title 'A Good Fight'. It seems strange that thirty years elapsed after the first edition before the publishers decided to use these illustrations. Most of them were drawn in outline rather like the early wood-engravings; in only a few has Keene introduced those variations in tone which were the most important feature of his later work.

Curiously enough, the next name in our alphabetical sequence is that of Phil May, another great master of the pen. The books with which he is associated were mainly collections of his drawings, new or reprinted, although he supplied illustrations for the text of four writers. The first is the book which established his reputation—*The Parson and the Painter* (1891)—and was a reprinted collection of weekly articles written by William Alison in *The St. Stephen's Review*, of which he was the editor. These described the adventures of a bland and innocent country parson, the Rev. Joseph Slapkins, and his more sophisticated artist nephew, Charlie Summers, at various theatrical and sporting resorts in London, with occasional excursions further afield to Paris, Boulogne, Whitby and Scarborough. Alison was one of May's earliest supporters in London, and his practical and regular encouragement rescued the young Yorkshire artist from the depths of poverty and hopelessness after his arrival from Leeds. To Alison, perhaps more than anyone, must be attributed the opportunity to make good which May seized with so much avidity and determination. Later, on the death of the paper, Alison became known as an authority on horse-breeding and as the 'Special Commissioner' of *The Sportsman*. Strangely enough, the articles attracted little attention or appreciation in their weekly appearance, but when, in 1891, they were published in book form at a shilling, thirty thousand copies were sold, despite the shrill protest of an eminent church dignitary which prevented its appearance on the railway bookstalls. A very appreciative three-column review in *The Daily Chronicle* acclaimed its merits and set the seal on the young artist's fame. The fine drawing and portraiture, the apparently effortless

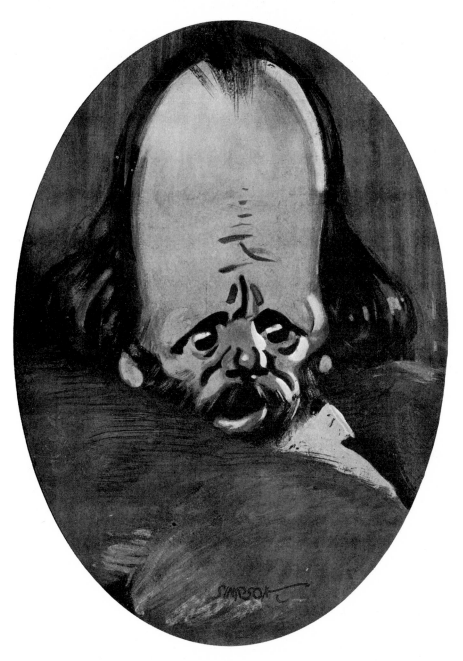

110. JOSEPH SIMPSON
Caricature of Hall Caine, drawn in body-colour. Original 12″ × 8½″
By courtesy of Frank L. Emanuel

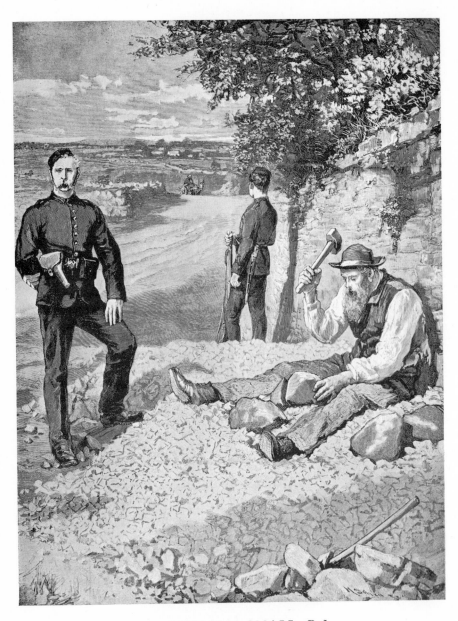

III. WILLIAM SMALL, R.I.
'The Boycotted Stone-Breaker'
Wood-engraving. *The Graphic*, 6 December, 1890

magic of his line, and the reckless light-hearted humour of the production proclaimed a new master in black-and-white art. Here May first established his own personal style, and some of the best of the drawings were never surpassed even by himself. To Byron Webber's *Fun, Frolic and Fancy* (Chatto and Windus, 1894) he contributed eleven drawings, most of which are in pencil. With F. C. Burnand, the editor of *Punch*, he collaborated in the *Zig-Zag Guide* (A. and C. Black, 1897), an irresponsible record of rambles 'round and about the bold and beautiful Kentish coast'. The book is full of delightfully characteristic sketches (there are a hundred and forty of them), personal and topographical, all made in a light-hearted holiday spirit, with much of the fascination that belongs to the sketch-book. In 1898 there landed from Australia an adventurer named Grin, or Grien, who called himself Louis de Rougemont, with wonderful stories of his experiences for thirty years among the aborigines of Central Australia. These were printed in the *Wide World Magazine* and were the talk of London. He was the modern Robinson Crusoe and most of his stories were received with yells of laughter, although it must be admitted in fairness that many of his most improbable yarns were proved afterwards to have a basis of truth. *The Daily Chronicle* set itself to expose his real history, and under the title *Grien on Rougemont* these articles were afterwards republished with a fragment of a De Rougemont Pantomime by Barry Pain and ten drawings and a cover design by May. These were done in his wildest spirit of caricature and with obvious enjoyment of the burlesque humour. May's other books were collections of his drawings. The *Annuals* have been already described. The others were *Phil May's Sketch Book* (Chatto and Windus, 1895), fifty page drawings reprinted from *The Sketch*: *Gutter Snipes* (Leadenhall Press, 1896), fifty original drawings in pen and ink; *Phil May's A.B.C.* (Leadenhall Press, 1897), fifty-two designs forming two humorous alphabets; *Fifty Hitherto Unpublished Pen and Ink Sketches* (Leadenhall Press, 1899) and the *Phil May Album* (Methuen and Co., 1899), a collection of his drawings from *Pick-Me-Up*. It

was immediately after the appearance of *Gutter Snipes* that May was elected R.I. There is a complete iconography of May's work in *Phil May* (Harrap, 1932).

H. R. Millar illustrated several of the Illustrated Standard Novels published by Macmillans: James Morier's *Hajji Baba of Ispahan* (1895), Thomas Love Peacock's *Headlong Hall* (1896) and Captain Marryat's *The Phantom Ship* (1896), *Snarleyow* (1897), and *Frank Mildmay* (1897). For Hutchinson and Co. he supplied drawings to *The Diamond Fairy Book*, *The Golden Fairy Book* and *The Silver Fairy Book*.

Edmund H. New was the greatest of the illustrators of the Birmingham School. His drawings were always accurate, with a bold technique and a charming decorative quality. For Macmillan he illustrated *The Gypsy Road*, by Cole (1894), for John Lane *In the Garden of Peace*, by Helen Milman (1896), and Izaak Walton's *The Compleat Angler* (1897), which contains nearly two hundred and fifty examples of his best and most delightful work. For Methuen he did C. A. Bertram's *Shakespeare's Country* (1899), A. H. Thompson's *Cambridge and Its Colleges* (1898), J. Wells's *Oxford and Its Colleges* (1897) and G. E. Troutbeck's *Westminster Abbey* (1900); and for their 'Rochester Dickens,' *Pickwick Papers* (2 volumes, 1899) and *Oliver Twist* (1900).

William Nicholson, to whom as one of the Beggarstaff Brothers reference has already been made, did some fine bold coloured woodcut illustrations for W. E. Henley's *London Types*, Rudyard Kipling's *An Almanac of Twelve Sports* and *An Alphabet*. All three were published in 1898 by Heinemann, who also issued in 1900 *The Square Book of Animals*, with verses by Arthur Waugh.

Henry Ospovat illustrated *Shakespeare's Sonnets* (John Lane, 1899) and *The Poems of Matthew Arnold* (1900), both full of insight and vision, and in the best tradition of the manner of the sixties.

H. M. Paget was a very popular book-illustrator, whose work may be seen in Scott's *The Talisman* and *Kenilworth*, published

by Black. Wal Paget did some capable drawings in the same series for *Castle Dangerous* and *The Black Dwarf* (Black), and for R. L. Stevenson's *Treasure Island* (Cassell, 1899). For Methuen he illustrated Mrs. L. T. Meade's *Out of the Fashion* (1894).

Alfred Parsons's accomplished pen-work was seen only rarely in English books. His harmonious association with E. A. Abbey in *The Quiet Life* (1890) has been already mentioned.

Carton Moore Park was an artist of the Glasgow school who did much work for the magazines and papers in the latter part of our period. He went to the United States of America in 1900. His illustrations, which show signs of the William Nicholson influence, may be seen in *An Alphabet of Animals* (1898) and *A Book of Birds* (1899), both published by Blackie and Son.

Many of Bernard Partridge's book illustrations were reprinted with F. Anstey's text from *Punch*: *The Travelling Companions* (Longmans, 1892), *The Man from Blankley's* (Longmans, 1893), *Puppets at Large* (Bradbury Agnew, 1897), and *Baboo Jaberjee* (Dent, 1900). He also illustrated Mrs. L. T. Meade's *Heart of Gold* (Warne). But his best work is seen in the drawings for Austin Dobson's delightful *Proverbs in Porcelain* (Kegan Paul, 1893) and in the *Lyceum Souvenirs* of Henry Irving's productions. His gift of portraiture, sense of character and deft craftsmanship are still reflected each week in the *Punch* cartoon.

Much of Fred Pegram's work appeared in Macmillan's series of Illustrated Standard Novels, for which he did three of Captain Marryat's—*Midshipman Easy* (1896), *Masterman Ready* (1897) and *Poor Jack* (1897)—and Disraeli's *Sybil* (1895). Among other books which he illustrated very delightfully were: *The Last of the Barons*, by Bulwer Lytton (sixteen drawings), 1897, *The Arabian Nights' Entertainments* (sixteen drawings), 1898, *London's World's Fair*, by C. E. Pascoe (1898), *The Bride of Lammermoor*, by Sir Walter Scott (1898), *The Orange Girl*, by Sir Walter Besant (1899), *Ormond*, by Maria Edgeworth (1900), and *Concerning Isabel Carnaby* (eight drawings), by Ellen Thornycroft Fowler (1900). In Nisbet's English Illustrated Library he did drawings for Lord Lytton's *The Last of the*

Barons (1897), Sir Walter Scott's *The Bride of Lammermoor* (1897) and *The Arabian Nights' Entertainments* (1898).

Joseph Pennell was born in America, but most of his work was done in this country, and he has illustrated many books for English publishers. Many of these were records of cycling trips made with his wife Elizabeth Robins Pennell, who supplied the text, and were published by Fisher Unwin: *The Stream of Pleasure* (1891), *Play in Provence* (1892), *To Gypsyland* (1893) and *Over the Alps on a Bicycle* (1898). Justin McCarthy's *Charing Cross to St. Paul's* (Seeley, 1893) contains about forty very typical examples of his work, which was largely influenced by Vierge and the Spanish artists. For Macmillans he illustrated Washington Irving's *The Alhambra* (1892) in their Cranford series, and, for the same publishers' *Highways and Byways*, the volumes dealing with *Devon and Cornwall* (1897), *North Wales* (1898), *Yorkshire* (1899) and *Normandy* (1900). For Chapman and Hall he illustrated Wickham Flower's *Acquaintance* (1897). *A London Garland* (Macmillan, 1895) was an anthology of poems edited by W. E. Henley, with drawings by the Society of Illustrators, of which Pennell was art editor and to which he contributed. The society was started by Pennell in 1894 as an attempt to organise the profession and maintain its privileges and dignity, but despite much vigorous work by the founder and the holding of a few dinners, it never attained much success and soon disappeared. G. R. Halkett was president in 1897. Artists have always been difficult people to weld into anything like a co-operative movement, although there is no doubt that such a society would certainly have improved their status and defended their interests. In any case, it seems that if it is to be successful it must not be managed by artists.

James Pryde's appearances as a book-illustrator were few, and the only record I can trace is that of *The Little Glass Man* by Wilhelm Hauff (Cassell, 1893), for which he did some delightful little drawings. His share in the designs for *Tony Drum* has been already referred to as a Beggarstaff production.

Arthur Rackham is one of the greatest English illustrators,

112. JOSEPH PENNELL
'Chancery Lane', from Justin McCarthy's *Charing Cross to St. Paul's*
By courtesy of Seeley Service & Co. Ltd.

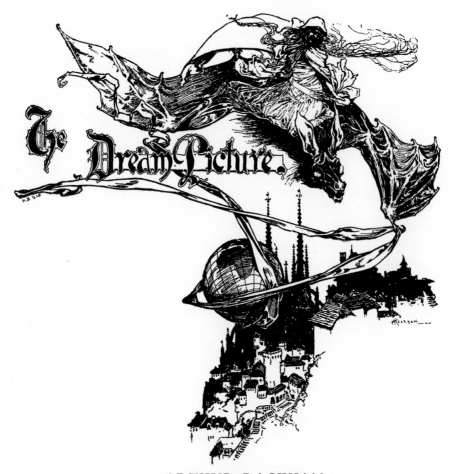

The Dream Picture.

113. ARTHUR RACKHAM
Heading for a story in *Cassell's Magazine*
By courtesy of The Amalgamated Press

though his best work has been done since the period which we are considering. But during that time he contributed promising work to many books, of which the following list is compiled from Frederick Coykendall's bibliography (1922).

	TITLE.	AUTHOR.	PUBLISHER.
1894.	*The Dolly Dialogues.*	Anthony Hope.	The Westminster Gazette.
	Samiseland.	A. Berlyn.	Jarrold and Sons.
	Guide to Wells and Neighbourhood.		Jarrold and Sons.
1895.	*Sketch Book* (2 volumes).	Washington Irving.	Putnams.
	Tales of a Traveller.	Washington Irving.	Putnams.
1896.	*Bracebridge Hall.*	Washington Irving.	Putnams.
	The Zankiwank and the Bletherwitch.	S. J. Adair Fitz-gerald.	Dent.
	The Money-Spinner.	H. Seton Merriman.	Smith, Elder.
1897.	*The Grey Lady.*	H. Seton Merriman.	Smith, Elder.
1898.	*Evelina.*	Frances Burney.	George Newnes.
	The Ingoldsby Legends.	R. H. Barham.	Dent.
1899.	*Gulliver's Travels.*	Jonathan Swift.	Dent.
	Feats on the Fiord.	Harriet Martineau.	Dent.
	Tales from Shakes-peare.	Charles and Mary Lamb.	Dent.
	Charles O'Malley.	Charles Lever.	Nisbet.
1900.	*Fairy Tales.*	The brothers Grimm.	Freemantle and Co.

His work is characterised by an ingenious fancy and invention and a delicate charm of pen-work and colour.

Herbert Railton was a prolific illustrator, whose work we have already noticed in most of the illustrated papers and magazines. He collaborated with W. Outram Tristram and Hugh Thomson in *Coaching Days and Coaching Ways* (Macmillan, 1894), which was reprinted from *The English Illustrated Magazine*. He also did some excellent illustrations for W. J. Loftie's *A Brief Account of Westminster Abbey* (Seeley, 1894) and for many of Dent's publications.

L. Raven-Hill is represented by *The Promenaders*, a book of spirited drawings published by *Pick-Me-Up* (1894) in connec-

tion with the attack by Mrs. Ormiston Chant and other puritans on the Empire music-hall.

E. T. Reed, another *Punch* artist, did some delightfully amusing drawings for *Tales with a Twist* by 'The Belgian Hare' (Arnold, 1898), a book of humorous rhymes which deserves to be better known. Many of his series of drawings in *Punch* were also re-issued in book form.

The three brothers Robinson—Charles, T. H. and W. H.—did many excellent illustrations for books. In collaboration they produced one hundred drawings for *Andersen's Fairy Tales* (Dent, 1900). Charles also decorated for the same publisher *The True Annals of Fairyland*, by William Canton (1900), *Perrault's Fairy Book*, *Odysseus* and *Sintram and His Companions*. T. H. did drawings for *Fairy Tales from the Arabian Nights* (Dent, 1899), Charles Kingsley's *The Heroes* (Dent, 1899), Sterne's *A Sentimental Journey* (Bell, 1900), William Canton's *A Child's Book of Saints* (Dent, 1900), Jane Porter's *The Scottish Chiefs*, Nathaniel Hawthorne's *The Scarlet Letter* and Mrs. Gaskell's *Cranford* (Sands). W. H. Robinson, who has since become more famous by his ingenious fantasies as Heath Robinson, illustrated *The Arabian Nights* (Constable), *Rabelais* (Grant Richards), *Poe's Poems* (Dent, 1900), *Andersen's Fairy Tales*, Lamb's *Tales from Shakespeare*, *Don Quixote* and Bunyan's *The Pilgrim's Progress*, the last four for the firm of Sands. All three brothers had a delightful sense of decoration, a clear flowing line and sound draughtsmanship.

William (now Sir William) Rothenstein's *Oxford Characters* (Matthews and Lane) was a collection of lithographed portraits which appeared serially.

Linley Sambourne illustrated with his fine accomplishment F. C. Burnand's *The Real Adventures of Robinson Crusoe* (Bradbury Agnew, 1893) and Charles Kingsley's *The Water Babies* (Macmillan, 1900).

Reginald Savage did some decorative drawings for Herrick's *Hesperides and Noble Numbers* in two volumes published by Newnes, but unfortunately these are not dated.

114. WILLIAM SMALL, R.I.

Story illustration in body-colour. Original $9\frac{3}{4}'' \times 7\frac{1}{4}''$

By courtesy of Charles Emanuel

115. E. J. SULLIVAN, R.W.S., R.E.
Illustration in body-colour. Original $15\frac{3}{4}'' \times 11\frac{1}{2}''$
From the author's collection. By courtesy of Mrs. E. J. Sullivan

PERSEUS
and the
GORGONS

116. T. H. ROBINSON

From *The Heroes* by Charles Kingsley (1899)

By courtesy of J. M. Dent & Sons, Ltd.

117. W. HEATH ROBINSON

'Master Peter': from *Don Quixote*

By courtesy of J. M. Dent & Sons, Ltd.

Byam Shaw, one of the best of the decorative illustrators, did some fine drawings for *Browning's Poems* (Bell, 1900) and for *Tales from Boccaccio* (George Allen, 1899). Both of these, like the designs he made later for the Chiswick Shakespeare, show his masterly gift for suggesting colour and his excellent sense of design.

William Small must have illustrated many books but the only one in our period that I have been able to trace is Bret Harte's *A Protégé of Jack Hamlin*, with twenty-six drawings (Chatto and Windus, 1894).

Lancelot Speed was another of many competent craftsmen whose work was adequate without being brilliant. Of the many books which he illustrated, *Stirring Tales*, by Skipp Borlase, and *The Shuttle of Fate*, by Caroline Masters, both published by Warne, Charles Kingsley's *Hypatia* (1896) and Lord Lytton's *The Last Days of Pompeii* (1897) in Nisbet's English Illustrated Library, may be mentioned as examples.

In Edmund J. Sullivan we have one of the great masters in pen-and-ink illustration. His drawing was always sound, and he used lines as though he loved them. Perhaps he insisted too much sometimes on the pattern of his lines, which was apt to confuse the design of the drawing. But he had a fine sense of contrasting tones and colour, and all his illustrations, either in line or wash, had an aristocratic air of distinction and a sympathetic understanding of his author. For Macmillan's Illustrated Standard Novels he illustrated George Borrow's *Lavengro* (1896), Captain Marryat's *The Pirate and the Three Cutters* (1897) and *Newton Forster* (1897) and, in the same publisher's Cranford series, *Tom Brown's Schooldays* (1896). For Macmillan's too he did some excellent drawings to *The School for Scandal* and *The Rivals* (1896). Tennyson's *Maud* and *A Dream of Fair Women* (Richards, 1900) supplied subjects in which he could display his charm of decoration and his appreciation of the beauty of womanhood. For a sixpenny edition of Henry Harland's *My Friend Prospero* (Newnes) Sullivan did some charming drawings in wash which are very representative of his work in this

medium. Although they lack the strength and vigour of his line work, these are in some respects more charming, in that the method is not so much insisted upon, and one can appreciate more freely their delicate artistic appeal. His drawings for *The Compleat Angler* (Dent, 1896) are adequate without being remarkable, but it was in Carlyle's *Sartor Resartus* (Bell, 1898) that he reached his highest level as an illustrator, not only embellishing the text but also adding to it an artistic commentary. This is one of the greatest triumphs of illustration of the nineties, worthy to rank with any of the productions of the earlier period and suggesting a comparison with the drawings of Frederick Sandys, who may have exercised some influence on the later artist. Many years later Sullivan wrote two books, *The Art of Illustration* and *Line* (Chapman and Hall, 1921 and 1922), both of which afford evidence of his serious interest in and respect for his craft.

Our alphabetical sequence once again brings two great names together. Hugh Thomson was perhaps the most charming of all the illustrators of the period and certainly one of the most popular. His art was more delicate than that of Sullivan, lacking his obvious strength and vigour. Although the construction was just as sound and conscientious, we are spared the insistence on the means employed to produce the drawings. The results were equally satisfactory and, perhaps because of this concealment of art, more artistic and pleasing. We can admire Sullivan's drawings; we love Hugh Thomson's. His illustrations always seem to have floated on to the paper without the slightest evidence of effort, and this surely is a very positive virtue. The accomplished craftsmanship of both men will be admired, but in Thomson's case it is more subtle. For this reason the artist's work is often undervalued by those who stress the importance of technique, which should always be kept under control and not allowed to obtrude itself at the expense of the complete production. Apart from this apparent ease and simplicity, Thomson appeals to us by his sound drawing, the sureness and freedom of his line, his complete knowledge of the costume and accessories of the period and his very human sense

118. W. CHRISTIAN SYMONS

Illustration in body-colour from *The Wide World Magazine*

Original $9\frac{3}{4}'' \times 13\frac{1}{2}''$

By courtesy of Arthur Morrison, owner of the drawing, and George Newnes, Ltd.

119. C. H. TAFFS

Story illustration in wash. *Lady's Pictorial*, 31 December, 1898

of character and humour. His people are never figures dressed in fancy costume, nor are his settings stage backgrounds. He not only understood but loved the period which he was portraying, entered into it and drew it from within. Although he had little of the usual art-school training and rarely drew from the model, his work shows signs of having assimilated some of the spirit of Randolph Caldecott and perhaps of E. A. Abbey. M. H. Spielmann and Walter Jerrold wrote a very good appreciation of the man and his work—*Hugh Thomson* (Black, 1931)—from which the following list of books that he illustrated is taken.

	TITLE.	AUTHOR.	PUBLISHER.
1890.	The Vicar of Wakefield.	Oliver Goldsmith.	Macmillan.
1891.	Cranford.	Mrs. Gaskell.	Macmillan.
	The Antiquary.	Sir Walter Scott.	Black.
	The Bride of Lammermoor.	Sir Walter Scott.	Black.
1892.	The Ballad of Beau Brocade.	Austin Dobson.	Kegan Paul.
1893.	Our Village.	Miss M. R. Mitford.	Macmillan.
	The Piper of Hamelin.	Robert Buchanan.	Chiswick Press.
1894.	Pride and Prejudice.	Jane Austen.	George Allen.
	Coridon's Song.	Reprinted from the English Illustrated Magazine.	Macmillan.
	St. Ronan's Well.	Sir Walter Scott.	Black.
1895.	The Story of Rosina.	Austin Dobson.	Kegan Paul.
1896.	Sense and Sensibility.	Jane Austen.	Macmillan (Illustrated Standard Novels).
	Emma.	Jane Austen.	
	The Chase.	William Somerville.	George Redway.
1897.	Highways and Byways in Devon and Cornwall.	A. H. Norway.	Macmillan.
	Mansfield Park.	Jane Austen.	Macmillan (Illustrated Standard Novels).
	Northanger Abbey and Persuasion.	Jane Austen.	Macmillan.

1898.	*Riding Recollections.*	G. J. Whyte Melville.	Thacker.
	Highways and Byways in North Wales.	A. G. Bradley.	Macmillan.
	Jack the Giant-killer.	H.T.'s illustrated fairy books; the only one issued.	Macmillan.
1899.	*Peg Woffington.*	Charles Reade.	George Allen.
	Highways and Byways: Donegal and Antrim.	Stephen Gwynn.	Macmillan.
	Highways and Byways: Yorkshire.	A. H. Norway.	Macmillan.
	This and That.	Mrs. Molesworth.	Macmillan.

Some of Thomson's later illustrations were coloured, generally with thin delicate tints applied with pleasant discrimination over line-drawings.

F. H. Townsend was another of the great illustrators of the nineties, who contributed to most of the magazines and papers of the period. He drew mostly in pen-and-ink, which was his happiest medium, but also did much good work in wash. His drawing was always sound and graceful, with a strong feeling for light and shade, which in some cases led to slight exaggeration of effects. Occasionally his work suffered from obvious haste, due to over-production, and this sometimes caused a diffusion of interest and lack of concentration on the essential theme of the subject. His humorous drawings were always inspired with a light-hearted gaiety and enjoyment which were inevitably transferred to the reader. He was the first art editor of *Punch*, a position which he filled with dignity and success until his death in 1920. In Nisbet's English Illustrated Library he was responsible for the drawings in Charlotte Brontë's *Jane Eyre* (1896) and *Shirley* (1897), Sir Walter Scott's *Rob Roy* (1897), Nathaniel Hawthorne's *The Scarlet Letter* (1897), *The House of the Seven Gables* (1897) and *The Blithedale Romance* (1898) and Charles Dickens's *A Tale of Two Cities* (1897). For Macmillan's Illustrated Standard Novels he did drawings for several of Thomas Love Peacock's works—*Maid Marian* and *Crotchet Castle* (1895), *Melincourt* (1896), *Gryll Grange* (1896),

The Misfortunes of Elphin and *Rhododaphne* (1897) and Marryat's *The King's Own*. These contain a very generous allowance of some of his best work, although the reproductions are too small to give their full value. For the same publishers he also did drawings for Mrs. Edwin Hohler's *For Peggy's Sake* (1898) and S. Baring Gould's *Bladys of the Stewponey* for Methuen (1897). For John Lane he illustrated Henry Harland's *The Cardinal's Snuff-box* (1900) and *The Lady Paramount*, and *The Joneses and the Asterisks*, by Gerald Campbell (1895). Sara Jeanette Duncan's *An American Girl in London* (Chatto and Windus, 1891) and *The Old Maids' Club*, by Israel Zangwill (Heinemann, 1896), both of which he illustrated, were reprinted from *The Lady's Pictorial* and *Ariel* respectively. He also illustrated three others of Miss Duncan's books, *The Path of a Star* (Methuen, 1899), *A Social Departure* (one hundred and eleven drawings!), 1890, and *The Simple Adventures of a Memsahib* (thirty-seven drawings), 1893, and one by V. C. Cotes, *Two Girls on a Barge* (forty-four drawings) 1891—the last three for Chatto and Windus. For Blackie and Son he did drawings in wash for *Gladys Anstruther*, by Louisa Thompson, and *Grannie*, by E. J. Lysaght (1891-2).

Paul Woodroffe did some very pleasant decorations for *Ye Second Booke of Nursery Rhymes* (1896) and Herrick's *Hesperides* (1897), both published by George Allen.

J. Walter West's six drawings for Walter Raymond's *Tryphena in Love* (Dent, 1895) were charmingly appropriate.

Patten Wilson illustrated J. S. Fletcher's *Life in Arcadia* (1896) and did many title-pages and decorations for John Lane.

Stanley L. Wood's spirited illustrations appeared in *A Waif of the Plains* (sixty drawings), by Bret Harte (1890), *Maid Marian and Robin Hood* (twelve drawings), by J. E. Muddock (1892), *The King's Assegai* (six drawings), by Bertram Mitford (1894), *Romances of the Old Seraglio* (twenty-eight drawings), by H. N. Crellin (1894) and *A Ramble Round the Globe* (1894), by T. R. Dewar. All were published by Chatto and Windus.

Alice B. Woodward made drawings for Mrs. Molesworth's *The House that Grew* and for the Countess of Jersey's *Eric, Prince*

of Lorlonia (Macmillan) and also illustrated *Banbury Cross* (Dent, 1900).

Jack B. Yeats has illustrated many amusing little books but most of these were undated. His *magnum opus* seems to have been connected with Defoe's *Romances and Narratives* (Dent, 1900), in which his forty-eight illustrations are reproduced by photogravure.

There are, alas, very many omissions in this incomplete record, but it is hoped that there is sufficient information to prompt an interest and encourage further research in a very fascinating subject.

120. HUGH THOMSON, R.I.

Unfinished drawing in pencil and pen and ink. Original 10″ × 8″

From the author's collection. By courtesy of Mrs. Hugh Thomson

121. HUGH THOMSON, R.I.
Unfinished drawing in pencil and water colour
Original $12\frac{3}{4}'' \times 10\frac{1}{8}''$
From the author's collection. By courtesy of Mrs. Hugh Thomson

CHAPTER VII

SOME CONCLUSIONS

The essential qualities of a good illustration are difficult to define exactly. In the first place it must be well drawn, with no obvious indication of apparent effort, and must reflect something of the artist's personality and joy in its production. It must also contain something more than a pictorial statement of the scene or incident described. The artist must add something by way of personal comment and embellishment, either by amplifying the ideas and suggestions of the writer or by introducing an additional interest in the charm of the drawing itself. Edmund J. Sullivan's drawings for Carlyle's *Sartor Resartus* are an example of the former method, and of the latter we may take any of the illustrations of Hugh Thomson. Sometimes an artist will select a passage from the book as a text from which to evolve a pictorial dissertation of his own, in the same way as a book-reviewer will write an essay prompted by a passage in the volume that he is supposed to be criticising. Neither practice is appropriate or fair to the author. A drawing of a lady, standing by a window, to illustrate the sentence 'she stood by the window', can be of value only when it has interest and charm of its own as a drawing. Even then it is probably not a good illustration, because it is unnecessary and adds nothing to our appreciation of the author's intentions. Without such merits it is entirely useless.

On the subject of what are ambiguously known as 'joke drawings' there are two very distinct schools of thought. The modern says that the drawing must be funny in itself without any reference to the letterpress below (although this rarely happens) and he will go to any length in his grim determination to make it funny. Inflated eyes bulging from their sockets, distorted limbs, disproportionate bodies and heads, and wildly ex-

aggerated facial expression—these are some of his methods for raising laughter. Having invented some device of this sort, he is inclined to repeat its use so often that it becomes linked with his name. In this way we have the 'Buggins eye', the 'Jenkins nose', the 'Wiggins feet' (to take three entirely fictitious examples), the mere sight of which is sufficient to cause amusement. For if the inventor does not make the fullest use of his creations, others soon will. The older school maintains that the drawing should illustrate the joke in the same way that an actor interprets the dialogue of the playwright. In this way it describes the circumstances and characters and obviates the explanatory matter, often contained in brackets, which used to be considered necessary for obtuse readers. It should be an intelligent study of character and setting rather than an example of wild buffoonery.

Both methods, if capably used, are justifiable and have their appropriate uses. The music-hall comedian who paints his face and wears a false nose and grotesque clothes will please many people; other members of the audience will prefer the performer who is equally funny in conventional evening dress. Each is judged by the success of his performance; appreciation depends on the point of view. There appears to be no sound reason, however, why a humorous idea should be an excuse for bad drawing. Phil May, L. Raven-Hill, J. A. Shepherd and many others have proved that humour and draughtsmanship can be satisfactorily combined. To many people bad drawing is as offensive as a harsh discord in music and detracts from the enjoyment of the humour.

Many illustrators have been incapable of evolving jokes and humorous situations. Many men have a valuable gift of inventing funny ideas, but, realising their limitations, have, until comparatively recently, abstained with commendable forbearance from attempting to draw them. Nowadays, unfortunately, such restraint is being withdrawn. Most of Charles Keene's jokes were supplied to him, and many modern artists rely for their inspiration on outside sources. But they are good interpreters and can put the idea on paper effectively. In this way the joke serves

an effective purpose in prompting the production of an excellent and charming drawing, which is surely a sufficient reason for its conception. Phil May was a great example of the combination of humorist and artist, and there is no doubt that such blending of the two creative gifts contributed to his success. For in most cases an artist will always interpret his own ideas with more enthusiasm and far more satisfactorily than those of others. But May used no recipe or formula in his drawings; his characters were always carefully selected, studied and realised, and the results were often great works of art without any sacrifice of their humour.

It should be noted that ornamental borders, initials, headpieces and tailpieces are not illustrations but decorations. Like the type and the cover, they belong to the production of the book rather than to the amplification of the author's text. The two processes—decoration and illustration—are quite distinct, although they are often confused. Great stress has been laid by some authorities on the necessity for the method of the illustration to match the type used in the letterpress, and where this is possible it certainly adds to the appearance of the book. But the contention was often allowed to justify much meaningless, laboured and conventional work, which, although it may have conformed to these requirements, did nothing to illustrate the author's text. These productions were often only a development of the printer's stock 'decorations', which he is so fond of scattering indiscriminately unless he is forcibly restrained. A good drawing by a master of illustration—Vierge, Menzel or Abbey—will take its place naturally and with dignity opposite any page, or if necessary this should be adapted to it. More satisfactory results can be achieved by making the arrangement of the page appropriate to the illustration, rather than by compelling the artist, who is the dominant factor, to modify or restrict his methods in order to accommodate the type-setter.

For the essential factor in the making of any drawing is the artist's ability to draw, and no tricks or conventions can successfully camouflage the lack of such ability. Good drawing is as

indispensable to the illustrator as a good length is to the bowler in cricket, and no great measure of success can be attained without it. Very often, particularly during the nineties, a lack of such ability was excused on the ground that the drawing was 'decorative'. This generally meant that the artist attempted to conceal his incompetence and to distract the critical instinct by a superfluous display of meaningless pattern and superficial cleverness. Clearness of design is another essential feature of a successful illustration, as it is, in a greater degree, of a poster. The drawing must be easily intelligible at the distance at which a book is generally held by the reader. Excessive elaboration of detail confuses the general effect and produces a result which resembles a puzzle-picture. It should not be necessary to unravel a tangle of lines to arrive at the artist's meaning, and simplicity in this, as in most things, is its own reward.

The materials by which black-and-white drawings are produced matter little and depend for their success on the personal fancy and preference of the artist. Some men work best in pen-and-ink, others in pencil, charcoal or wash, but there is little doubt that the most exacting medium is pen-and-ink, because it demands more definite and precise statement and allows less opportunity of concealing uncertainty and inaccuracy. The greatest masters of illustration have worked in line, and perhaps for this reason it is the most attractive method. The illustrators of the sixties drew in pencil on the wood-block and the actual rendering of the drawing into lines was done by the engraver. In later periods many draughtsmen, like Menzel, Keene and Abbey, have imitated this method of using lines to produce tones. Others, like Dürer, Vierge and May, used the line to make its own statement, often unsupported by any assistance of tone. They gloried in the bold assertion of the line itself, and their method is made more attractive by its apparent simplicity. There is great joy in a well drawn outline.

By the careful disposal of contrasting tones, a black-and-white drawing can be made to suggest colour quite effectively, and this quality adds considerably to its interest. The dexterous

placing of a spot or mass of black in a line drawing is a simple and well-known application of this principle. H. R. Millar, for example, was very fond of using this method of enlivening a drawing. This suggestion of colour can be effected more easily in a wash-drawing; and many of the illustrations by such men as William Small, William Hatherell and Frank Craig have much of the quality of water-colour drawings, although they were made with lamp black or ivory black and chinese white. But it is also not beyond the power of a line-drawing, as L. Raven-Hill, E. J. Sullivan, Charles Keene, Alfred Parsons, E. A. Abbey, W. Ralston and many others have shown. In this respect Maurice Greiffenhagen was successful in either medium.

In recalling the excellent printing in colour done by Edmund Evans between 1850 and 1880, it seems strange that, with so much talent available, little was attempted in this process between 1890 and 1900. Evans printed the drawings of Randolph Caldecott, Kate Greenaway and Walter Crane and, as he lived until 1905, might have continued his work with some of the later artists. A number of excellent books illustrated in colour were issued between 1905 and 1914, but these were generally printed from three or four colour blocks. They provided an interesting and popular field for many artists, but since the War their production has been very much restricted by the prohibitive increase in cost. A sad reflection on modern progress and trade methods!

A comparison of the work of the nineties with that of the sixties is difficult and perhaps unnecessary because of the difference in the conditions. In the earlier period artists could work with more deliberation, because less urgency and haste were necessary in their productions. Although their drawings were not so faithfully reproduced they were more fully appreciated, and they themselves were regarded as artists rather than as journalists. They enjoyed also more unrestrained opportunity in their choice of subjects and method of treatment, which were not influenced by the fashion of the moment nor by the dictates of incompetent editors. The control and publication of their

work was in the hands of men like the Dalziel Brothers, who were themselves artists or, at least, had some practical knowledge, discrimination and love of things artistic. They were allowed to be themselves and not expected to conform to the narrow conventions supposed to lead to popularity and success. They were, in fact, in many instances greater artists as their successors became greater craftsmen. In judging the merit of their black-and-white work, it should be remembered that much of it was produced before they became more famous as painters. The drawings of Fred Walker and J. E. Millais, for example, were in most cases not made by Frederick Walker, A.R.A. and Sir J. E. Millais, P.R.A., although this fact is often overlooked. Nor was the making of such drawings considered derogatory to their calling as artists, although such an opinion has prevailed at various times since. Then, as later, there were many men, such as Arthur Boyd Houghton and Charles Keene, who were content to remain black-and-white draughtsmen without the more usual ambition to become painters: but neither of these received the full recognition due to the excellence of his work, which it would have received if it had been hung in a public gallery. It is by the production of such men, constant rather than transient, that the standard of work must be judged. Drawings were then more often published solely on their merits as drawings, without the descriptive lines, humorous or otherwise, which were considered necessary later. In the work of the men of the nineties, the conditions of necessary haste did produce, in many cases, certain qualities of directness and sureness and a rapid development in the knowledge of their craft. A careful study and comparison of the work of the two periods, making all allowances for the difference in aims and conditions, lead only to the conclusion that there is little superiority in the excellence of the work produced by the best men of either date.

In making this brief survey of the work done between 1890 and 1900 we have been greatly impressed by the vastness of the subject, a complete history of which would fill many volumes.

Never have there been such a wide opportunity and such an open market for the work of the illustrator, and it appears very unlikely that such favourable conditions will ever occur again. That full advantage was taken of the occasion, both in quantity and quality, has been conclusively established. Never have so many capable draughtsmen been engaged in producing illustrations, and the work of the best of these is sufficient to form a very great feature in the history of English art. Never have there been such perfect conditions for the training and development of young artists, some of whom used them as a prelude to a career of painting, while others remained constant and developed remarkable proficiency and facility in craftsmanship and invention. It is interesting to watch this progress in particular cases and to notice the amazing rapidity with which they sometimes acquired knowledge and experience.

The number of artists capable of producing effective illustrations was enormous, as may be seen by referring to the list of their names in the index. The wide general knowledge which is so necessary for their work, their understanding of the methods necessary for effective reproduction and their facility of production are equally wonderful. In considering the colossal output of such men as Gordon Browne, Alfred Bryan, L. Raven-Hill, Charles Harrison and Herbert Railton, to take a few examples of the many great 'producers' of the period, one is amazed by their industry, physical and mental energy and endurance, and sustained fund of invention. For their work was continued regularly, week by week, over a great number of years and, if not always brilliant, was generally adequate. Naturally some developed mechanical methods and oft-repeated mannerisms (it would have been surprising if they had not), but that they contrived to maintain so consistently high a level of accomplishment is very surprising.

Another characteristic feature of the record of the nineties, which distinguishes it from that of the earlier period, is the more ephemeral nature of much of the work produced. Some of the older men and their followers certainly continued the academic

tradition, and made drawings that were as conscientiously produced as any oil-painting. But much of the work was done purely for the moment, topical in subject and lightly handled, like the spontaneous epigram which raises a smile of appreciation and then is forgotten. Such work naturally led to the development of tricks to ensure speed and to convey a certain deceptive impression of suggesting more than was actually stated. In the hands of a capable draughtsman this slickness was excusable, but many young artists developed the mannerisms without the preliminary knowledge which justified their use. There also arose, especially in the lighter and more humorous publications, an artificial, Puckish, irresponsible spirit of frivolity and fun, which infected both the subject and the method of the illustration. Pierrot became a favourite character. Aubrey Beardsley, Dudley Hardy, Raven-Hill and Phil May did much to introduce and encourage this light-hearted, boyish outlook on the affairs of the world, which did much to break down the stolid, conventional, circumscribed, Victorian idea of humour.

With the coming of the photographic camera and the development of its powers the interest in black-and-white art has sadly declined. There is to-day little interest in, and less demand for, drawings. The love of beauty and art is being crowded out of our lives by the feverish conditions of modern life. It is this lack of appreciation which has been responsible in large measure for the sad decline in the standard of modern magazine production in this country. In the absence of an art editor, the modern director knows little or nothing about the merit or attraction of illustrations. Generally he judges their value by the nearness with which they resemble a photograph, and in most cases he prefers the photograph itself. In one instance at least, as far back as 1898, we have seen that photographs have been used to illustrate stories, with the unsatisfactory results that should have been expected. The joy of the sketch, as compared with the labour of the highly finished drawing, appeals to him not at all. The former merely suggests a form of laziness on the part of the

122. F. H. TOWNSEND
Illustration in wash to Bret Harte's *A Mercury of the Foothills*
Original 9″ × 12″
From the Sir William Ingram Bequest, Victoria and Albert Museum

123. T. WALTER WILSON, R.I.
'Lord Salisbury in the House of Lords'
Double page wash-drawing. *Illustrated London News*, 12 March, 1892

artist and an attempt to shirk the work entailed in an elaborately detailed picture. 'Finish' is his fetish, and he can appreciate no other quality. Spontaneity and originality of treatment are not considered, although meaningless eccentricity is often allowed and encouraged.

There has also been an inexplicable lack of appreciation of the value of illustrations in contributing to the attractions of a newspaper or magazine. Most editors have failed to recognise this quality even for its commercial value and have made no mention of the artist either in connection with the illustrations or in the index. The writer's name was always given, but only very rarely was there any reference to the illustrator. Often his work was of equal attraction to that of the text which it accompanied: in many cases indeed it was far greater. Even when collections of stories were reprinted in book form, there were few instances in which the illustrations were included. On the other hand *The Cornhill Magazine* and *The Quiver*, to take two examples from the earlier period, published volumes containing only selections from the drawings that had appeared in their pages.

The insistence by the author and the editor on a very literal translation of the text also exercised a restricting influence on the work of the artist. Many editors, when sending a story or article for illustration, are very careful to indicate the passages to be translated into drawings. These generally include a large crowd of people with an extensive background, so that the directors may be assured that they are getting full value for their money. It would be useless and unthinkably improper for the artist to suggest that he is a better judge of what will make an effective illustration. The most successful results were always obtained by giving the artist perfect freedom and relying on his discretion and pride in his work to produce the best of which he was capable. This policy, coupled with competent appreciation and encouragement, makes the successful editor. Until these ideas are once more restored, we shall never have an illustrated paper or magazine which is worth serious consideration.

By its enormous volume alone the illustration of the nineties

will always form an important period in the history of British art. And how much of it will survive? Here again, its own immensity defeats its chances of permanence. Good, bad and indifferent were all mixed in a torrent so wide and rapid that it is difficult even now to distinguish the salient features. A fairly representative assembly of the best work of the sixties can be housed on a few feet of shelves, but the bound volumes of the periodical publications of the nineties alone can be accommodated only in a large public library, and even then the collection is not complete. The only practical method of keeping a private record is a judicious selection from their pages, but there must necessarily be many inevitable omissions. Such a selection is undoubtedly worth making and keeping, both for artistic and historical reasons, because already most of the work is unfortunately forgotten. Of the greater part the loss is not seriously regrettable, but there were many men whose work certainly deserves to be preserved: Linley Sambourne, Phil May, Aubrey Beardsley, Bernard Partridge, J. A. Shepherd, L. Raven-Hill, F. Barnard, A Forestier, Caton Woodville, Charles Green, Frank Dadd, W. Small, Paul Renouard, Hugh Thomson, Herbert Railton, Frank Brangwyn, William Hatherell, John Gülich, Gunning King, S. H. Sime, Maurice Greiffenhagen, Edgar Wilson, Dudley Hardy, Joseph Pennell, F. H. Townsend, Fred Pegram, Alfred Bryan, W. G. Baxter, Walter Crane, Henry Ospovat, Alfred Parsons, Byam Shaw, H. M. Brock, Edmund A. New, Arthur Rackham and Jack B. Yeats. Of these the first three at least have undoubtedly exerted a great influence on much of the black-and-white work done since their time.

Here are some names, and there are many others, of men whose work certainly justifies the importance which has been attributed to their period. Perhaps at some future date, when they have been dead a sufficiently long time, some intrepid critic or historian will rediscover them, and copiously illustrated monographs will be written on their work. That these would be of interest has been proved by similar productions in other countries. But is it necessary or advisable to wait so long?

SOME CONCLUSIONS

In these days when beauty and art are being pushed so violently out of our lives, and so much that is cheap, ugly and vulgar is forced upon our notice, it is surely worth while recording and rescuing from oblivion all that is worthy of remembrance and appreciation.

INDEX

INDEX

INDEX

INDEX

INDEX

INDEX

INDEX